small town Big Dreams

small town
Big Dreams

the life of Nancy Zeckendorf

NANCY ZECKENDORF

with Jane Scovell

goff
BOOKS NOVATO, CALIFORNIA

GOFF BOOKS

Published by Goff Books, an Imprint of ORO Editions.

Executive publisher: Gordon Goff.

www.goffbooks.com

info@goffbooks.com

Cover design: Shannon Medrano (with Pablo Mandel)
Book design: Pablo Mandel / circularstudio.com
Goff Books Project Coordinator: Kirby Anderson

10 9 8 7 6 5 4 3 2 1 FIRST EDITION

Library of Congress data available upon request.
World Rights: available.

ISBN: 978-1-954081-89-5

Color separations and printing: ORO Group Ltd.
Printed in China.

International distribution:
www.goffbooks.com/distribution

ORO Editions makes a continuous effort to minimize the overall carbon
footprint of its publications. As part of this goal, ORO Editions, in asso-
ciation with Global ReLeaf, arranges to plant trees to replace those used
in the manufacturing of the paper produced for its books. Global ReLeaf
is an international campaign run by American Forests, one of the world's
oldest nonprofit conservation organizations. Global ReLeaf is American
Forests' education and action program that helps individuals, organizations,
agencies, and corporations improve the local and global environment by
planting and caring for trees.

*To my friends Shelby Stockton Lamm
and Kelly Hardage for encouraging me to write my
memoirs, and to Debbie Klein who has kept my
life together for these past 30 years.*

Chapter One

T HE DAY I WAS BORN, my grandfather hitched his white horse, Dolly, to a buggy loaded with milk bottles and began his delivery rounds. That morning he deviated from his usual drop-and-go routine. Instead, he put the bottles on the stoop, knocked on the door, and when it was opened, proudly informed his customers,

"I've got a new granddaughter and her name is Nancy."

Which was odd because my parents hadn't yet named me. Grandpa, it seems, had taken matters into his own hands. Every weekday he listened to *Just Plain Bill*, a popular radio soap opera, and it just so happened that Bill had a daughter named Nancy. Grandpa liked the name and decided it suited his new granddaughter. He announced it to his customers and informed my parents. They still hadn't figured out what to call me and went along with his choice, adding a middle name, Ann. Thus, I became Nancy Ann King. Nancy is acceptable, yet I've always felt that my last name lacked heft. King is good if it comes before your name, King Henry VIII, say, but after, it's too short and not suited to what I would eventually become—a dancer. For a while, I toyed with the idea of changing my name to Natalia or Natasha. But, practically speaking,

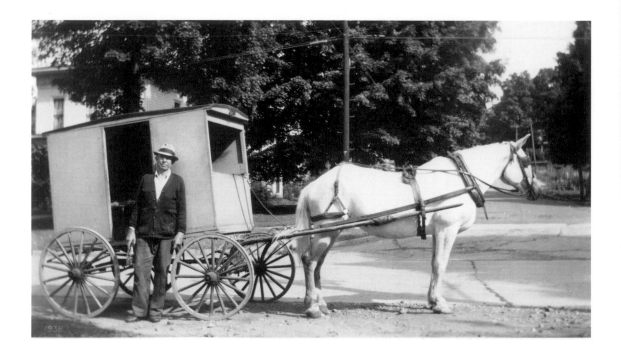

1.1 Grandpa King with Dolly and the milk wagon

Nancy fit better with King, so I let it go. One of the reasons I liked marrying Bill Zeckendorf was that last name of his. Zeckendorf was much better suited to a ballet dancer than King. It is ironic that at the same time I became Nancy Zeckendorf, I stopped dancing professionally.

I was born on April 16, 1934, in Tidioute, a small town in northwestern Pennsylvania. It was a grand total of 1.4 square miles and a population of nine hundred that was either comfortably fixed or poor and mostly Protestant, or, like me, Catholic. We had a pocket-sized post office, two pint-sized grocery stores, a soda shop, a movie house, a large schoolhouse for grades one through twelve, and a main street lined with Victorian homes. Four churches—Presbyterian, Methodist, Baptist, and Catholic—nestled in compatible neighborhoods. Small? We didn't even have a traffic light. The name Tidioute comes from the Iroquois language and alludes to a sharp bend in the Allegheny where Tidioute quietly sat, a dot on the map, until the summer of 1859. That August, Edwin L. Drake, an employee of Seneca Oil Company, appeared in Titusville, sixteen miles from Tidioute. Drake had been sent to search for oil deposits and secure land titles. As a result of his efforts, Drake drilled the first commercial oil well in America, and thanks to him, Tidioute, like other towns in the surrounding area, was swept up in the ensuing oil boom and prospered.

All that happened long before I was born. By then, Tidioute had quieted down. Although the oil industry no longer flourished, a steel mill, a Sylvania factory, and a clothing plant in a town nearby provided plenty of employment, if not excitement. Life in Tidioute was predictable. After you graduated from high school, you'd get a job and marry someone with whom you went to school. Not I. I knew that I was destined to move on. I wanted to go somewhere, do something, be somebody. I spent my childhood and young adulthood studying dance, piano, singing—whatever I thought might help me move on. I wasn't shy about letting my desires be known; my classmates were routinely informed

of my intention. So, it's not surprising, though I did have some friends, I wasn't particularly popular. In my opinion, ambitious people usually aren't that well liked, especially in small towns. Looking back, I don't think I would have liked me much either.

Given that I came from a financially secure background and given that my mother and father were good people who treated me well, where did my discontent come from? Not, I suspect, from my parents. Grace Evangeline McCloskey and George Bernard King had grown up in true Tidioute tradition. They were in the same class at school. After graduation, my father continued his education at business school. Bright as my mother was, her formal education stopped there. My mother was the oldest of ten children and very much a caretaker. She was a wonderful woman, truly an angel. She never complained. She was kind, gentle, and caring, but not demonstrably affectionate. Hugs and kisses weren't on the daily menu. Likewise, my father. Oh, there were smiles, taps on the head, and pats on the back, but neither of my parents could be accused of doting. Their behavior may have reflected their English and Scandinavian roots, but most likely, they were simply of their time and of their place.

In my home, we didn't have maids and we didn't have cooks; we had Grace McCloskey King, and she looked after all of us. There was an exception. By the time I was born, my parents already had four children. A girl, Harriet, was followed by three boys, Bernard, always called Nard, Joe, and Jim. Harriet was twelve years older than I, and nine years separated me from Jim, my closest sibling. When Jim was born, my dad bought a house and moved the family into town from the dairy farm where they had been living with Grandma and Grandpa King. The Tidioute life cycle had been fulfilled. Then our mother got pregnant with me. A dream come true for my parents, but a bit of a nightmare for sister Harriet. The thought of an added little King and the chance it might be another rambunctious boy proved too much for Harriet. One afternoon she returned from school and announced,

"I want to go home."

Home for her was the dairy farm. Grandma and Grandpa King were quite willing to have their granddaughter live with them even after they were apprised that this was not to be a temporary arrangement.

"If you take her, you keep her."

Grandpa and Grandma weren't put off. They took her and they kept her, and Harriet was released from the burden of being a caretaker. Her placement may sound harsh on my parents' part, but I know they loved Harriet, and it was, after all, what she wanted.

When my parents moved into Tidioute, my father got a job with the Hunter Lumber Company. In time, he bought out the owner and changed the name. The company made good money for one very good reason. Tidioute was smack in the middle of a major camping area surrounding the Allegheny River. Every year hordes of people came up that river, built rudimentary one-room cabins to live in, and spent the summer fishing along the banks and hunting in the woods. They bought the lumber to build the camps from King Lumber and Supply. My dad was a successful businessman but somewhat insular. He was interested in politics, business, and lumber, and that was about it. My mother had little time for outside interests. She was caught up in raising us, putting food on the table, and tending her garden.

Tidioute was a pleasant, tranquil town but, culturally, rather comatose. We didn't attract community concerts which were in big cities throughout the country. Neither of our two potential venues, the high school gym and the movie theater, would have provided the right setting. The gym was out of the question, and the movie theater was a small space with a small stage inside a commercial building. There was no marquee and no accommodations for anything other than showing films. Well, not totally. When I was about three and a half, a tap dance teacher came to Tidioute, hired the movie theater, and gave a series of dance classes. It became an event. My mother took me and my cousin who was a year older. We were

too young to participate but that didn't stop us from standing in the back and doing our own little steps as we watched others tapping away on the theater's tiny stage. I kept thinking I'm going to go up and dance with those big girls. At the last session, I marched up front, pushed my way onto the stage, and got in line. I can't remember where my mother was while this was going on. She may have stepped out of the theater to talk with friends. I stood there as the girls began dancing. Some of them gently tried to get me out of the way; others placed a couple of good kicks in my direction. I wouldn't budge. Finally, the lady who worked in the post office came to the edge of the stage, put out her arms, and said,

"Nancy, won't you come down and sit with me?"

She was very kind, and I must have been worn out because I fell into her outstretched arms. She lifted me off the stage and returned me to my mother who had reappeared. It happened more than eighty years ago, but I've never forgotten that moment. I believe that it permanently affected me. I always felt that my three-year-old mind interpreted this incident as one in which I got up the courage to join in but wasn't good enough. It lodged in my brain and left me ever vulnerable to over-heard putdowns such as, "Who does she think she is?" Small-town talk makes no bones about the ambitions or pretensions of others. Imagine, after all these years, I remember that public slight.

Despite the tap-dancing experience, Tidioute's movie theater remained a welcoming sanctuary for me. I saw my first films there, a lot of Metro-Goldwyn-Mayer (MGM), especially Judy Garland and Mickey Rooney and their "let's put on a show" entertainments. I loved Judy and Mickey. I also loved Margaret O'Brien, who holds a special place in my pantheon of stars because she appeared in *The Unfinished Dance*, the first film about ballet. I saw every movie she was in. Of all the people in the world, Margaret O'Brien was the person I most wanted to meet. Watching MGM musicals gave me the idea of becoming a performer, an idea that made me a full-fledged anomaly in our household. Except for my brother Joe, no one in the family was musical. Joe sang and played

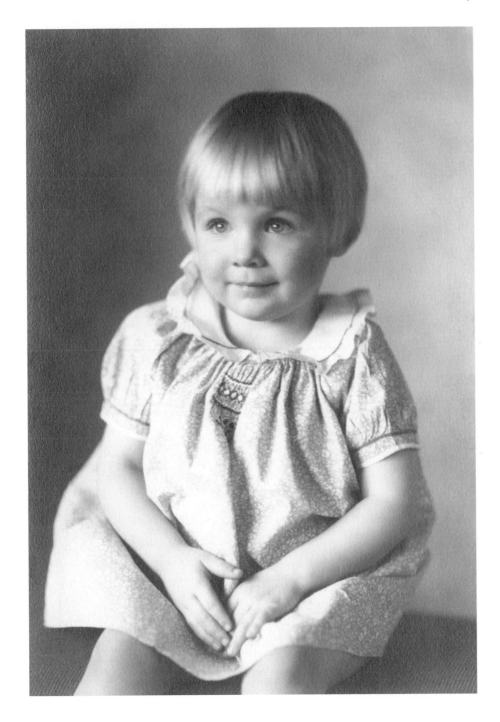

1.2 Nancy at three years

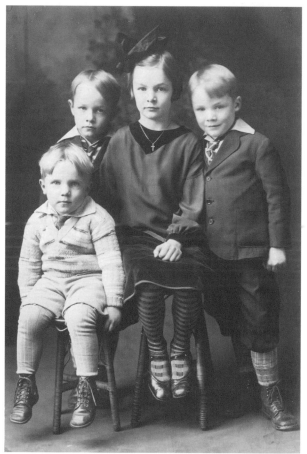

1.3 The King home on the family dairy farm in Tidioute

1.4 Nancy's brothers and sister circa 1926, Jim (seated), Nard, Harriet, and Joe

the trumpet and the piano. He was a navigator in the Air Force for twenty years and flew missions over Germany during World War II. When I was nine, I used to sit beside him on the bench in front of our spinet piano. We'd sing the same song, "Cowboy Jack," over and over. I still remember some of the lyrics:

> He was just a lonely cowboy
> With a heart so brave and true
> He learned to love a maiden
> With eyes of heaven's own blue

Except for these musical moments with Joe, actual time with my brothers was rare. I was much younger and usually fell below their radar. They teased me a lot. When dessert was put on the table, they would pretend to vie for mine. Nard could be a sweet, sensitive big brother, though. Every Christmas Eve, he'd read *'Twas the Night Before Christmas* to me. Those annual readings made a big impression. I looked forward to them and never forgot them. After I'd left home, and as soon as I could afford it, I sent a box of candy to Nard every Christmas for the rest of his life with a note quoting the poem's last line, "Merry Christmas to all and to all a good night."

For reasons I still haven't figured out, I felt that my brother Nard was the only person in the family who loved me. I know my parents loved me, but they never told me. Except for our shared piano moments, Joe was not there, and Jim and I weren't exactly pals. Harriet, of course, was under another roof. Familial love wasn't a topic of conversation in the King house. That's the way people were back then, no parents worshipped their children the way they do now. It wasn't done. I saw an ad on TV recently in which a little girl kicks a soccer ball into the net; her parents jump up and down cheering as her coach rushes to embrace her while she accepts a bouquet. I find it bizarre. All this celebrating over kicking a ball into the net. How is this child going to grow up? It was all I could do to get my

mother and father to one of my recitals. They simply didn't fuss over me or my siblings. I remember one time after I'd done summer stock, been in a Broadway musical, and become a member of the Metropolitan Opera Ballet, a friend asked my mother how she felt about my career. My mother's answer was not, "oh, we're all so proud of her," as one might expect to hear. No, she smiled and said humbly, "I never thought that a daughter of mine would be that talented." She said it sweetly, and meant it kindly, but it wasn't exactly praise. Another time, during my years at the Met, I had a lead role in the big ballet scene in Act III of Massenet's *Manon*. Miracle of miracles, my mother came to see it. Once again, someone asked my mother what she thought about the performance. My mother's reply? "I liked the group dances." I was the principal dancer, and she focused on the corps de ballet. She didn't say it in a derogatory or a mean-spirited way—but talk about faint praise. My guess is, I was so out of her orbit that she didn't know what to make of me. In the King household, you never got kudos, so you kept trying harder. That's the way my parents were brought up and that's the way they brought up their children.

The one and only way my brothers and I could get our parents' attention was by doing well in school. That meant: 1) never be absent—perfect attendance was a cornerstone of education; 2) never be late; and 3) get straight As. Both of my parents had been at the top of their class throughout their schooling, and they believed in acknowledging academic excellence. When report cards were given out, we each received twenty-five cents if we had not been late or absent and ten cents for every A. I was never late, and no matter how sick I might be, I'd go to school throwing up all the way rather than stay home and spoil my attendance record. We all got straight As and were in the top of our classes. My brothers and my sister graduated from college. When it came to education, anything less than perfect was unacceptable in my parents' eyes.

We were raised to be respectful, but we were also raised to be independent, for which I'm extremely grateful. My parents let us do what

we wanted to do, unless it was the wrong thing to do. I have never had trouble making up my mind because my parents let us make our own decisions from an early age. When I was a little girl, if I asked my mother what I should wear, she'd say, "Wear whatever you like." So, by the time I started school, I was mistress of my closet. That was the beginning of my independence. Every summer I went to Girl Scout camp for a month or more. It was a far more convivial atmosphere than school. I loosened up and made a lot of friends. Nonetheless, when we did a production of *Snow White and the Seven Dwarfs*, and I was being considered for Snow White herself, I refused to play any character other than Grumpy. I was born for the part. While I was at camp, I made a momentous decision. Because my hair was long and always blowing around my face and getting in the way, I decided to get a feather cut. Once I did, my hair was under control, but it looked awful. I waited impatiently for it to grow out and swore that I'd never cut my hair short again—and I never have.

During my childhood, I was alone a lot and comfortable being so. I had my passions such as reading and playing with dolls, both solid and paper ones. My favorite was McGuffey Ana, Madame Alexander's version of a country girl. When I wasn't playing with dolls or reading, I wrote. I had decided, thanks to Judy and Mickey, that I was going to be a performer, preferably a dancer, but if none of that happened, I had a backup. I would be a writer. I was working on a novel about a lady and a horse—even though I knew nothing about horses. Did I have any real talent? Unlikely. That didn't stop me from writing stories and poems for myself and plays for my classmates to perform in school. I wasn't viewed as precocious or advanced. Maybe because I was born in April and couldn't start school until I was nearly seven, I was too old to be thought of as precocious. One afternoon, when I was nearly six and a half, a neighbor noticed me playing outside the house and asked me why I wasn't in school.

"I'm smart enough," I said, "but I'm just not old enough."
When I finally entered the first grade at the Tidioute School, I was

excited. I couldn't wait to learn. The school set a good standard when it came to studies, but when it came to extracurricular activities, it was bare bones. We did have a chorus and cheerleaders. Eventually I became a cheerleader, and I liked it except for our colors which were orange and black. Halloween colors, for heaven's sake. We had neither orchestra nor band, and there was no football or baseball, only basketball. That was fine with me. Frankly, I don't like sports or games that much. The reason I don't reveals a hard truth about me—I don't play if I'm not going to win, and if I don't think I'm going to win, I don't play. It sounds awful but it's true. I was a good student from the get-go and not solely for the monetary rewards. I had an old-fashioned thirst for knowledge. I've always wanted to be as informed as I can be, and I've remained devoted to reading and music.

When I was four, my mother bought me a miniature record player with tiny records of someone singing nursery rhymes. I couldn't read, so she drew pictures on the record labels. I still have some of those records. One has a little lamb pictured on it, my mother's indication that it was "Mary Had a Little Lamb." I played those records over and over. The simple melodies got to me. I sang along with them until I could no longer sit still and sing; I had to express my feelings through movement. I began to sway as I sang, and soon I was dancing to the records and improvising steps as I went along. In time, another record appeared in our house. I can't remember how it got there, but that record took me from nursery rhymes to opera. One side was the "Pilgrim's Chorus" from Wagner's *Tannhäuser*, and the other side was the "Anvil Chorus" from Verdi's *Il Trovatore*. Forget the "Pilgrim's Chorus." The "Anvil Chorus," on the other hand, was thrilling—so I began conducting. I was about twelve when my mother purchased a recording of Tchaikovsky's *Piano Concerto in B-flat Minor*. I was enraptured and wanted desperately to participate in the music, somehow throw my body into it. I'd stand in the middle of the room, body swaying, arms waving, leading the orchestra through Tchaikovsky's sublime music. My enthusiasm and

my energy were boundless. One day I conducted so vigorously and for such an extended period of time that I couldn't move my arms the next morning. Convinced that I had polio, I panicked and didn't pick up my imaginary baton for a full day. The next afternoon, I was back on my podium. But it wasn't enough for me to pretend to lead the orchestra, I had to move more than my arms. I began to improvise dance steps. Music literally made me dance. Antony Tudor, who became my teacher and mentor, said, "Dancing is singing with the body." It's true. If you sing with the body, it never stops. From the beginning, improvising was a part of my life. When I moved to those nursery rhymes with no one guiding me, it was because of the music. I wanted to *be* the music.

Although I characterize Tidioute as a cultural desert, it's only fair to mention that music was taught in our school. Music was taught in nearly all public schools in America back then. From the beginning, I knew I wanted to do something with music, but I wanted to do it somewhere other than in Tidioute. Judy Garland and Mickey Rooney had launched my interest in popular entertainment, and a deeper interest was set in motion when Mr. Lewis, my first-grade music teacher, formally introduced me to opera. One day, he brought operatic selections from his record collection to school and played them for the class. I doubt that any other student in the room gave two hoots about hearing Enrico Caruso, Amelita Galli-Curci, and Lawrence Tibbett. I was spellbound, especially when Mr. Lewis played the "Toreador Song" from *Carmen*. It was love at first hearing. *Carmen* is wonderfully accessible. Even people who don't know opera know *Carmen*. The next year, my second-grade music teacher mentioned that *Carmen* was going to be the Saturday afternoon radio broadcast from the Metropolitan Opera. I made a mental note. That Saturday, before I went out to play, I asked my mother to turn on the broadcast and call me for the "Toreador Song." While I played in the backyard, my mother sat at her sewing machine, sewing and listening, until the time came for Escamillo's big moment. She tapped on the glass, and I came through the door in time to catch the thrilling first

bar, "Votre toast, je peux vous le rendre!" I have to confess, my love for *Carmen* centered around that particular aria for a long time. Eventually, I embraced the entire score. The first recording I bought with my own money was a *Carmen* album featuring the reigning Carmen of the day, Rise Stevens. Can you imagine how it felt years later when I danced on the stage of the Metropolitan Opera in a production of *Carmen* starring Rise Stevens? Such a possibility never entered my wildest dreams.

Once my interest in opera had been sparked, Judy and Mickey had to make room for Deanna Durbin, Jeanette MacDonald, and Kathryn Grayson because they always sang arias in their films. I liked Jane Powell, too, although she sang operetta rather than opera. I was also a huge fan of Lauritz Melchior, the great Danish tenor who went from the Metropolitan Opera to MGM where he always managed to squeeze in a couple of songs during each of his movies. Melchior was the first opera singer I saw in person. He was sitting in a restaurant in St. Petersburg, Florida, when I caught sight of him through a window. I stood there gazing at him, thrilled beyond the moon. After I'd had my fill, I raced home to record the event in my diary.

From the time I could write, I've chronicled my life. My diaries, letters, photographs, newspaper and magazine clippings, programs, and souvenirs—ranging from paper dolls to a Buccellati ring given to me by an admirer—are neatly stored in my house. In preparation for this book, I began rummaging through the diaries and letters and discovered a recurring theme. I was curious about the future and what it would bring. When I was thirteen, I took pen and paper and wrote, "Where will I be in fifteen years? What will I look like? Will I have gone to New York?" I still have that piece of paper. At sixteen, I wrote the following note to myself:

> Today is September 26. What will I be like in twenty years? What will I look like, what will I feel? Twenty years from today

I will be 36, perhaps I shall have lived through another war, maybe I will have studied in New York.

Also found in the memorabilia were notes from a handwriting analyst whom I consulted in 1968:

> You are serious in all your undertakings. Even though you do have a sense of humor, you are not a frivolous person, and you feel it's wrong to waste time or thought or energy on things or people when they do not have a definite interest for you or when you realize that the goals you seek will not come through. You like to direct your thoughts and energies towards worthwhile goals.

Did she ever get that right?

Many years ago, I burned a particular batch of letters, and after this book is finished, I plan to incinerate all my mementos, except for the jewelry. The truth is, even though I've been recording and collecting all my life, I never thought I'd have the nerve to write a memoir. I'm doing it because friends have been urging me for years. Even with a pretty healthy ego, I'm not dumb enough or vain enough to think that my life is that important. Plenty of small-town girls have succeeded. On the other hand, along with my determination to do what I wanted with my life, I've known a wide range of genuinely significant people, many of whom inspired and mentored me. I am proud of what I've achieved in my long life and hope that my story might encourage some young girl not to take the easy way out, but to challenge herself.

❋

Chapter Two

MY LIFE WAS SUFFUSED WITH MUSIC at an early age, and the ante was upped when my second-grade music teacher offered piano lessons to any student who wished to learn. I couldn't wait to sign up. Almost all of my classmates began studying, but when I asked my mother if I could take lessons, she shook her head and said no. I begged her, but she stood firm. By the start of the next school year, every one of those kids had quit taking lessons. At that point, my mother said I could begin. The other children took lessons right away and tired of them. I yearned for those lessons and stayed with it until I finished high school.

By the end of my second year of piano lessons, I had progressed enough to move on. We found an advanced teacher in Warren, twenty miles away. Jean Robertson was a graduate of the Eastman School of Music and an extraordinary teacher. She gave me a solid background in music which proved invaluable to my career. Transportation was the one obstacle to my studying with her. I had to find a way to get to and from Warren. She put us in touch with Mary Kaye Green whose mother

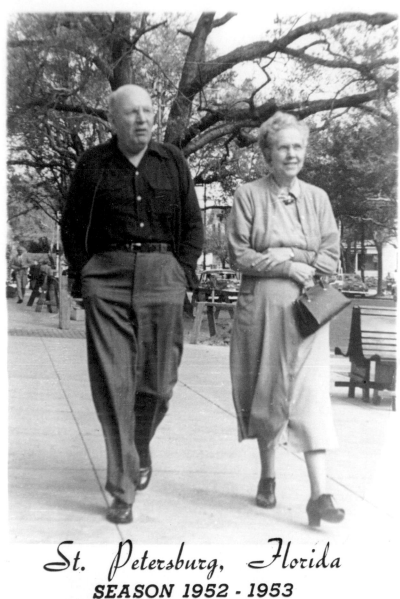

St. Petersburg, Florida
SEASON 1952 - 1953
The Sunshine City

2.1 Grace and George King in St. Petersburg

drove her to Warren on Wednesday afternoons. My mother arranged for me to ride with them. Another step forward in my musical education. I adored Mary Kaye; she was like a big sister to me.

As part of my musical awakening, I became an avid record collector, although the going was slow. I simply didn't have the funds. Realizing that my academic rewards couldn't keep up with my desire to purchase records, I went into business. I made a quick assessment of the possibilities and vetoed a lemonade stand. Definitely not my style. However, hunting and fishing, the core of Tidioute's economy, offered potential. I couldn't sell bullets, but I could sell bait. We lived by the river, the perfect location for nightcrawlers, an earthworm variety that thrives in moist surroundings. They're different from regular red earthworms; they are larger and come above ground to feed, especially at night when it gets foggy and wet. They're excellent fish bait, and Tidioute was crawling with them. I knew a woman in town, a classmate's mother, who sold them, and I became one of her suppliers. There was no overhead. An old paint can and a flashlight were all the supplies I needed. Come nightfall, I'd go outside, flashlight in one hand and pail in the other, and crawl along the wet grass. Once I spotted a worm, I'd put down the flashlight, grab the wriggling thing, and drop it in the bucket. And what did I get for all this scrabbling? One worm was worth one penny. I averaged about fifty worms a night, which wasn't bad. The next day, I'd take my catch to the bait lady. She'd pay me fifty cents for my haul, and when I had enough, I'd buy a record. It took a while, but I was patient. I've always been good about saving money.

Good as I was at saving my own money, I became equally adept at getting others to part with theirs. I regularly participated in three charity drives. Once a year, schoolkids collected money for the March of Dimes. We went door to door and stopped people on the streets asking for change. I also put my efforts into selling cookies for the Girl Scouts. Once more I went door to door offering the delights of shortbread, peanut butter

sandwiches, and chocolate mint cookies. An easy sell. Finally, I sold magazine subscriptions for the *Saturday Evening Post*, *Reader's Digest*, *LIFE*, *TIME*, *Look*, and *Collier's* to raise money for my high school class. I enjoyed raising money and was unabashedly competitive about it. I had to bring in the largest amount. And I did. Each year, I collected more dimes and sold more cookies and subscriptions than anyone else. The experience of collecting all those pennies and nickels and dimes started me on the path to my future career—raising millions of dollars for the arts. I've always been able to concentrate my energies on getting the thing done, whatever the thing might be.

In addition to the perpetual sameness in Tidioute, another good reason to leave was the unbearably cold winters. Snow started in November and you didn't see the ground again until April. We were lucky, my father had enough help in the lumber yard and enough money in the bank for us to be snowbirds. My first year of junior high, I spent January and February in sunny Florida with my parents and Grandma King. My dad rented an apartment in St. Petersburg, and I enrolled at Southside Junior High. That first year in Florida I was homesick, which was strange for someone who blatantly scorned her hometown. But I was not homesick for Tidioute itself, I missed my familiar academic surroundings. Although my first Florida experience was not overwhelmingly successful, there were compensations. The best thing about our time in St. Petersburg was the opportunity to be with my father. Every young girl wants her father's attention, and I outdid myself trying to get his. It wasn't that easy in Tidioute because he worked all day, six days a week. I do remember when I was little, my father would put me on his shoulders and take me downstairs. On the way down he'd call out "low bridge" and that was my cue to duck. Even today, when I see signs along the highway saying, "Low Bridge," I think back to those precious moments perched on my father's shoulders. It was different in Florida. The attention I pined for in Tidioute was mine in St. Petersburg. He was home every day. We had good times together.

The second Florida winter was a big improvement. First, I went to a new school, a wonderful place called Mirror Lake Junior High, and second, I discovered the Eborn School of Dance Art, St. Petersburg's first and only dance academy. I was thirteen when I went there by myself and enrolled. Eborn was more rudimentary than professional. Still, I loved it and attended classes for the next three winters. We were taught ballet basics, arabesques, and pirouettes, period. The teaching may have been inadequate, but as far as I was concerned, I'd found my niche and was beyond happy. Dance would be my ticket out of Tidioute. Thirteen was late for starting ballet, but that wasn't going to stop me. When I got home, I began searching for a ballet teacher. Good luck finding a ballet teacher in Tidioute. Once again, Warren saved me. On the way to piano lessons, I noticed a sign on a nondescript building that read The Rapp Dance Studio. I told my mother about my discovery and asked if I could take ballet classes on Saturdays. She said it was OK if I could find my own way of getting there. In the end, the U.S. Postal Service came to my rescue. I learned that a mail truck bound for Warren left the Tidioute post office every Saturday morning around seven. I went to the post office and asked to speak to the driver, whose name was Perry. He agreed to take me round trip for twenty-five cents. On Saturday mornings, I would meet Perry at 6:45, climb into the front of the truck, and off we'd go to Warren. Other passengers occasionally showed up. If they did, I'd sit in the back on top of the mailbags. One thing I was sure of, Perry's mail truck had no springs. We'd bounce all the way from Tidioute to Warren, where I'd spend the rest of the day taking class after class. In the early evening, I'd bounce back to Tidioute. Exhausted and exhilarated, I'd head straight for a hot bath to soak as long as I could. I'd soak and reflect. At last, I knew where I was going—I was going to be a dancer. It was my one and only goal, and nothing was going to get me off track. If you want to dance, you must be single-minded. Not long ago, the teenaged granddaughter of a friend came to see me. She wanted to be a dancer and was looking for guidance. The first thing I asked her was,

"Is there anything else you might want to be?"

She thought a moment and answered,

"A doctor."

"Then be a doctor," I replied.

I stand by my advice. If you want a career as a dancer, there's no room for wanting to do anything other than dance. If you have an alternative goal in mind, you will not endure the rigors of dance training. It's hard work and requires complete dedication. First of all, you have to keep yourself in the physical shape that's required for classical dancing. As athletes do in many sports, you learn to accept pain. It's funny, when you're performing you don't feel pain. In class or rehearsal you do, but onstage, no. Dancers have to be sacrificial, willing to abuse their bodies and maintain them. I'm not talking about going to extremes, such as bulimia or anorexia. I can't recall anyone I danced with going to those lengths. I didn't. I was five foot five, weighed one hundred and three pounds, and thought I looked great. That said, we all watched our intake like hawks and lived on a thousand calories a day. We ate the same things over and over—grapefruit, hard-boiled eggs, lean cottage cheese, and chicken that we bought cooked and put in the oven and cooked some more so we could eat the bones, too. Whatever eating fad came along, we tried it, from bran muffins to seaweed. Sugar and dairy were the enemy. We worked hard to stay slim, as hard as the models who walked the runways. The only time you allowed yourself to relax and indulge a bit was when you were taken out to dinner by a gentleman. You did it all because you wanted to dance. In my case, not only did I want to dance, I had to dance. There was nothing else I wanted to do. I had no second choice for a career. It was dance or die.

Looking back, I don't feel good or bad about what I did or didn't do in my life. I think people who say, "I should have done that" have created a monstrous burden to live with. The way I see it: you did it, you accept it, you move on. I wanted to dance. I didn't know if I was born to dance, but I knew I was born to do *something*, anything to get out of Tidioute.

2.2 Nancy at six years

I don't fool myself—there are many others from small places who go to New York and make it. I'm not unique. I am, however, relentless.

My parents tried to raise me to become a typical Tidioute native, that is, Christian, Republican, and conservative. Inevitably, I rebelled. Regarding Catholicism, like most impressionable girls of my era, I loved the whole package. The mystery, the ceremony, and the pageantry intoxicated me. I happily participated in all the steps to salvation. My christening, presided over by Father Jacob at St. John's, was attended by the requisite godfather and godmother. The former was our family physician Dr. Krugh, and the latter, Marie Karg, was a friend of the family. My relationship with my godfather was strictly clinical, tonsils and the like, but I hit the jackpot with my godmother. Marie would send small gifts and devise special treats for me. When I was six years old, she invited me to go with her to New York City where she and her husband had moved after they were married. She took me to Radio City Music Hall to see the Rockettes. I was enthralled. She took me to the other premier New York theater, the Roxy. The Roxy was torn down in 1960, but good old Radio City is still going strong. When my visit was over, Marie made a tuna fish sandwich and handed it to me as I boarded a Greyhound Bus for home. That's right, a six-year-old girl was traveling 354 miles for more than six hours all on her own. My parents knew this was the plan and had no qualms about it. That's what I mean about their bringing me up to be independent.

Continuing on my religious journey, I took first communion at seven and was confirmed at twelve. My confirmation was a big deal because the bishop came down from Erie to our little parish. The twelve communicants were herded together and brought into the presence of His Excellency, who proceeded to ask questions. Nobody could answer them—except for you know who. After the ceremony, everyone stood up as the bishop exited the church. On the way down the aisle, His Excellency turned to Father Jacobs and asked,

"Where's that little girl who answered all the questions?"

There, in a nutshell, is an accurate illustration of what I was about, and maybe why so many classmates were indifferent to me. Me, me, me, anything to get attention. What a smarty pants I was.

I continued to be a practicing Catholic until I took up residence in New York City. I was still attending church when my faith was put to the test, and all because of my voracious appetite for reading. I had started a book that I knew was on the *Index Librorum Prohibitorum*, the list of books banned by the Catholic Church. I was already veering from my religious upbringing, and this was the final straw. The idea that I had to tell a priest I was committing a sin by reading "Madame Bovary" was unacceptable. It got me thinking. The result? By the time I finished reading the book, I had finished with the Catholic Church. As for my political affiliation, I was from Tidioute and a Republican. This little apple fell right off the tree of her father's Republicanism. Then I became a New Yorker and took stock. At the same time that I questioned my faith, I also questioned my political beliefs. The answer? I became what I remain, non-religious, liberal, and a Democrat.

※

Chapter Three

WARREN, MY FIRST HAVEN, is the county seat of Warren County, Pennsylvania, and the nearest big city to Tidioute. The population is down from some fifteen thousand persons, when I was commuting there, to nine thousand today. Still, compared to Tidioute, it is a metropolis. Warren was my cultural sanctuary, the place where I took piano and ballet lessons, where I bought classical records, and where I found the kind of intellectual stimulation and support that I was not getting at home—as wonderful as my parents were. Throughout my high school years, I spent more time in Warren. At first, I didn't venture far from the Rapp Dance Studio. I spent 90 percent of my Saturdays within its confines. After I discovered the record store, I'd occasionally slip out between classes and go there. If I had enough money, I'd buy a record, if not, I'd browse.

The studio was founded by Dick Rapp and his wife, Grace. Dick was the sole teacher. Grace managed the business which was housed in their apartment on the top floor of a two-story building. A flight of stairs led from the street to a large front room that served as the dance studio.

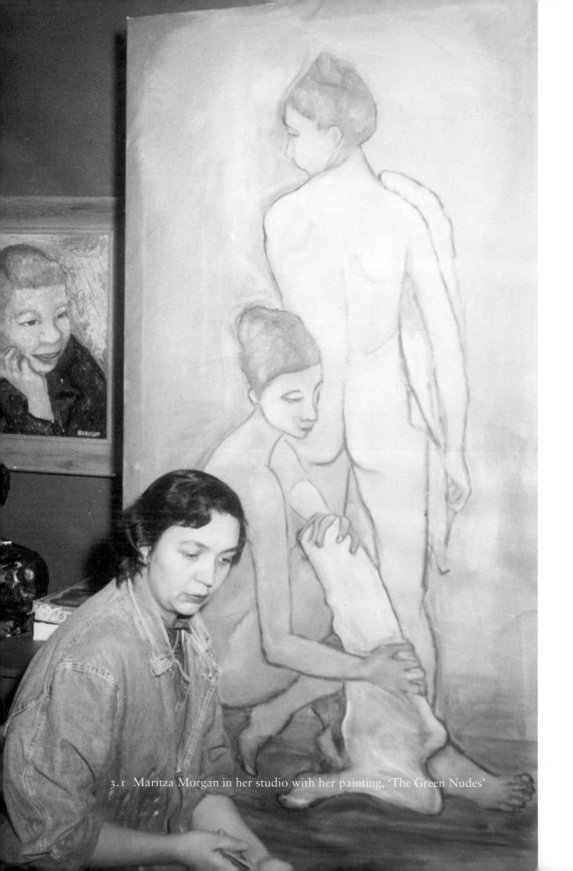

3.1 Maritza Morgan in her studio with her painting, 'The Green Nudes'

One wall was mirrored with a barre attached. An upright piano stood in the opposite corner, and a rehearsal pianist was ever present, beating out the music. That was the business end of the apartment. The Rapps lived in the back. The place was an oddball combination, more cozy than professional. The training was adequate rather than inspiring, and yet, I was inspired. I loved The Eborn School of Dance in St. Petersburg, but it, too, wasn't that professional. The Rapp Studio was a small step up. I was blissfully ignorant of all this and reveled in the opportunity to dance. I began my studies with Dick Rapp when I was fourteen, that was old for a ballet beginner, which is what I was, although I didn't know that either.

While I was studying at the Rapp Studio, the movie *The Red Shoes* was released. It completely captivated me, and I wasn't the only one. Dancers and dance students everywhere were bowled over by the best ballet film ever made. The star of the movie was Moira Shearer, a beautiful redhead and a principal dancer with London's Sadler's Wells Ballet. Sadler's Wells, the precursor to the Royal Ballet Company, made its first American tour in 1949. Among the cities in which they performed was Pittsburgh, 120 miles south of Tidioute. Nothing could keep me from seeing the Sadler's Wells company and the glamorous Moira Shearer in person. I was dying to get her autograph. Along with a few ballet chums, I went to Pittsburgh and checked into a hotel, the same hotel hosting the Sadler's Wells company. That afternoon, my friends and I eschewed any normal sightseeing activity and zeroed in on Moira Shearer. After finding out what room she was in, we congregated outside her door and waited there for more than an hour. Another guest, an older woman, saw us hanging around and asked what we were up to. We told her that we wanted to see Moira Shearer.

"If you want to see her," she advised, "why don't you go to the lobby and call her on the house phone? Ask if you could meet with her."

In those days, unlike movie stars, ballet dancers, even stars, were pretty much on their own. Consequently, there was no assistant in the room

with Moira Shearer. When I called, she actually picked up the phone herself. I said something like,

"Hello, this is Nancy King. My friends and I would like to get your autograph. May we come up to your room?"

Oh, did she let me have it.

"How could you think of such a thing? How dare you disturb me? We have so little time for ourselves. No, you may not come up to my room!"

That said, she hung up.

Plan B had failed. Undaunted, we returned to Plan A and huddled around her door. The funny thing is, Margot Fonteyn was the prima ballerina assoluta of Sadler's Wells but none of us cared that much about getting her autograph. Why? She wasn't a movie star like Moira Shearer. Time passed and we were asked by the management to leave our post. We transferred our vigil to the lobby where Margot Fonteyn appeared. Even though we weren't that interested, we went over and asked for her autograph. She was gracious and lovely and invited us to come back and see her after the performance. Still, she wasn't my target. I'd about given up when I found myself in an elevator with Moira Shearer, among other passengers. I pulled out my autograph book and a pen and politely asked for her autograph. She took my book and scrawled her signature. She didn't say a word, although she did bestow a slight up-twitch of her lips, her version of a smile. There was no banter as there had been with Margot Fonteyn, but I had what I wanted—and, like most of the bits and pieces of my life, I still have it. In hindsight, and in Moira Shearer's defense, I now realize exactly how I would have reacted if some youngster had called my room when I was trying to get some rest. Later, when I saw Margot Fonteyn in *Sleeping Beauty*, I was converted. She wasn't a movie star, but she was the best, a prima ballerina assoluta.

A lot of younger children attended classes at the Rapp School, and I began helping out with them. I wasn't particularly interested in children,

but these were interested in what I was interested in, and that made a difference. I enjoyed working with them. The second year, I began helping a girl named Penny Morgan. She was bright, and unlike the others, wasn't thrilled to be taking ballet classes. I encouraged her to the point where she was enjoying herself. We got on well. I believe she had a crush on me. Speaking of which, I wonder, do girls still get crushes? I hadn't thought about the subject for years, and not long ago I asked a friend if she remembered having crushes when she was a kid. She looked at me quizzically.

"What do you mean by crushes?"

"You know," I responded, "when you had a teacher you admired or an older girl who was everything you wanted to be, or some movie star."

"No, I never had anything like that."

I could see she was telling the truth. She had no idea what I was talking about. It was hard to believe. I thought that getting crushes was part of growing up for girls. When I was young, I got them all the time—on teachers in school, instructors in ballet class, counselors in camp, older girls, movie stars, you name it. I had crushes on everybody, mostly females, although I did have a sort of crush on Mr. Lewis, my first-grade music teacher. He introduced me to opera. In second grade, I was completely dazzled by my music teacher, Betty Bastress. Eventually, she married, had a little boy, and moved to Lockhaven, a three-hour drive from Tidioute. We kept up our acquaintance and exchanged cards and letters. I even went to visit her when I was eleven. That Christmas, Miss Bastress sent me a present. It arrived early, and I begged my mother to let me open it. Wonder of wonders, she did. Miss Bastress had sent me a stuffed cat with a music box in its belly. The cat was covered with fluffy white fake fur, and "Rock-a-bye Baby" rumbled out of its stomach when you turned the key. I carried it around for days and slept with it at night. When I moved to New York and was too busy to look after anything but myself, my dear music box cat was a constant companion. I didn't own a real cat until after I was married. It was then that Bill and I found one advertised in the local paper, and the two of us bought

this wonderful creature who was my pal for nineteen years, and whom I named Nicky. Since then, I've never been without one or two cats in residence. My current four-legged companion, Miso, looks like the music box cat, white and fluffy with blue, blue eyes. At night he sleeps on a pillow above my head under the watchful eye of my faithful music box kitty sitting on the dresser.

Another important crush was on my seventh-grade teacher, Evadna Anderson. Her nickname was Bubbles. Of course, I didn't call her that—to her face, anyway. I adored her. She always wore black, and I made up my mind that as soon as I was old enough, I was going to wear black, too. I still do, adding a bit of white in the summer. By wearing a single color, I don't have to worry about what I'm going to put on. Besides, I look better in black. All told, crushes were part of my young life, and I recognized the tell-tale signs of that phenomenon in Penny Morgan.

I liked Penny and I was impressed with her mother, too. I noticed that Mrs. Morgan not only brought her daughter to the studio, but she stayed to watch the class. Oh, what I would have given to have had my mother do that for me. This was my introduction to the woman who would shape my artistic life. I can say unequivocally that if it weren't for Maritza Morgan and her husband Norman, I never would have become a professional dancer. If I hadn't become a dancer, I probably would have been a music teacher, a career for which I had zero aptitude. I'd have stuck it out as a teacher, but I never would have been content.

I simply couldn't get over the way Mrs. Morgan sat quietly on the sidelines and watched her daughter's class. Most of the mothers brought knitting or books. Mrs. Morgan observed intently. After a while, we began chatting. I had never met such a cultured person. It didn't take long for me to fall under her spell. We talked about ballet, opera, and books, and within a few weeks, we became fast friends. Even though

she was fifteen years older than I, it felt as though she were a contemporary, a very wise contemporary. Soon, I was welcomed into the Morgans' home where I met Penny's brothers. Seven-year-old Vin was the oldest, then came Penny, Jon, who was five, and Kip, who was three. Later, after I'd left the fold, the Morgans had another daughter, Cam. They adopted me into their family. I was the big sister, the eldest, the reverse of my position in the King household. Penny, who became an acclaimed writer, described the Morgan's family life in this excerpt from an autobiographical essay:

> I grew up in a noisy family. Very noisy. My three brothers and I were close in age, and we were always into something: backyard baseball games; canoeing, swimming, and fishing in the creek that ran behind our house; and fighting with each other about this and that. There was also always music. We had a family orchestra: my dad played the piano, my mom and brother Vin played the cello, my brother Kip and I played the violin, and my brother Jon played the clarinet. We kids weren't very good, but we played anyhow. For several years, my parents also owned a farm with a huge barn and a swimming hole. We had three horses, six sheep, a goat who jumped on the hood of moving cars, and a flock of exotic-looking chickens that my dad and I ordered from a catalog. When all the noise and activity got to be too much, I would go for long bike rides. I loved to ride with no hands on the handlebar, and I got to be so good that I could read a book and ride my *bike.*

Could anything have been more different from the home I grew up in? I was intoxicated by their lifestyle. Eventually, I became one of them. Oh, how I loved being a Morgan. And, oh, how I loved Maritza.

Maritza Leskovar Morgan was born in 1920 in Zagreb, Croatia, which was then part of Yugoslavia. She emigrated with her parents to the

United States during World War II. By the time I met her, she was completely Americanized. Still, with her dark hair and dark eyes, she stood out. She didn't look as though she was from Tidioute. Like many Slavic women I came to know over the years, Maritza was subject to bouts of melancholy. In my experience, depression affects certain middle-European ladies, and Maritza was one of them. She was moody. Maritza went to Cornell University where she met her future husband, Norman Morgan. They graduated and married in May 1942. Norman became a psychiatrist on staff at Warren State Hospital, a venerable public psychiatric facility. Maritza was a journalist, writer, translator, and artist. In the 1950s, she was features editor for the *Warren Observer*. First and foremost, Maritza was a painter. Norman realized that his wife was happiest when she was painting, and he encouraged her. She wasn't painting much when I first knew her. Then she took it up again and began painting me. She did many portraits, some of which are hanging in my home today. I became Maritza's model and muse. I was getting all the attention I didn't get at home. It was flattering. I was happily posing, Maritza was happily painting, and Norman was happy because his wife was content. Later on, when I moved to New York and could no longer pose regularly, Maritza turned to wood carvings and religious paintings. Maritza had ambition. She would go on to have a respectable career as a writer and, more important to her, a painter. She wasn't a major artist, but she was a good one and a known one. Her works were exhibited, and she was interviewed by Barbara Walters on NBC's *Today Show*.

In no time, Maritza and Norman became the most significant persons in my life. I thought I was the luckiest girl in the world to know them. They were worldly people who were living in a small town. Not as small as my town, but certainly not a place where they could fully realize everything they wanted to do. And so, they improvised. They amassed a group of friends who were interested in the arts. Some were amateur musicians who got together to play chamber music. They also met to

talk, covering a wide range of subjects from Schubert to Schopenhauer. The Morgans brought me into their intellectual circle of friends, and I often asked myself, why? I was a high school kid. Upon reflection, I believe they were responding to my potential as well as my aspirations and ambition. Maritza and Norman saw this young person who was eager to get someplace, to do something, to be somebody, and it struck a chord. Whatever their motivation, the outcome was exhilarating. I had found my true home.

✳

Chapter Four

BECAUSE I WAS SPENDING A LOT OF TIME with the Morgans, my parents, and my mother in particular, became more interested in me and a little envious of my relationship with them. Later, after I moved to New York, I'd come home to visit, but it was difficult. Everything was the same. It was Tidioute. My mother was hurt by my lack of enthusiasm. She'd make remarks such as, "Seems like you should be with the Morgans rather than here." She was right. I did want to be with my Morgan family more than with my own family. Why wouldn't I? Maritza and Norman encouraged me. Maritza was my ballet mother. She attended some of my classes and made helpful comments. My mother never came to a single class. When it came time for performances, the Morgans were always there. My parents? Rarely. I loved my mother and father, and they loved me, but I'd reached a point in which I needed more than love. I needed encouragement and guidance. Simply put, my parents provided the funds, Maritza and Norman provided the encouragement. Though my parents never encouraged me to dance, they didn't discourage me either. All they wanted was for me to get a college degree. All I wanted was to dance.

It always seemed to me that George Bernard King was indifferent to the activities that nourished me, such as playing the piano or dancing, and it hurt. I worshipped my father and wanted to please him. Yet, he never professed the tiniest interest in what I did. One time when he promised to come to my piano recital, he arrived nearly an hour late. I was crushed. All I wanted was for him to see me perform—whatever I was doing. The worst rebuff happened while I was studying at the Rapp Studio. One Sunday, shortly after I participated in a dance recital in which I figured prominently, my father, my mother, and I were walking to church. I don't remember why we were walking, as we usually drove. On the way, I excused myself and ran into the general store to pick up a copy of the Erie paper. I'd heard that a reporter from the *Erie Times-News* had been at the Rapp recital and I was curious to see if there was any coverage. Unlike Tidioute or even Warren, Erie—sixty miles away—was a proper city with a population of one hundred and forty thousand. I flipped through the paper and there it was—an article about my dancing career and a photograph of me dancing. I was beside myself. The picture and the article were the first major recognition I'd received. I mean you didn't have to do much more than score high points in a basketball game or have your bicycle stolen to get into the Warren paper. This was big time; this was the *Times-News*. I paid the clerk, flew out the door, and chased after my parents.

"Look, look! There's a story about me in the Erie paper. With my picture!"

My father stopped, turned around, and said,

"We've heard enough about you."

Then he turned again and continued walking with my mother following him. I don't know if he meant it exactly the way it sounded. He wasn't a mean person. Still, I was devastated. It was a pretty strong put-down. But that's the way he was with me. Thinking about it, it seems that my father and I were always vying with each other, not for attention, but for recognition. My father knew who he was; I wasn't sure who I was. The truth is, I knew I could have won his approval by getting a college degree, marrying a local boy, and settling down in Tidioute. None of which I planned to do.

In the spring of 1950, my high-school music teacher, Mrs. Barr, stopped me as I was leaving the classroom.

"You know, Nancy," she said, "I heard about this summer camp in Michigan that offers all kinds of programs in the arts, including dance. It sounds like something you might like. You should check it out."

I did, and I liked what I saw. I asked my parents if I could go to the Interlochen National Music Camp. They agreed, paid the tuition, and drove me there. Interlochen started out as a music camp in the 1920s. Over the years, additional disciplines were added. When I was there, it was a culturally diverse, six-week summer paradise offering instrumental, singing, acting, and dance classes. There's still a traditional summer session, but Interlochen is now a year-round center for the arts. The dance department had been founded in 1940 by Hildegarde Lewis who was teaching when I was a camper. Hildegarde was an institution at Interlochen; everyone venerated her. The campers who assisted her were called Hildegarde's Minions. She was an accomplished woman but struck me as a poor man's Martha Graham. Then again, I'm a harsh judge. On the first day, I met two girls from New Jersey, Ellen and Jo. We hit it off right away. They were savvy girls, and I was dazzled when I learned they took ballet lessons in New York City. Despite their more sophisticated training, I was assigned to an advanced dance group and they weren't, which in no way affected our friendship. As much as I loved being at Interlochen, I felt that the training wasn't top-notch. Receiving less-than-the-best training seemed to be my fate. Considering how little I knew, my having an instinct for what was the best is surprising. I knew that the three dance academies I'd attended were varying degrees of OK. There wasn't anyone, even at Interlochen, whom I wanted to emulate. Imitation is part of learning to dance. You need a model of excellence in order to improve. I didn't dwell on Interlochen's shortcomings, though. The atmosphere was charged with music and dance, and I reveled in it. We put on a few shows that summer, including abbreviated versions of famous ballets. My favorite production? We did *Swan Lake* on roller skates. Don't ask. When the season ended, Hildegarde Lewis invited me to come back the next year as one of her

Minions. I was flattered, but I didn't return. I went to New York, and for that I have to thank my Interlochen pals, Ellen and Jo.

On the last day of camp, the three of us were saying our goodbyes. Between hugs and declarations of friendship forever, they gave me valuable advice. They told me if I didn't get out of Tidioute and get to New York, I would never make it. I knew they were right. Ellen and Jo were from New Jersey, but they studied dance formally in New York City; they knew the real McCoy. I couldn't afford to sit around for another two years. I had to take control of my destiny. Interlochen became a major turning point in my life. I had made up my mind to be a dancer. Now I was determined to get the kind of instruction I needed, and fast. I knew where I was going. All I had to do was get my parents to go along with me.

Back home, I made an appointment with the principal of the high school. I told him I wanted to combine my upcoming junior year with my senior year and graduate in the spring of 1951. I was not going to waste precious time. My grades were high enough, so I was allowed to accelerate. It meant more work, but it had to be done. And I did it. One thing irked me, though. I had the same grades as the top two students in my class, but I wasn't graduated with honors. I let it go because I'd achieved what I wanted. My last year, I was so focused on studies that my social life suffered—not that it had been particularly lively. I liked boys, but I was far more interested in a career. Dating an assortment of guys or settling on one suitor might sabotage my plans. I knew all about the birds and the bees, and I also knew plenty of girls were sleeping around. The looming threat of an unwanted pregnancy was the sword hanging over our pageboy-bobbed heads. It derailed lives and destroyed families. If you got yourself into the predicament, you had to pay the consequences. I coped by putting my head down, working hard, and barreling towards my goal.

Now that I'd accelerated my high school years, the next thing I had to do was come up with a way to tell my father that I wanted to go to

ballet school instead of college. I was petrified and expressed my fears to Maritza and Norman. Norman gave me a pep talk and told me that I had to stand up for what I wanted.

"Don't wait for your parents to bring up the subject. They won't. You have to ask for it yourself. Bargain a little bit. Tell your father if he lets you go to ballet school for a year and it doesn't work out, then you'll go to college."

I continued to procrastinate until one evening after dinner, I took a deep breath and said,

"Dad, I want to go to ballet school for a year. And if it doesn't work out, then I'll go to college, I promise."

My father listened and responded.

"I have a better idea. You'll go to college for a year, and if that doesn't work out, *then* you can go to ballet school."

In no way was that a better idea. It wouldn't work because I was already too old for entry level at a ballet school. But that was the choice I was given, and I had to work with it.

In the spring of 1951, I began looking at colleges. Rather, I looked at dance programs at colleges. I pored over catalogs from various schools, checking first for dance classes and reasoning that I could continue my dance studies as I searched for a major. It wasn't surprising that dance didn't figure prominently in most curricula. So, I began looking at colleges and universities in big cities, figuring that if the school had no dance program, there would be independent dance classes nearby. I explored all the possibilities and narrowed it down to colleges that offered a major in music. Jean Robertson, my piano teacher, and Mary Kay Green, my fellow student, both attended the Eastman School of Music at the University of Rochester, and each of them recommended it. The city of Rochester had a respected ballet school, and without ever seeing the Eastman School, I applied and was accepted.

✳

Chapter Five

I GRADUATED FROM HIGH SCHOOL in June and performed in a recital of *Swan Lake* for the Rapp School a week later—in toe shoes, not on roller skates. Here I was portraying the iconic Swan Queen and I barely knew a *battement* from a *changement*. Despite my deficiencies, I received good reviews. When *Swan Lake* finished, I had the rest of the summer to do as I wished. I grabbed the opportunity to do exactly what I'd been aching to do, take dance classes in New York. I'd read so much in *LIFE* magazine about the New York City Ballet (NYCB) company and its director, George Balanchine, that I'd set my sights on taking classes there. The NYCB offered dance classes during the summer, and I asked my parents if I could attend. Because I'd kept my end of the bargain, entering college in September, they gave me the go-ahead.

I stayed in Elizabeth, New Jersey, with family friends. On the appointed day, I took the train into the city and went to the ballet studio on Madison Avenue. I watched a class and then presented myself to the teacher, Muriel Stewart. I had read that she once performed with Anna

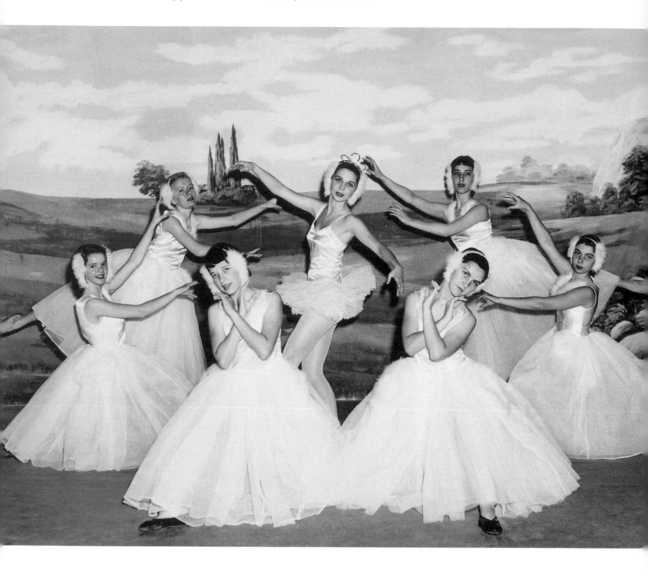

5.1 Nancy and students from the Rapp Studio performing *Swan Lake*

Pavlova, the great Russian ballerina. Pavlova! It took my breath away. All I had to do was dance some steps for her to evaluate my ability and assign me to a class level commensurate with my skill. She asked me to do some *pliés* and *tendus*. When I finished, she handed me a piece of paper on which she'd written: Pre-beginner. No point work. Three classes a week. I was dumbstruck. PRE-BEGINNER? No point work? Three classes a week? For heaven's sake, I was going to be there only two weeks. I was being sentenced to dance kindergarten. Irate and humiliated, I got my things together and left the studio. I knew my training left much to be desired, but I'd been encouraged for so long, even lauded in some instances, that to receive such a demoralizing judgment was devastating. The terrible thing was, despite all the time and effort I'd exerted, I'd been told exactly what I'd always suspected and feared. I was not sufficient in technique. I was crushed. Among other things, I'd been counting on doing well to prove myself to my parents. I panicked and promptly called Maritza. She calmed me down and urged me forward. Her exact words were,

"That's not the only ballet school in New York City. Find another one."

I did.

I got in touch with Jo and Ellen and they recommended Ballet Arts which held classes in Carnegie Hall's Studio 61. It was an open school; they didn't require auditions or evaluations, just the tuition fee. That suited me fine. My dancing had been judged, and I did not want to go through that process again. When I went to register at Ballet Arts, I was asked in what level I thought I belonged. Without hesitating, I answered,

"Intermediate."

I began taking classes with Lisan Kay and found them extremely demanding. I couldn't keep up. Everyone else in the class would do combination steps, and I'd look at them and think, "What the hell are they doing?" It was becoming clear that I'd gotten away with murder at the Eborn and Rapp studios and Interlochen. I was seventeen years

old and it felt as though I'd never taken a ballet class before. I tried hard, but I couldn't maintain a satisfactory level of performance. I wasn't sure that I'd been taught basic ballet properly. Once more, I called Maritza and told her how discouraged I was. She conferred with Norman, and he told her to get on a bus and go to New York.

"Stay with Nancy for a couple of days. Encourage her."

Maritza sent me a telegram:

"Can you cancel all engagements except for dancing? Arrive NYC sometime Friday. Your folks say hello. Maritza."

What a relief to read those words. My guiding light, my mentor, my friend was coming to save me, and I needed her. If you're embarking on a career, you have to have somebody behind you, a teacher, a mother, an aunt, especially in the beginning. If you don't hear encouraging words, you get pulled down. Maritza always bolstered me, telling me not to give up, to keep going, all the while reassuring me that I had the talent.

The next morning, Maritza boarded a Greyhound bus and arrived in the city six hours later. She stayed at the Empire Hotel, across the street from what is now Lincoln Center. She came to my class, watched me, and then spoke to the instructor. Later we went to her hotel room and sat on the bed while she gave me a pep talk.

"I talked to your teachers. They told me you're talented. They think you're going to make it."

I thought Maritza was making it up to give me the courage to continue. Why would the teachers talk to her about me? And what was this baloney about my being talented? I could barely do the right steps. I protested, but Maritza kept insisting that I had the stuff. It took a while, but I calmed down. Maritza knew exactly how to handle me. She sympathized but she wouldn't let me wallow in self-pity. The message was clear: Buck up. The next day I returned to class and began to work. The first thing I did was to stop glancing at what the others were

doing. If they were doing better than I was, so be it. I threw myself into my work. When it was finished, I felt I'd done well. That evening Maritza took me out to dinner to celebrate. She was leaving on an early bus the next day. It was nice having her around, and I tried to get her to stay longer.

"I'd love to stay with you," she said, "but I've got to get back to Norman and the kids. Besides, you don't need me anymore and they do."

When we said goodbye, she gave me a big hug.

"You're good, Nancy," she told me. "You've got it. You'll get there."

Maritza's brief visit set the tone for the days that followed. I was happy with my classes, so happy I wanted to extend my stay. I called my parents and asked if I could remain in New York for an additional week. I was going to college so, no surprise, they agreed. I threw myself into the classes and learned more in those weeks than in all the time spent at Eborn, Rapp, and Interlochen put together. Again, I stayed in New Jersey, but not with our family friends. Instead, I moved in with Jo's family, lovely people who welcomed me with open arms. I sometimes think about all those friends, acquaintances, and even strangers who were kind and generous to me when I was an aspiring dancer. I've tried to do the same and encourage or mentor young dancers. It's a good thing to do because at the same time you're helping someone, you remain closely connected to the discipline you love.

Going back and forth from Jersey to New York was a breeze. I was completely caught up in my classes, and the rest of the time I spent writing letters home. I wrote to my parents, of course, but I showered Maritza with mail, and she responded in kind. That's how people remained in touch back then. Almost every evening, I wrote her pages and pages telling her what was going on in my classes and in my mind. I probably never wrote a letter that was shorter than eight pages, and the letters I received from her were of similar length. Alas, the luxury of letter writing is lost. Holding a letter in your hands while you read

it is one of the great pleasures of communication. The same goes for newspapers. I don't want to read headlines on a screen. I want to hold the newspaper in my hands. I'm rarely on the internet, and I do not own a computer or a smart phone. A flip phone and an iPad are my only concessions to our cyber times. I have an email address, but it's managed by my assistant in New York, Debbie Klein. Debbie has been with me for more than thirty years and is indispensable. She either telephones and reads the messages to me or copies and faxes them. I do not use email; I find it confusing. It's a variation on the same old story—if I don't think I can fully master it, I'm not going to try.

I returned to Tidioute with about a month left before starting Eastman. My parents continued to indulge me, probably in hopes of keeping me at home rather than at the Morgans. I took advantage of my newly exalted position to check off another one of my aspirations. There was enough time to attend a summer session at Chautauqua. Everyone knew Chautauqua, an arts institute on Lake Chautauqua forty-five miles north of Tidioute. Chautauqua was summer camp for grown-ups. In the beginning, its purpose was to introduce adults to "great ideas, new ideas, and matters of public concern." By the time I went there, the scope had expanded to embrace the arts, including dance. I was more fired up about dancing than ever, but as I was bound to the college bargain with my father, I wanted to cram in as much dancing as I could before my exile to Eastman. I set off to Chautauqua with Phoebe Jewell, a friend from the Rapp School. I adored Phoebe. She was younger, full of enthusiasm, and probably had a crush on me. We rented a room together and took dance classes with Winona Bimboni, daughter of the Italian conductor, Alberto Bimboni. Winona had studied with Michel Fokine, esteemed choreographer for the Ballets Russes. Chautauqua was near enough to Tidioute and Warren for me to visit my parents and the Morgans.

Again, I spent more time with my artistic family than with my birth family—a sore spot for my mother.

5.2 Nancy's registration ticket for classes at Ballet Arts Studio

While I was at Chautauqua, events were happening at home, events regarding my future that would forever change my life. The chief engineers were my guardian angels, the Morgans. Maritza and Norman had a friend, Mary Johnson, who taught at the Juilliard School in New York. She told them that Juilliard was introducing dance classes in the coming semester and offering a Bachelor of Science degree for dance majors. The Morgans knew my parents were a hard sell, but this was a bona fide opportunity for me to earn a college degree doing what I so passionately wanted to do. Mary Johnson was on her way from California to Juilliard, and the Morgans asked if she would make a side trip to Tidioute and speak to my parents. That wonderful woman went three hundred miles out of her way to visit them. She sat in our living room and talked about the new addition to the Juilliard curriculum. When the magic words, "college degree," were uttered, my father's response was immediate.

"If Nancy can get in, she can go."

To get in, I had to audition with barely two weeks to prepare. I decided to choreograph a brief musical excerpt from Gounod's *Faust*. I worked diligently. The time came for me to return to New York and present myself to Juilliard. Maritza joined me for moral support. My parents were happy that someone was going with me. On the bus ride to New York, Maritza lavished me with variations on the theme, "You can do it." This time, however, was different. I was nervous, but I was prepared and eager to show what I could do. There weren't that many people at the audition. Most of the applicants came from performing arts high schools in the New York area. I felt like an outlier. We danced before a board of judges consisting of Juilliard faculty members. It's probably better that I didn't know who they were, or I might have spent more time gawking than dancing. I had no idea the panel included Martha Graham, Antony Tudor, and Martha Hill. Although not as celebrated as Graham and Tudor, Hill holds a firm place in dance hagiography; she started the dance program at Bennington College and convinced Juilliard to add dance to its degree

curriculum. When it came my turn, I took my place, the adrenaline surged, and I danced. Did I do OK? I couldn't tell you. But I did my best and it was good enough. In September of 1951, I entered the Juilliard School of Music.

✻

Chapter Six

FIRST THINGS FIRST. I had to find a place to live. Someone recommended the Parnassus Club on West 115th Street. The Parnassus Club, a boarding house for women, was founded in 1921 by Miss Florence McMillan, a former concert pianist and accompanist to Leo Slezak, a prominent tenor. Most residents were students at Juilliard, Barnard College, and the Columbia University School of Nursing, all of which were in the neighborhood. Other residents included semi-professional performers, artists, and writers. Carson McCullers, the southern-born American novelist, was probably the most famous boarder. It was a nice club, a safe place where parents could send their daughters and be assured that they were in good hands. The club had rules and regulations enforced pleasantly but firmly by the staff to protect its residents. Among the rules, men could go no higher than the first-floor gentlemen's parlor, where space was provided for them to await their lady friends, who had to be returned by the eleven o'clock curfew. My parents were far more amenable to my living in New York knowing that some form of supervision existed in my lodgings.

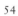

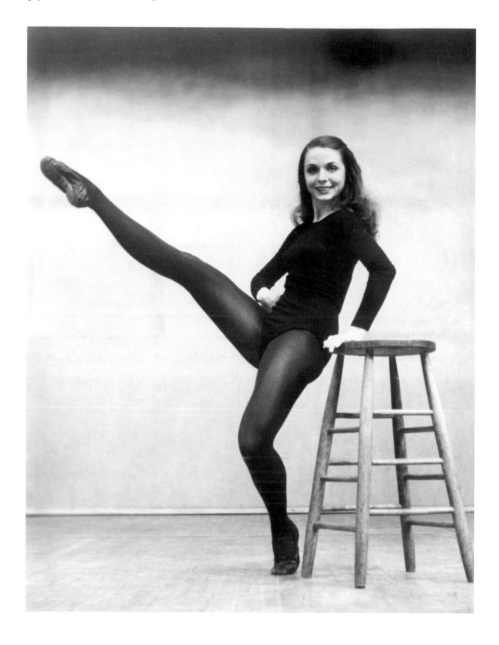

6.1 Nancy as a student at Juilliard in 1952

Today, the Juilliard School is part of the great Lincoln Center complex, but in 1952 it was located in far humbler accommodations on Claremont Avenue in the Morningside Heights section of Manhattan. Because dance was new to the school, Juilliard's facilities didn't include a proper ballet studio. We had to walk across the street to the International House and use its gymnasium. I-House, a private, nonprofit residence and program center for graduate students and research scholars, was not affiliated with Juilliard, merely a good neighbor. The gym wasn't a proper studio either, but it did have space. Instead of mirrored walls, there was a huge mirror that was movable as were the barres. The setup was jerry-rigged and didn't feel like a ballet studio, but we made do. During this time, I began to carry a tote bag, the unofficial accessory for not only ballet dancers but any woman who works in the theater. First thing in the morning the bag was loaded with everything you'll need for the day, so you don't have to return home. Like most dancers, I was a walking notions counter. In addition to my wallet, my bag held hoop earrings, a toothbrush, a small tube of toothpaste, hairpins, a thermometer, tissues, lipstick, mascara, rouge, and powder. To this day, I carry a modified version. Except for the hoop earrings, it contains pretty much what I carried around at school.

There were fifty dance students; I was in an advanced ballet class of twelve. We took courses in ballet, modern dance, and dance notation, interspersed with courses from the liberal arts curriculum. In a credible ballet school, you're taught by knowledgeable and, in many instances, renowned artists, a tradition that continues today. Great ballet dancers don't fade away—they teach. I studied with some of the great ones, including Martha Graham, Margaret Craske, and Antony Tudor. I took dance notation with Ann Hutchinson and dance composition with Louis Horst. During the year, Doris Humphrey and Agnes de Mille each conducted a four-week course with us. I'm still amazed at the number of legendary figures from the dance world I met in one school year. As for non-dancing classes at Juilliard, I took English literature and a

course titled Literature and Materials of Music, referred to as L&M. The former was taught by a man who was rarely there; he was working on a book and shuttling between New York and London. Others substituted for him. The latter course was taught by Norman Lloyd, a pianist and composer. In L&M, one of our assignments was to compose a twelve-tone piece. Norman Lloyd was impressed enough with my composition to orchestrate it for two clarinets and a snare drum. I was asked to choreograph a dance for my piece, and it was performed at a Juilliard concert series.

The dance curriculum included Pre-Classic Forms, a class in which we created contemporary compositions in the style of early dances such as jigs, waltzes, and gavottes, and Modern Forms that explored studies in love, anger, depression, and other kinds of nonclassical expression. My teacher was Louis Horst, a faculty member and one of the highly regarded dance composition teachers of his time. Horst was Martha Graham's musical director, mentor, friend, and off-and-on lover for many years. Graham once said, "Without him, I could not have achieved anything I have done." Horst probably would have demurred, but it does illustrate his importance. His classes in dance composition were stimulating and challenging. A heavyset man, he would sit at the piano with a cigarette dangling from his lips and play different pieces for us, telling us how to create a theme and develop it. He wasn't a dancer or a choreographer. He was a brilliant man, a wonderful man, a formidable man, and we were scared to death of him. He was an exacting teacher and at times piled on so much information you could barely keep up. Occasionally, a student would burst into tears and run out of the room. Horst would look up from the piano and ask, "What did I do?" For some reason, I got along with him. Occasionally he'd throw a compliment my way.

"You know you haven't got a Graham mask," he once remarked. "You haven't even got a Rena Gluck mask, but you've got something."

Mask is the facial structure of a performer, the aspect, the set of the eyes, the line of the cheekbones. Graham's mask was angular. Gluck, a

6.2 Exterior of the Parnassus Club

principal dancer with Batsheva Dance Company of Israel, had a softer structure and a narrower width across the cheekbones. Both women were striking. At the time, I didn't know what Horst was talking about, but it sounded good. On another memorable occasion after my twelve-tone piece was played at the concert, he stopped me in the hallway.

"You have some talent in composition, Nancy," he said. "Your piece is similar to one that I wrote for Martha Graham."

I was astonished to hear him not only compliment my music but compare it to his. I managed to say thank you and then rushed off. Later on, after I'd left Juilliard, Louis Horst and I became friends. I used to have dinner with him. Once he gave me wise counsel about living with another person.

"The problem with Martha and me," he confided, "was having two toothbrushes on the same bathroom sink."

The image impressed me. I could see those toothbrushes together. The lesson I took from it was always to respect my husband's space. I never moved in on him or tried to top him. Luckily, I never wanted to.

Every instructor at Juilliard had a fascinating backstory. Martha Graham hardly needs an introduction. A quote from her obituary in the *New York Times* tells it all, "The Graham technique became the first enduring alternative to the idiom of classical ballet." Think about what that statement says. At the same time Graham was teaching at Juilliard, she was running her company and dancing, too. She couldn't teach on a regular basis, but the value of her name on the roster and her teaching even a small number of classes was worth it. If she was unable to make a class, she'd send someone from the company to sub for her. Three that I remember were Mary Hinkson, Helen McGehee, and Robert Cohan. Although studying with Martha and her disciples was exciting, it was modern dance, and I was a ballet baby. My interest lay in the classical discipline. I deeply admired Martha Graham, but I was more at home in classes with Antony Tudor and Margaret Craske.

Margaret Craske was English-born and a pupil of Enrico Cecchetti, the Italian ballet master who devised an eponymous ballet training method. Miss Craske, among other disciples, passed it along. During her dancing career, she performed with Diaghilev's Ballets Russes and toured with Sadler's Wells Ballet. When she injured her foot and had to stop dancing, she was undeterred and turned to teaching. She began by assisting Cecchetti at his London studio, then opened a studio of her own. At the same time, she served as ballet mistress for the Royal Ballet. At the suggestion of Antony Tudor in 1946, she was invited by the American Ballet Theatre (ABT) to become ballet mistress. She liked the idea, closed her studio, and went to New York. In 1950, ABT, in collaboration with the Metropolitan Opera, opened a school at the Met which became the Metropolitan Opera Ballet School. Miss Craske was first a teacher at the school and then became its director. She also taught at Juilliard and the Manhattan School of Dance and at Jacob's Pillow in the summers. Her professional life was impressive; her personal life was no less remarkable, principally because of her long association with Meher Baba, an Indian spiritual master with a wide following in his own country and abroad. (Pete Townshend of The Who and The Beatles' George Harrison were disciples.) During the Second World War, Miss Craske went to Baba's ashram in India, stayed for seven years, and became a practicing Hindu. My first year at Juilliard, I knew little about Miss Craske's life. It wasn't until the following year that I got to know her. The same goes for Antony Tudor.

Martha Graham and Margaret Craske were both great teachers. But in my heart of hearts, there was only one—Antony Tudor. For me, Tudor was a god. He was never called Tony or Antony; it was always Tudor. His real name was William Cook but he wasn't satisfied with his name. I married out of mine; he changed his. Born in London, Tudor came late to dance, something else to which I could relate. He began his working life at 16 as a delivery boy and didn't take up ballet until he was 19. He studied with Margaret Craske at her London studio and began his professional

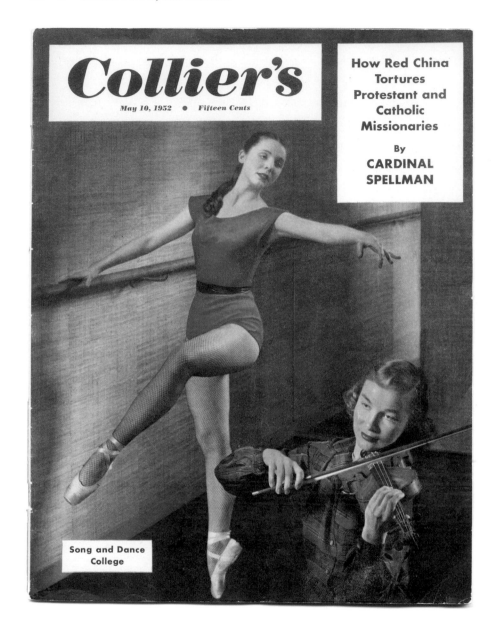

6.3 Nancy on the cover of Collier's

dancing career in Marie Rambert's ballet company. Soon he was creating ballets for Ballet Rambert. In 1939, he joined New York's Ballet Theatre (later renamed American Ballet Theatre) in its premiere season and remained with the company as dancer, choreographer, associate director, and finally as choreographer emeritus, a position he held until his death in 1987. The invitation from Ballet Theatre came at a time when Britain was criminally prosecuting homosexuals. Tudor and his partner, Hugh Laing, welcomed the opportunity to leave the country. Tudor and Laing had a lifelong relationship and were devoted to each other. Laing was a dancer, too—a better dancer than Tudor. Tudor could dance but he was more of an actor. His genius lay in teaching and creating ballets. As it had been with Miss Craske, my relationship with Antony Tudor was solely that of teacher/student the first year at Juilliard. The following year, my association with each of them was dramatically altered.

As grateful as I was to be there, freshman year at Juilliard was sometimes hard going. I was bothered by doubts and fears not only about ballet and dance class, but about life itself. I was frequently in an emotional tizzy. How did I get into Juilliard in the first place? What did anyone see in me? I felt like an imposter. My diaries from those years are so full of self-doubt that they're painful to read—angst smolders on every page. At that age, you don't know who you are. You don't think you're bright and you don't think you make intelligent conversation. You get bogged down and have to fight to pull yourself out of the dumps. Thank goodness I was always willing to fight. Becoming a performer goes beyond perfecting technique; you have to build self-confidence. I never had any delusions about my dancing. I assessed my talent and concluded that I could go just so far—and that would never include being a prima ballerina. The irony is, in everything else, I had to be the top or I wouldn't even compete. With dancing, almost from the beginning, I knew I wasn't going to be a number one, but I so loved to dance that I could accept being less than the best. I only had to do my best and I would be satisfied. An unusual example of maturity in my younger days.

Midway through my freshman year, something special happened, something that changed the course of my life. Remember how I made money selling magazine subscriptions when I was a kid? *Collier's* had been one of the top sellers then and was still popular in the early 1950s. Known for its investigative reporting as well as fiction, *Collier's* popularized the short story, which usually fit on a single page. In those days in rural America, going to the mailbox was a big event, especially when magazines were delivered. In February 1952, sparked by interest in the school's new dance program, *Collier's* selected Juilliard for a feature article. Suddenly, writers and photographers were everywhere, walking around the corridors, sitting in classes, attending performances, gathering material. The editors were so pleased with the material that they gave Juilliard the May cover story. Guess who was chosen to be the cover girl? I was ecstatic. All I could think of was how the people in Tidioute would be going to their mailboxes and seeing me on the cover of *Collier's*. It was delightful to contemplate. Let's face it, no one from the hometown crowd believed I was going to make it. Thanks to *Collier's*, the perfect vindication had arrived. Except for Maritza, I told no one, not even my parents. On a bright May morning, when my mother and father and their fellow Tidioutans went to their mailboxes and took out *Collier's*, there was Nancy King. After all these years, I'm afraid I'm still gloating. It knocked my parents' socks off. They were impressed. Getting into Juilliard, dancing in the Metropolitan Opera Ballet, being in a Broadway show—nothing ever equaled my being on the cover of a national magazine. That was the decisive moment for Grace and George King. They finally got it. They still didn't attend my performances, but they never again questioned what I was doing, and they continued to provide financial support until I was able to stand on point on my own.

Bearing in mind everything I went through to get into Juilliard, it may be surprising that I left after my freshman year and never earned a college degree. Here's why. I did well at Juilliard, well enough to be offered

a $1,200 scholarship to continue my studies. I was ready to pounce on it, but as the summer break approached, one by one my teachers spoke to me. They all gave similar advice, suggesting that if I wanted to be a professional dancer, I was wasting my time in college and needed to enroll in a professional ballet school. I was taken aback, but it made sense. Spending four years in college when I was trying to make up for lost time did not make sense. I could not have cared less about getting a college degree. My parents were the ones who cared. The minute I got home, I told them that I wanted to leave Juilliard and join the Metropolitan Opera Ballet School. Voicing a few demurrers, they gave their consent. I am one hundred percent sure they never would have allowed me to drop out had it not been for *Collier's*. The cover showed them that, college degree or not, I was going somewhere. At the end of my freshman year, I withdrew from Juilliard and signed up for the Metropolitan Opera Ballet School. I had extraordinary teachers, and in the future there would be others, but it all began with Craske and Tudor at Juilliard. The best thing was that Tudor and Craske also taught at the Metropolitan Opera Ballet.

❋

Chapter Seven

In the summer of 1952, Maritza and Norman rented a house in Chautauqua and invited me to join them. Being with the Morgans was always a joy but this was a particularly happy time because I knew I was headed to ballet school when I left. I played with the kids at home, took classes, and danced in operas. Meanwhile, as they did in Warren, people gathered at the Morgans' home to play music and exchange ideas. One evening, someone came with Norman Thomas, a guest speaker at Chautauqua. Thomas was a pacifist Presbyterian minister who ran for President of the United States as a Socialist six times. He spoke eloquently, and I was impressed. If my father had known I was sitting in the Morgans' living room listening to Norman Thomas, he'd have gone through the roof.

Maritza painted a few portraits of me that summer, my days as her muse were waning, as was the intensity of our relationship. I wasn't a needy novice anymore; I was growing up. By the time I returned to New York to study at the Metropolitan Opera Ballet School, I was feeling better about myself. I wasn't such a loner anymore. I was making

friends and being guided by good teachers. Anxieties came calling, but I learned how to close the door on them. My life became centered in New York and visits to my two homes grew further apart. New York became home. I was a bona fide New Yorker. Maritza and I saw less of each other but continued to correspond. We never lost touch.

After a few years of renting, the Morgans bought a home in Chautauqua where they spent the rest of their lives. It was the perfect place for them. Norman died in 1969. Though Maritza never remarried, she lived with a companion for twenty years. Robert Ludwig, an artist and lecturer, worked on a few of her later projects, some of which are still on exhibit at Chautauqua. Bob was younger than she and took loving care of her until her death in 1997. By then, Maritza was an esteemed member of the Chautauqua community. Among other honors, she was named artist-in-residence at both the Chautauqua Institution and the Pittsburgh Theological Seminary. Her obituary noted her forty-year career as a journalist, writer, translator, and artist, citing also that she was co-founder and manager of Good Morning Farm Restaurant, the associate editor of the *Chautauquan Daily*, and a twenty-five-year volunteer firefighter for the Chautauqua Fire Department. I am still struck by the good fortune that brought me to Maritza Morgan. I remain forever grateful to that remarkable lady, and to Norman, too. They made it possible for me to live the life I wanted and not the one expected of me.

❋

7.1 Maritza Morgan's painting
of Nancy titled 'Bittersweet,' 1956

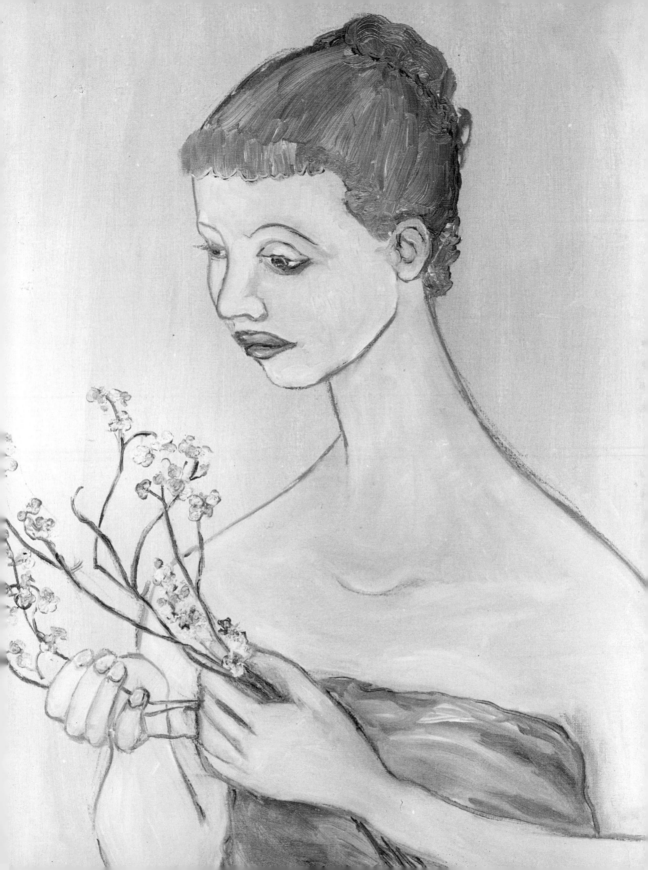

Chapter Eight

THE METROPOLITAN OPERA School of Ballet classes were held in a vast studio four stories high on the top floor of the old Metropolitan Opera House. The expanse of height, width, and depth was staggering. It was like being in a cathedral. So much splendid space. The grandeur of that roof-top studio deeply affected me. I can still see it in my mind's eye. A lot of my fascination with architecture came from being in ballet studios, particularly that one. As if the surroundings weren't thrilling enough, the glorious sound of music permeated the entire building. I never felt happier. I never felt more at home. The experience was heaven, and the shining stars in that firmament were Antony Tudor and Margaret Craske.

The Metropolitan Opera Ballet was different from the New York City Ballet. The NYCB dancers were athletic and fast; the Met dancers followed the lyrical and classical style of the Cecchetti method—no surprise, as Craske and Tudor were Cecchetti acolytes. Margaret Craske was a grandmotherly type when I studied with her, more like a den mother than a ballet instructor. At the same time, she was a wonderful

teacher who was big on corrections. One day in dancing class, Miss Craske walked over to me.

"What are you doing with your arms?" she asked. "You look like you're hailing a taxi."

I got the point, and with her help, corrected my *port de bras*.

That was Miss Craske. If you had a problem, in or out of class, she was the one to see. You could go to her office and pour out your troubles. She'd question you, assess the situation, counsel you, then give you special exercises and vitamins. She was a skilled fixer with a spine of steel. Miss Craske, like all the instructors, did not suffer fools. I remember an incident that illustrates her mettle. Class had begun when one of the students came running in. She threw off her coat and started to kick off her shoes when Miss Craske said,

"You're late!"

"The train was delayed," the student replied, reaching for her ballet slippers. Miss Craske waved her arm.

"That's no excuse. You know what time class begins. It's your responsibility to be here on time."

"But it wasn't my fault," protested the student. "The train was late."

"In the future, get up earlier and take an earlier train," said Miss Craske. "You cannot come to class today."

The dancer had no recourse but to put on her shoes and coat and leave. It was a stern welcome to the real world of dance but totally appropriate. A hard but good lesson. I learned a couple of things myself. First, never be late—and I never have been. Second, when you're in a group, it's not all about you, it's all about us.

Miss Craske was a Hindu and a follower of Meher Baba. She didn't talk about Baba to us. However, if we asked about him, she'd open up. I found her stories riveting. Some of my classmates and I became followers. We called ourselves Baba People. It wasn't a cult; we were a group that found something soothing and inspiring in what he had to say. By the way, "say" is not quite right. Baba didn't say anything. In

July 1925, he stopped speaking and remained silent until his death in 1969. At first, he used an alphabet board to communicate, pointing to letters to create words. Later, he used a series of unique hand gestures which were interpreted and spoken by one of his disciples. I met him when he came to New York during a tour of the United States. Miss Craske helped get him a room at the Delmonico Hotel where he received devotees. (The Delmonico Hotel would later play a significant role in my life.) A dozen of us walked into the room where he was seated at the opposite end. He had the most beatific aspect, the widest smile, the kindest eyes and a general aura of goodness. He embraced each of us. When he put his arms around you, you felt at peace and surrounded by love. I've always considered myself to be a bit of a cynic, but Baba won me over, and, for a few years, I was a dedicated devotee. We Baba People would get together and discuss his teachings and celebrate his birthday by fasting and keeping silent for twenty-four hours. Nancy King, silent for twenty-four hours, that's a stunning tribute to Baba's magnetism. His teachings remained with me even when my active Baba worship ended. I knowingly embraced his philosophy, but many others have been influenced by him unknowingly. In the late 1980s, one of his precepts, "Don't worry, be happy," was put to music by Bobby McFerrin and became a popular hit. Like all Baba's beliefs, it's based on love and makes good sense.

I learned so much about dancing, and life, from Margaret Craske.

"I think you have something," she once told me. "You'll make it, but only if you work hard."

I have never forgotten her dictum; I have always worked hard. After Miss Craske retired, I kept in touch with her. She settled in Myrtle Beach, South Carolina, where I'd visit as often as I could. She was well into her nineties the last time we met. When it came time for me to leave, we hugged goodbye.

"You've been a very lucky girl, Nancy," she said. "You haven't had a lot of bad things happen and you've had a wonderful life."

I think Miss Craske was right.

Margaret Craske was a Hindu; Antony Tudor was a Buddhist. Neither of them ever tried to proselytize. Only if you expressed interest would they talk about their beliefs. I felt their mystical leanings brought something special to their teaching. Make no mistake, they were tough, but they were fair. All they wanted was to bring out the best in their students. Tudor was a relentless taskmaster. He said, "What you must do with dancers is to strip them of their superficialities. Strip them of their own conception of themselves, until you find something underneath. This takes time, patience, and occasional bullying." That's how Tudor worked. He probably wouldn't be able to do it today, particularly the bullying. You have to remember, though, bullying covered a lot of territory in the arts. Like it or not, it was an accepted practice. In ballet, it was another word for disciplining. The same was true in music-making; many orchestra conductors were acknowledged tyrants who humiliated their musicians. Arturo Toscanini, the acclaimed Italian-born conductor, famously threw his baton at one of his musicians. Yes, Tudor was strict, but he was never cruel to me. If he appeared cruel, it was because he was trying to get to the essence of the dancer. If you think about it, there's no way you can tiptoe around that.

The first few weeks in the Met classes, Tudor never acknowledged that I was there. For my part, I was constantly trying to get him to notice me. One day, I was leaning against the barre waiting for the first group to finish dancing and pondering ways to get Tudor's attention. Class is divided into two groups, while one dances, the other waits. Then they switch places. I stood there racking my brain when it struck me that I was doing the same thing with Tudor as I had with my father—desperately seeking recognition. And, as it was with my father, nothing was happening. I gave up and turned to watch the dancers in the center of the room. At that moment, Tudor called out,

"Nancy, what are you thinking?"

My mouth fell open.

"I couldn't possibly tell you," I said.

The minute I stopped trying to get him to notice me, he noticed me. Not only that, but he called me by name. Later I learned that he had his eye on me. Another dancer told me she had overheard an exchange between Tudor and a rehearsal pianist. The pianist said,

"Isn't Nancy attractive?"

"Yes," he answered, "but she tries to destroy every bit of character in her face that she can."

He was right. I wanted to be beautiful and everything that went with it. I was not showing, thinking, or being who I really was, and that was anathema to Tudor. It was as though he could see right into your soul and wanted it exposed, uncluttered. He could be scathingly critical, but he tore you down to build you up. Some dancers cried when he spoke harshly. I never did. For Tudor, getting the best from his students wasn't a demand, it was a right. Yes, he dished it out, but people who worked with Tudor were devoted to him in the same way people at the New York City Ballet were devoted to Balanchine. Tudor was never a great dancer himself, but what a great teacher and choreographer he was. His ballets for ABT were acting ballets, dramatic psychological works that explored the dark themes of jealousy, frustration, rejection, and grief—all performed within the confines of classical techniques. He used the corps de ballet to carry the emotions and the story forward and not simply pose prettily. Tudor's *Lilac Garden, Pillar of Fire,* and *The Leaves are Fading* became cornerstones of ABT's repertoire. The company's reputation was built on them. I love ABT, but it bothers me that his works aren't performed on a regular basis. If I were running the company, there would be at least one Tudor work every season.

Tudor was a latecomer to dance. He played the piano first and he knew music, hence his maxim, "dancing is singing with the body." His teaching methods were unique. Some of the exercises didn't involve physical movement at all. One was particularly challenging: Everyone would sit on the floor in a circle with legs crossed. One person was designated *It. It* was told to imagine being an umbrella opening, closing, and snapping

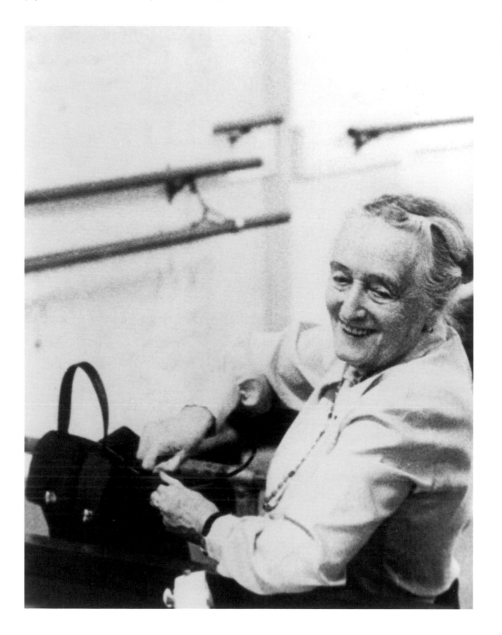

8.1 Margaret Craske in the ballet studio

shut—not to pantomime the action, only to imagine it. Meanwhile, the rest of the class was told to imagine what was happening in the mind of *It*. Any outsider walking in during this exercise would have seen a circle of seated dancers doing nothing. I believe this kind of exercise had its roots in Tudor's Eastern thinking about the integration of mind and body. There was another assignment in which Tudor had us do a *port de bras*. While we were doing it, he said,

"The back of your head should be surrounded by a yellow light. You should be feeling the color on you."

Then he'd pause and ask the class, "Can we see it?"

And you did see it, but like the opening and closing of the umbrella, it was all in your mind. Tudor was an enigmatic teacher who made you think about things, not simply do them. Imagination played a key role in his teachings. For whatever reason, this incredible man liked me and looked after me. That first year with the Met Ballet School, Tudor took me to Juilliard to appear in a work he choreographed for them, but it also allowed me to attend classes. He thought I would benefit from further study. Thanks to Tudor, I got to sit in on Louis Horst's second-year composition class—gratis. Tudor would always be my teacher, but he became my friend, and our relationship continued for three decades.

As far as a social life during the early Met years, once again I was indebted to Maritza and Norman. I had been introduced by them to many people who ended up in New York, such as Bert Alper and Charles Ryberg. Charles was from Sheffield, Pennsylvania, right next to Warren. They were the first gay couple I'd ever known. Bert and Charles lived in a beautiful apartment on Riverside Drive. I went to their home every Sunday for dinner and spent every holiday with them if I couldn't get home. They became my New York family and wonderful, nourishing friends.

❋

Chapter Nine

REMEMBER *A Chorus Line*, the Broadway musical about Broadway musicals or at least about auditioning for the chorus line in Broadway musicals? When I was taking classes twice a day at the Metropolitan Opera Ballet School, I was part of that scene—another little chorine trying to make it on the Great White Way. It all began in the summer of 1953. Rather than spending happy times with the Morgans, I decided it was time to get a job, a paying one, and one that allowed me to dance. The answer was summer stock. The pay wasn't much; dancers made $80 a week. That was OK with me. I'd always lived modestly, and my parents still were paying for my living expenses and dance classes at the Met. I wouldn't be dancing ballet, but I'd be dancing in classic musicals. My first job was at the Cape Cod Melody Tent in Hyannis, Massachusetts, and I loved it. I spent another summer at Melody Fair in Tonawanda, New York. I was in a production of *Happy Hunting* which had been an Ethel Merman vehicle on Broadway and a summer stock staple. The Merman role was played by Nancy Andrews, a talented performer and a lovely woman. While appearing in *Happy Hunting*, I received my first review as a professional.

WORLD PREMIERE 1 WEEK
THE GIRL IN PINK TIGHTS
A NEW MUSICAL COMEDY

9.1 Zizi Jeanmaire outside the Mark Hellinger Theatre

"Miss Nancy King, looking like a sea nymph, performed a surf
dance while she bounced a beach ball. It was highly effective."

I adored summer stock. Everything's done at a professional level, but at
the same time, it's summer and the living's a little bit easier.

While I was able to land parts in stock, I was not successful auditioning
for shows in New York. I tried a couple of times, but I didn't get past the
first cut. It was discouraging, but I wouldn't give up. In the fall of 1954,
Broadway beckoned again; a casting call went out for a new musical,
The Girl in Pink Tights. The plot was standard Broadway fare and a bit
dated—the adventures of a touring French ballet company stranded in
New York City after the Civil War. The show had a lot of preproduction
hype for a few good reasons. For starters, the musical score was the last
work of Sigmund Romberg, the composer of many Broadway hits and
musical films. (Think Jeanette MacDonald and Nelson Eddy.) Romberg
had been working on the *Pink Tights* score when he died. Don Walker,
a composer and orchestrator, took Romberg's musical notations and
developed them. Even though the composer had been dead for three
years, his name still carried weight. The choreographer, Agnes de Mille,
brought considerable clout herself. A decade earlier de Mille had revo-
lutionized dance in the theater with her choreography for *Oklahoma!*
when, for the first time on Broadway, dance became an extension of
the story and not merely a showcase for fancy footwork. A year before
Oklahoma! premiered, de Mille had reshaped classical ballet by com-
bining American musical themes and folk dance in Aaron Copland's
Rodeo, for the American Ballet Theatre. While Romberg and de Mille
were names with which to contend, the show's biggest asset was its star,
Zizi Jeanmaire. Jeanmaire, a French dancer, had made a sensational
New York debut in a sizzling production of *Carmen* (not my beloved
opera, but a dance version by Roland Petit's company, Ballets de Paris).
Petit and Jeanmaire, two attractive people, were an item, a fact that
generated a lot of publicity on its own. Everyone was certain a surefire

hit was in the works. I'd been in summer stock but had yet to appear in a show on Broadway. I was excited about this one. In my zeal to audition, I even skipped a few ballet classes.

Casting procedure has changed little since I was involved in it more than fifty years ago. Protocol dictates that the first call goes out to union members. Once those performers are selected, an open call goes out to nonunion members—that's when an old theatrical conundrum rears its annoying head. You can't be in the union if you haven't been in a show, and it's hard to get in a show unless you're in the union. Now, if you make it through the open and final calls, and are chosen to be in the show, you become a union member and the next time you'll qualify for the closed call. How many times do dancers go through endless open calls and are never chosen? What keeps us going? I guess we all believe that one day the miracle will happen and we'll get through.

Casting calls are always a scene. You arrive at the theater and line up across the stage, twenty hopefuls at a time. The powers that be—director, choreographer, producer, etc.—are seated in the orchestra, observing, deliberating, and signaling. Their assistants deal directly with the performers onstage. One of the assistants stands in front of the line pointing and calling out,

"You, you, you, you … thank you very much. The rest of you go over there and we'll audition."

"Thank you very much" means you have been eliminated.

The chosen ones are shown a combination of dance steps and told to do them. That done, the assistant, informed by the powers that be, calls out,

"You, you, you," and they, too, are eliminated.

And so it goes until the finalists are picked. The finalists of the first call, that is. Next comes the open call. The first call for *The Girl in Pink Tights* brought in three hundred hopefuls; the open call drew five hundred. Closed or open, the procedure is the same and the winners from both calls are ready to compete.

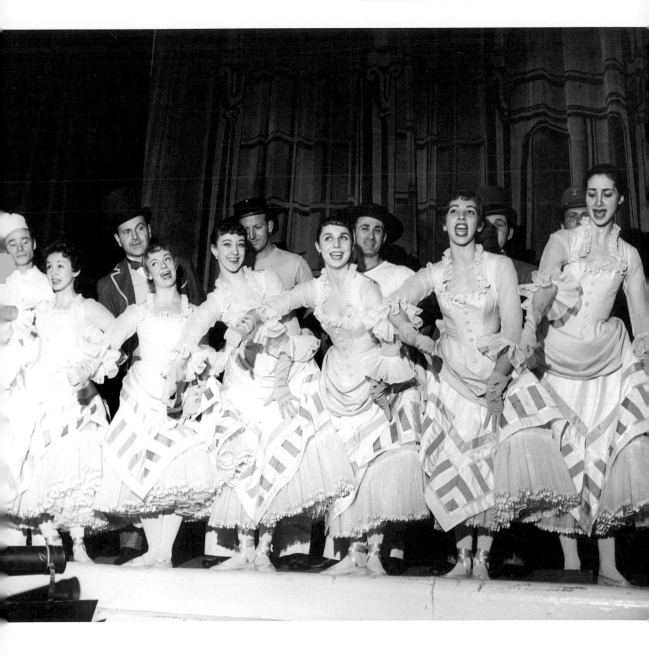

9.2 A scene from *The Girl in Pink Tights* with Beryl Tobin, Joan Bowman,
Eva Rubenstein, Nancy King, Rhonda Kearns and Lynn Marcus

You've passed the first hurdle and now you're on the stage being evaluated by decisionmakers seated in the orchestra. At this point you have to stand out. To do so, you have to ask yourself some questions and figure out the answers. The most important question is: what are they looking for? If you think they're looking for someone tall, you stretch. If you think they're looking for someone small, you shrink. And if you think they're looking for someone sexy, you put your hand on your hip, thrust it forward, and look out at the auditorium with half-closed eyes. If they're looking for an innocent young maiden, you stand there and bat your eyelashes. How do you know what they're looking for? You know what the show is about, so you take it from there. After a while you develop an instinct for knowing what's wanted.

The Girl in The Pink Tights was easy to analyze. It was a dance show, so you knew to highlight your dancing. Perhaps you'd stand in a ballet position. Whatever I did, I managed to get through to the final call. At that point, each of us was asked to do a solo spin across the stage. After everyone finished, we were lined up and the assistant repeated the point-and-go routine. She didn't point to me. I was in! I couldn't believe it. The truth is, I had never had much confidence in myself. I'm not being modest; I'm being honest. I don't know how I got all my parts, but I did find out how I got this one.

At the time of *Girl in Pink Tights* auditions, I was living at the Parnassus Club and working as a hostess in the dining room. During my hostess stint, I made friends with a number of residents, including one named Michelle. Michelle had studied at Juilliard and was now working for *The Girl in Pink Tights* production company. According to her, de Mille had a particular method for choosing her dancers. She used index cards to make notes as each dancer did a turn. She wrote the dancer's name at the top and an A or B under the name. Sometimes she'd jot down a descriptive word or two, but basically it was A or B. The day of the final call, de Mille told Michelle there were too many people.

"Just call back the As," she said.

I should have been out because my card, no surprise to me, was marked B. However, de Mille had written beneath the B, "like very much." Michelle let the description override the alphabet, and thanks to her, I was called back. If she hadn't made an adjustment, I'd never have gotten into the show. Which brings me to the essence of what you need to get ahead in show business. You've got to have the right blend of talent, chutzpah, and plain old luck. When you're auditioning, you're selling yourself, and often, luck and nerve trump talent. I know that was the case in my audition.

I was ecstatic doing *The Girl in Pink Tights*, my first Broadway musical and first *real* job. I was finally earning enough to pay rent and cover living expenses. I no longer needed to rely on my parents, and by mutual consent, they stopped supporting me. I made the transition easily, in part because I knew they'd come to my rescue if things changed. I was a lucky girl in more ways than one. I was about to dance on Broadway when, by a fluke, I snagged a speaking part. Fluke, that's another word for luck. Before rehearsals began, one of the assistants asked if anyone could speak with a Russian accent or a French accent. Both times, my arm went up and waved vigorously. I was conversant in French. One of my friends was the daughter of the legendary pianist Arthur Rubinstein. French was spoken in the Rubinstein household, and whenever Eva and I met for lunch, I would ask her to speak French with me. That's how I knew I could do a French accent. As for the Russian accent, many ballet teachers were Russian and spoke English with thick accents. I'd been mimicking them for years. Because of my French accent I got a speaking part. It was only one line, but it was all mine. More delights awaited. I was thrilled to learn that Karinska, one of the influential costume designers of the twentieth century, was doing the costumes for *Pink Tights*. What a wonderful experience it was having all these people sticking pins in me, saying,

"You King? You King? Remember what dress is yours, King."

After a few weeks of rehearsal, the co-director called me to his office.

He sat me down, walked around the desk, and looked at me for a few seconds without saying a word. I was nervous. All I could think was, I'm going to be fired. Finally, he spoke.

"Nancy, we want you to understudy Zizi Jeanmaire."

I was certain I'd misheard, so I asked him to repeat what he'd said. I'd heard correctly. I had caught the eye and the ear of the director, Shepard Traube. Jeanmaire was my height and same coloring. My French accent proved I could sound like her. Despite my inexperience, Traube was confident that I could do it. I learned Jeanmaire's part in less than a week and was onstage for an orchestral dress rehearsal. Me, Nancy King from Tidioute, Pennsylvania, dancing, singing, and acting on Broadway albeit sans audience. After the rehearsal, Traube came to the front of the stage.

"Nice work, Nancy," he said. "You did a prodigious job."

I was absolutely dancing on air.

The Girl in Pink Tights opened on March 5, 1954. No surprise, the Morgans were there and my parents weren't. Maritza made a painting of me to commemorate the occasion. I thought *The Girl in Pink Tights* and I would be on Broadway for years. I thought wrong. We closed three months later on June 12. How could a guaranteed hit miss? I never figured it out. Meanwhile, I'd had an exhilarating experience in the show and made an important connection. Agnes de Mille took a liking to me. I had no time to mourn the passing of *The Girl in Pink Tights* as I was soon caught up in auditions for the Metropolitan Opera Ballet. It was one thing to be a student in the Met Ballet School and another to become a member of the Metropolitan Ballet Company itself. For four days, I had to do every ballet step imaginable, including thirty-two *fouettés* on point. That's the magic number of turns that Odette, the Black Swan, executes in Act III of *Swan Lake*. How many times had I sat in the audience counting out the turns as they unfurled with all the other balletomanes in the audience? It's not simply managing to do the turns; you have to stick like glue to the same spot on the stage. During those

auditions, adrenaline surged through me like a tidal wave. Exhausted by the end of each day, I'd drag myself to my apartment over Chummy's Bar at 253 West 55th Street and flop into a hot tub. A ballerina's best friend is her tub. Finally, at the end of four grueling days, I became a member of the Metropolitan Opera Ballet Company.

True confession. If a few things had turned out differently, I might have chosen a career on Broadway rather than in classical ballet. First, if *The Girl in Pink Tights* had been a hit, I may have stayed with it. Second, sometime after *Pink Tights*, I had auditioned for a big role in an upcoming musical. The role and the musical? Gypsy in *Gypsy*. If I'd successfully auditioned, I wonder if I could have turned that down. Third, I did successfully audition for the Metropolitan Opera Ballet. Call it kismet, but the fact that those three events happened as they did put me into the Metropolitan Opera Ballet. I have never regretted it. Even today, I have to pinch myself now and again for a reality check. Yes, it's true, I danced on the stage of the Metropolitan Opera house, the old Met, not the present one in Lincoln Center. I've never been on that stage and have no particular feeling about it, but that old Met was something special.

❋

Chapter Ten

THE METROPOLITAN OPERA opened in October 1883, at 1411 Broadway, right in the middle of New York's Garment District. It occupied the entire west side of the block between West 39th Street and West 40th Street. The yellow brick exterior looked more like an industrial building than an opera house, consequently, the old Met was affectionately known as "The Yellow Brick Brewery." It was damaged by fire in 1892 and redesigned, restored, and reopened in 1906. Forty-six years later, in 1952, I arrived. According to the photos I had seen, the Met looked exactly the same. It remained the same until it was torn down in 1966. I'll never forget walking into the auditorium for the first time and seeing the great curved proscenium arch over the stage, at the top of which six composers' names were inscribed: Gluck, Mozart, Beethoven, Wagner, Gounod, and Verdi. It makes a good trivia question. Most people who remember the old Met can't name all of them. It's like the seven dwarfs, at least one is bound to be forgotten.

The first day I reported to work for the Metropolitan Opera Ballet Company with the other newbies, I was assigned a chair in the dressing

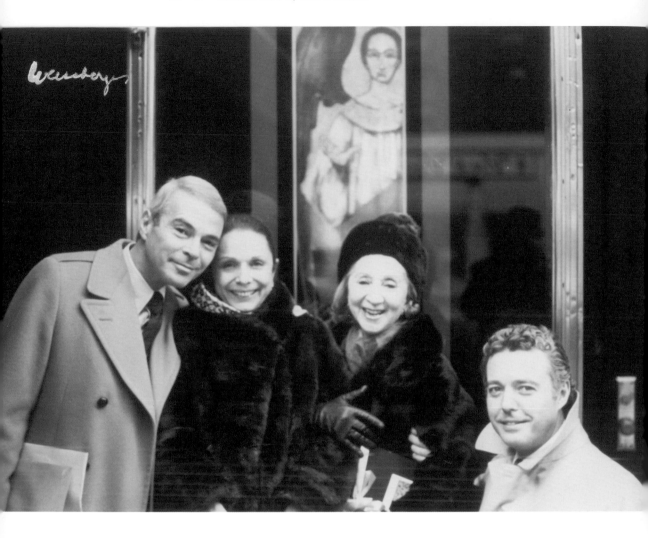

10.1 Lewis Ufland, Nancy, Danilova, and Michael Thomas outside the
Russian Tea Room

room. As luck would have it, Louellen Sibley, another novice, was seat-
ed next to me. We hit it off instantly and sat side-by-side for the next
nine years, which is longer than a lot of marriages I've known. We've
remained friends all our lives. Louellen was from Paducah, Kentucky,
but her family moved to Miami so she could study ballet. Louellen had
wonderful parents. I believe her father was an accountant, and I know
he was much older than her mother. Her mother was a schoolteach-
er; she and Louellen were close. Louellen and I were about the same
height and weight. Although I was a brunette and she was a blonde, we
were often taken for twin sisters. We had the same taste in clothes and
dressed similarly. We did everything together—even gave each other
manicures and pedicures. Louellen was smart and funny and had real
flair. I was smart but serious and eventually acquired flair. Everyone
loved Louellen. She was alive and amusing. Whenever I appeared any-
where without her, the first thing people asked was,

"Where's Louellen?"

I'm not sure the reverse was true.

Louellen and I were quite a pair. The great Alexandra Danilova,
who worked with the Met Ballet, called us "the two jewels in the
crown of the Metropolitan Opera." Later, Danilova and I became
close. We were brought together by her personal manager, Lewis
Ufland, a dear friend of mine. Lewis enjoyed bringing people together.
Choura, as everyone called Danilova, had an illustrious career. She
danced with Diaghilev's Ballets Russes, Ballets Russes de Monte Carlo,
and guest starred with major companies in Europe and America. She
was smart, charming, and funny. In 1977, long after her ballet dancing
days were over, she was cast in *The Turning Point*, a Hollywood bal-
let-themed film starring Anne Bancroft and Shirley MacLaine. Mikhail
Baryshnikov was in a featured role as was Leslie Browne, a young ABT
dancer. Choura, seventy-four at the time, was singled out for her por-
trayal of a ballet teacher. There was talk of an Academy Award nomi-
nation for Best Supporting Actress, and she was interviewed on many
occasions. Lewis told me about a session with newspaper reporters.

Following questions about her life and the differences between acting in a film and dancing in a ballet, one of the reporters asked,

"How do you keep yourself in such marvelous shape, Madame Danilova?"

"How?" replied Choura, in her Russian-coated English. "Here is how. Every morning I am getting out from bed, going to open window, and taking many deep breaths. Then, I am doing a few special exercises, stretches, and bends. Then, I am getting dressed and going into kitchen to make tea. I am drinking orange juice and having the tea with piece of toast, no butter. Then I am going to studio and doing barre for forty minutes or so. I am having small salad for lunch and piece of fruit. Then I am teaching classes. At end of classes, I do little more barre to loosen up and then returning home and having small dinner, fish, vegetable. Before I am going to bed, I go to window and am taking deep breaths."

"That's some schedule and it's obviously worked," replied the journalist. "I wonder, Madame Danilova, do you know what Leslie Browne does to stay in shape?"

Choura looked at the reporter.

"Miss Browne? Miss Browne is being nineteen."

That first year at the Met was an overwhelming experience, so much to learn, so much to do. I was happy doing all of it. It was a kick walking in and out of the stage door. After performances, people lined up waiting to get autographs from the stars. One night I left the theater alone, and as I walked down the line, someone thrust an autograph book in front of me.

"Please, Miss Moffo, please sign my autograph book," she cried. I'd been mistaken for Anna Moffo, who had sung that evening.

I looked at her and shook my head.

"I'm sorry, I'm not Anna Moffo," I said and moved off.

I was flattered. Besides being a lovely singer, Anna Moffo was a beautiful woman, and if someone thought I looked like her, fine. I did wear my hair the way she wore hers in *Traviata*. That was the first time

I was mistaken for Anna Moffo, but not the last. People began coming up to me, particularly on tour.

"Aren't you Anna Moffo? May I have your autograph?"

I'd say no and keep moving. The thing is, a lot of those people got upset. A few got mad and made no bones about telling me where to go. Don't ask me why. Maybe some of them thought I was Anna Moffo being snooty. After a while, I decided it was probably better for me, and for Anna Moffo, to keep her fans happy simply by signing her name—which I did.

Professionally, the Met was a well-run machine. On a personal level, it was slightly discombobulated. For example, we had no lockers in which to put our belongings, so we left them on the floor. If you were tired and wanted to grab a catnap, there was a cot in the dressing room which we had to take turns using. The inconveniences were minor. Being in that house, going into the rickety old elevator that groaned and squealed as it carried you up to the dance studio, walking by the huge baskets piled with costumes, hearing the muffled voices of singers warming up in their dressing rooms, going into the flys and looking down at the stage—the look, the sound, the very air of the old Met was tonic. Who could ask for anything more? Sometimes more doesn't need to be asked for, it just happens.

While I had a mailbox at home, I also received mail at the opera house where business and personal correspondence could be sent to employees. The incoming mail was sorted into nine large boxes and each box was marked by letters of the alphabet. Mail would be placed in the box marked with the letter of your last name and you'd rummage in the bin looking for it. One day, I fished out a postcard and read the following message:

Dear Nancy,
Please telephone me any day 5-6, SP 3-3024.
Cordially, Agnes de Mille.

Agnes de Mille? It was almost a year since *The Girl in Pink Tights* closed and I had not seen or heard from her since. Needless to say, "any day" was that afternoon. I called her one minute after five. She explained that the State Department was sponsoring a European tour of *Oklahoma!* in May. Remembering me from *The Girl in Pink Tights*, she wondered if I would like to join the company. I took the wonder out of the situation and told her I'd be thrilled to do it. I think I said yes before she finished asking. One slight problem, the *Oklahoma!* tour overlapped the Met season by a few weeks. I would have to leave the spring tour early, and I needed to request a release. The Met was fine with it. During the first week of May, I slipped out of the Met and joined the cast of *Oklahoma!* I was in the chorus and the understudy for Laurey in the dream ballet. Rouben Mamoulian, the original director, was directing, and Shirley Jones and Jack Cassidy were Laurey and Curly. Rod Steiger started out as Jud, but he got fired along the way. Agnes, of course, was in charge of the dancing. We were scheduled to perform in Paris, Rome, Naples, and Milan. Maybe, if the corresponding state departments could get their acts together, the tour would end in Russia. It was a great experience, with the exception of one minor vexation and a tragic turn of events. In the minor category, Mamoulian wanted to rehearse all the time in Paris. He was the only one who did, but he was the director. When Jones and Cassidy left after our Naples appearance, their understudies took over, and a terrible thing happened. When we got to Milan, Shirley's understudy contracted polio and died. It was so quick that it didn't seem real. The producers panicked and couldn't get us out of Milan fast enough. That trip to Europe, my first, is a bittersweet memory because of the way it ended, but it was a glorious experience while it was happening. I should mention that shortly after I accepted the *Oklahoma!* gig, Tudor took me and two other dancers to audition for ABT. I only did it because Tudor wanted me to. We auditioned for Lucia Chase, the director of the company. After I finished, she seemed pleased with what I'd done. ("Very good" were her very words.) She asked me what my immediate plans

were, and I told her that I'd been invited on the *Oklahoma!* tour. She thought a moment and said,

"Agnes is part of our family. I think that you should do it, Nancy."

I took her advice. And that's as close as I ever got to dancing with the American Ballet Theatre. I never auditioned for ABT again.

As alike as we were, Louellen was never driven the way I was. Within a year and a half, I became a principal dancer while Louellen remained in the corps. She was happy for me and content for herself. Our friendship flourished. We could read each other's thoughts and finish each other's sentences. One time we were sailing to Europe and standing at the rail. As the ship pulled out of the dock, we turned to each other and said in unison,

"What do we do now?"

Our echoing each other's words happened frequently. We clicked in so many ways. Everybody in the company adored Louellen, including the Italian bass, Cesare Siepi, the company's reigning Don Giovanni. Cesare was tall, dark, handsome, and a great singer. Louellen fell for him like a ton of bricks. As gregarious and easygoing as Louellen was with everyone else, it was different with Cesare. She was still funny, but she was uncharacteristically uptight. It's hard to be carefree when you're in love. Don't forget, back then, when women were dating, they didn't pick up the phone and call the man. At last, after a half-dozen years of courtship, Louellen and Cesare married. At the time of his death in 2010, they'd been man and wife for forty-eight years. When she married, Louellen quit dancing, as I did. But, as I did not, she stopped everything, including ballet classes, and devoted herself to her husband and their children. She was completely family oriented. When Cesare retired, they settled in Atlanta, Georgia, where I would visit them. For some reason, he never wanted to go back to the Met or even talk about the place. I have to admit I was taken aback the first time I heard Cesare address Louellen as "Mamma." She was the mamma. She cooked for him and saw to all his needs. As time passed, they didn't go out much and amused themselves by playing cards and Scrabble.

10.2 A postcard written to Nancy from Agnes de Mille inviting her to join the European tour of *Oklahoma!*

MRS. WALTER F. PRUDE 25 EAST 9TH STREET NEW YORK 3, N. Y.

Dear Nancy —
 Please Telephone
me. any day 5 — 6
 Gra 3 - 3 0 2 4
 Cordially
 Agnes deMille

After all those years of hijinks, Louellen had become an old-fashioned Italian housewife. Had I been in the same situation, I would have gone mad. As far as I could see, Louellen loved every minute of it.

At the time that Louellen and I were with the company, the Metropolitan Opera was in one of its golden ages and overflowing with singers whose names still resonate: Renata Tebaldi, Victoria de los Angeles, Zinka Milanov, Eleanor Steber, Rise Stevens, Jussi Bjorling, Richard Tucker, Franco Corelli, Ezio Pinza, Cesare Siepi, and Leonard Warren. Warren, one of the great Verdi baritones, died on the Met stage on March 4, 1960, during a performance of Verdi's *La Forza del Destino*. I was on the stage that night and it was as eerie as it was shocking. Warren had started to sing an aria in Act III that begins, "Morir! Tremenda cosa" ("To die! A monstrous thing") when he suddenly pitched forward, hit the floor, and lay face down. For a moment, everything stopped. We stood there, paralyzed, looking down at Warren's still form. One of the singers went over and knelt beside him. No one else moved until someone allegedly cried out, "For God's sake, bring down the curtain!" I don't remember that, but I do remember the curtain was drawn and a priest was ushered onstage to administer the last rites. The priest was Warren's friend. He'd been in the audience with the baritone's wife. The Met's general manager, Rudolf Bing, came onstage and stood with the rest of us while the rites were intoned. Then he went to the curtain and stepped in front of it to address the audience. We could barely hear him.

"This is one of the saddest nights in the history of the Metropolitan," he began.

The audience groaned in anguish. After a few words about Warren, he asked everybody to stand in memory of one of the Metropolitan's greatest performers. Bing concluded by saying that he felt everyone would agree that the performance could not go on. He turned and walked back through the curtain. I don't think I've ever experienced a more shattering moment. Life and death in the blink of an eye. The story didn't end there. From the moment of Warren's death, descriptions

of what happened that night have differed. I was an eyewitness and still found it impossible to recall the details that were reported in the press. The *New York Times* described it one way, the *New York Herald Tribune* described it in a different way. Accounts of the tragic incident were so mismatched that, for decades, Columbia University's Graduate School of Journalism taught Leonard Warren's demise as an exercise in deadline writing, entitled "Death at the Opera."

I was on the Met stage with La Divina herself, Maria Callas. I met her when she first arrived in New York and was the guest of honor at an intimate gathering Francis Robinson held at his Central Park South apartment. Francis, also known as Mr. Metropolitan, lived and breathed opera. He held many positions at the Met; at that time, he was the assistant manager. He's probably best remembered for his intermission features, *Biographies in Music*, on the Met Radio broadcasts. They were beautifully crafted audio portraits of opera greats. I still miss listening to them. At the Callas evening, I was shocked to see her eat one of the biggest hamburgers I'd ever seen. Considering that she'd recently had a remarkable weight loss, I couldn't believe how she wolfed it down. I guess she planned to control herself later on. In her mid-career quest to lose weight, Callas used Audrey Hepburn as inspiration. A hard example to follow, but Callas trimmed down substantially. The weight loss altered her appearance. What a striking woman she was. Her eyes were large and wide set, her nose prominent, and her mouth generous. She was every inch a diva, a goddess, and, like all goddesses, open game for gossipmongers. At the time, one rumor in particular was making the rounds. It purported that, in order to lose weight, Callas had a tapeworm implanted in her intestines. After she shed the pounds, the tapeworm was removed. Many singers and operaphiles believe that a significant drop in pounds adversely affects the voice. In Callas's case, no one in his right mind believed the tapeworm poppycock, but many did feel that the slimmed down Callas never sounded the same.

At the Met, Callas was singing Violetta in Verdi's *La Traviata*, but she was stepping into an old production, not headlining one created for her. This meant that she and the other principals were rehearsing on the roof stage rather than on the main stage with the rest of us. In *Traviata*, I played a guest at a party given by Violetta in her home. The curtain opened on the party scene and I was the first lady to come down the stairs on the arm of my escort. I was supposed to run across the stage in front of Violetta, drop a curtsy, and move on. It didn't sit right with me. I went to the stage director, told him how I felt, and politely offered what I thought was a good solution.

"It seems ridiculous to run in front of Miss Callas and block her from the audience. Shouldn't I run behind her?"

The stage director looked at me disdainfully.

"No," he said, "you cannot change the stage directions."

Well, at least I tried.

Come opening night, Callas didn't know what was going to happen because she was rehearsing separately on the roof. The curtain parted, and I went trippingly down the stairs and started my dash across the stage. Instead of being flustered that someone darted between her and the audience, Callas held out her arms, embraced me, kissed me on both cheeks, and gestured for me to make myself comfortable. It was exactly the way a good hostess would react and positively balletic in its execution. Nobody needed to tell Maria Callas what to do onstage, she was an instinctual artist. In Lucia's mad scene, she walked tentatively around the stage, her eyes darting every which way. She couldn't seem to focus on any one person. Later, I learned that she had gone to mental hospitals to observe the patients and incorporated what she saw in her portrayal. Callas was at home on the stage and glided around with grace, all the more amazing because she was blind as a bat. Offstage, she wore thick, horn-rimmed glasses. But she moved unerringly around the set, and those eyes of hers were mesmerizing. The end of her life was terribly sad. She was only fifty-four when she died alone in her Paris

apartment. Rumors had followed her to the end of her life. Forget the rumors, listen to the artist. For me, there have been three perfect entertainers: Charlie Chaplin, Judy Garland, and Maria Callas.

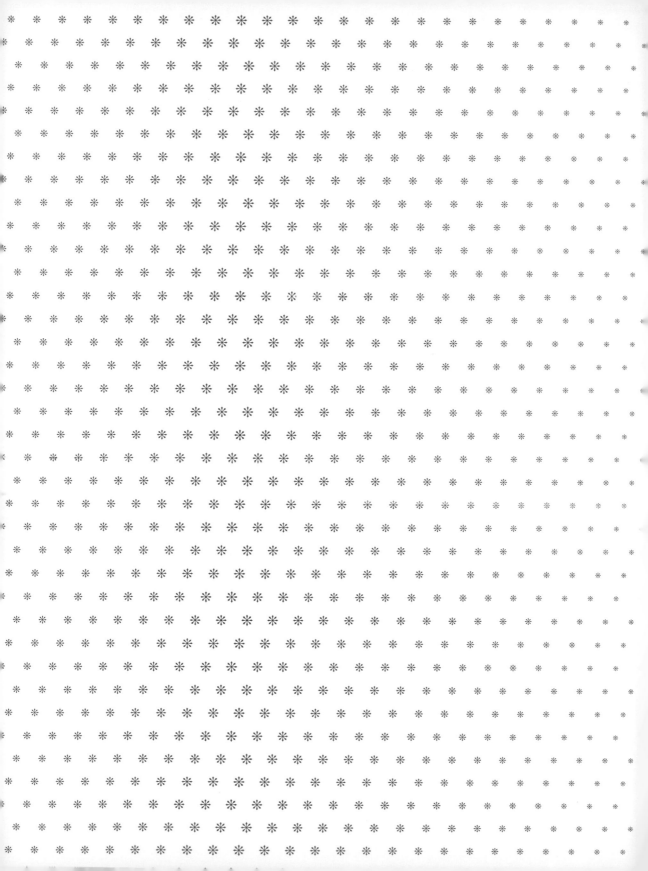

Chapter Eleven

MY YEARS WITH the Metropolitan Opera Ballet were magical. Sounds corny, I know, but it's true. I was twenty years old and I had achieved my goal. I was dancing with a genuine professional ballet company, not a freestanding one, such as the American Ballet Theatre or the New York City Ballet, but still, an important and well regarded one. Following the European tradition of La Scala in Milan, the Opera National in Paris, and The Royal Ballet in London, the Met had maintained a ballet company since its inception. Major opera houses needed a dance corps because many operas contain elaborate and extended dance scenes. They range from the wild seguidilla in Bizet's *Carmen* to the elegant Cours la Reine ballet in Massenet's *Manon*. There was one notable difference between the Metropolitan Opera's resident dance company and its European counterparts. The opera ballets in Milan, Paris, and London had their own seasons during which they performed classical works—*Sleeping Beauty*, *Giselle*, *Swan Lake*, et al.—as well as new ones. The Metropolitan Opera Ballet was subservient to the operas and had no separate season. That changed when Rudolf Bing was

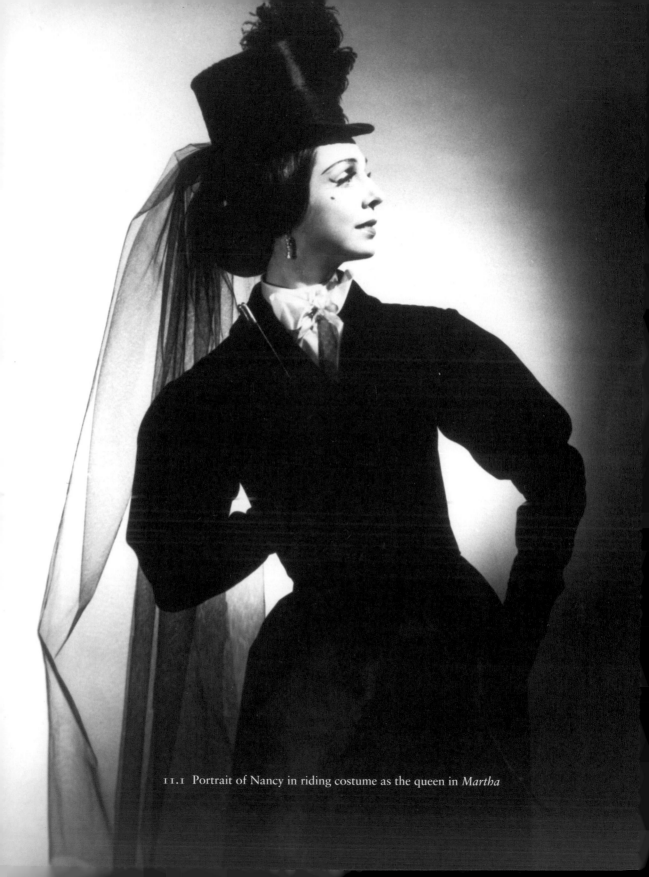

11.1 Portrait of Nancy in riding costume as the queen in *Martha*

appointed general manager of the Met in 1951. Bing did a lot of house-cleaning. Sprucing up the dance company was one of his priorities. To that end, he hired Zachary Solov, a twenty-eight-year-old dancer, as ballet master and chief choreographer. (George Balanchine held that position briefly in the 1930s.) Solov had come up the hard way. He was born to deaf, non-speaking parents, a fact which some believed explained his striking ability to communicate with his body. (Whenever we played charades, you knew exactly what Zachary was doing.) His family was poor. By the age of six, Zachary was dancing for pennies in the streets of Philadelphia. From the streets he moved to radio and *The Horn and Hardart Children's Hour*. Horn and Hardart ran a popular chain of self-service automats; there were forty of them in New York City alone. On the *Children's Hour*, he performed tap dances, sometimes solo and sometimes with another youngster, Honi Coles, who became a star of vaudeville, theater, and movies. When he was eleven, Zachary began studying ballet at the prestigious Littlefield Ballet School in Haverford, Pennsylvania. Catherine Littlefield, one of the pioneers of ballet in America, created the first company in 1934. Zachary continued his studies at Balanchine's School of American Ballet, and for a short while he danced with Ballet Caravan, the precursor to the New York City Ballet. During World War II, Zachary served in an entertainment unit, choreographing dozens of shows. After the war, he joined Ballet Theatre. Zachary appeared on Broadway and television and partnered Carmen Miranda, the movies' Brazilian Bombshell, at the Roxy Theatre in New York City. His dancing background could not have been more eclectic, and he fit right into Rudolf Bing's master plan.

Zachary's first Met assignment was to choreograph Johann Strauss's *Die Fledermaus*. The production was a big hit, and the dancing was singled out as a major component of the opera's success. Zachary was a brilliant choreographer for opera which is entirely different from creating stand-alone ballets. Whether it was a tarantella in *Forza del Destino*

or a minuet in *Don Giovanni,* and whether a dozen or a hundred people were onstage, he had a knack for devising pieces that fit perfectly. For me, his genius did not transfer to creating ballets outside opera. Conversely, Tudor, a genius at creating ballets, was a fish out of water on the operatic stage. Before I joined the Met, he had choreographed the waltz in *Fledermaus,* and it was a fiasco. Typical Tudor, he was choreographing a waltz without including waltz steps. Aside from his Met efforts, though, for me Tudor could do no wrong.

Zachary Solov's innovations had started a few years before I joined the company and continued while I was there. He added extensive choreography to many operas, initiated ballet nights at the Met, and created two original ballets—*Vittorio* to the music of Verdi and *Soiree Musicale* to the music of Rossini. These expansions raised both the status and the morale of the dancers. In time, Zachary and I became good friends. He'd invite me to his home in Saratoga where I stayed in either the Maria Taglioni Room or the Fanny Elssler Room, named in honor of immortal 19th-century dancers. I don't know how pleased Fanny or Maria might have felt about having their names attached to those musty, cobweb-filled chambers, but it was thoughtful of Zachary to pay tribute to them. When Zachary left the Met in 1958, Tudor replaced him. Creating opera ballets wasn't Tudor's forte. However, he did choreograph a ballet for the company entitled *Fandango,* which featured five of us ballet girls portraying characters that captured our individual characters in real life. Suzanne Ames wanted to be a singer and she loved being on point. We all teased her about her singing aspirations and her need to be on her toes. In *Fandango,* her character was on point and singing while two of us followed her around going "ya, ya, ya, ya." Tudor gave us all names, although the names didn't appear in the program. My character was called Nina. The only time I ever said to Tudor, "I won't dance, don't ask me" happened when he was the Met's ballet master. He wanted me to do a solo part in the Walpurgis Night ballet in *Faust.* Even though the ballet was one

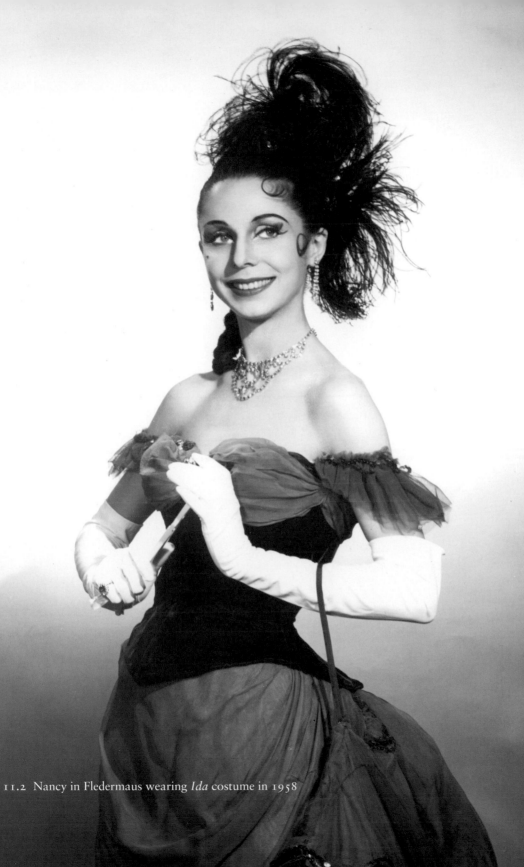

11.2 Nancy in Fledermaus wearing *Ida* costume in 1958

of Zach Solov's works, I thought it was a mess. I thanked Tudor and declined, and he let me off the hook.

No surprise, Tudor didn't last long as the Met ballet master. It wasn't his thing, and when he left, Alicia Markova took over. The idea that I would be onstage with Alicia Markova was mind-boggling. But I was, quite a few times. During a performance of Gluck's *Orfeo ed Euridice*, I stood in the wings with her as she waited to go on stage. Her cue came and she stepped onto the stage, but not before she handed me a tissue with which she'd been dabbing herself. I have to say she perspired heavily. Yet, I kept that tissue until it disintegrated. Dame Alicia was a lovely lady and did her best to keep the company strong. She arranged for performances at Town Hall, choreographed *Les Sylphides* for us, and was kind to me. She even turned over her role to me. But neither Tudor nor Markova had Zachary's opera ballet chops. It was Zachary Solov who molded the Metropolitan Opera Ballet and developed a new company. Under his guidance, a golden age of the Met Ballet flourished. It never became autonomous or earned a separate season, but there were two dedicated ballet evenings. Walter Terry and John Martin, two of the leading critics of the day, heaped praise on Zachary for his leadership and his choreography. He received recognition then, but he deserved more. Alas, now he's another footnote in the long history of the Metropolitan Opera House.

While it wasn't the same as dancing with a freestanding ballet company, being with the Metropolitan Opera Ballet was exhilarating, exhausting, and limiting. Limiting because, in the 1950s and early '60s, even if you were a ballet dancer, you were supposed to be married by the time you reached thirty. You needed to have one eye on the stage and the other on the altar. In a freestanding ballet company, you worked every day but you weren't necessarily onstage every night. Thus, ABT and NYCB dancers were able to marry and continue their careers. It was different at the Met. Being a member of the Metropolitan Opera Ballet meant

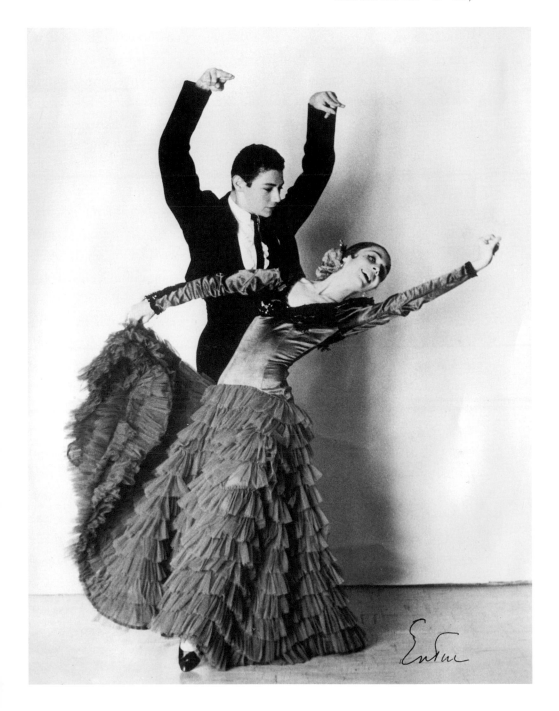

11.3 Nancy and Bruce Marks opening the fourth act of *Carmen*, 1958

that, except for Sunday, you rehearsed every day and could be onstage every night. If you weren't dancing, you could be called onstage as a super. We were at the Met if not 24/7, definitely 14/6. What spouse would tolerate such a schedule? So, you danced your heart out until you got hitched, and then you hung up your slippers. Those of us who joined the company at the same time were around the same age, and we were all married and out of the Met within a decade.

My debut in the fall of 1954 in the opening night production of *Faust* was closely followed by appearances in *Rigoletto, Boris Godunov, Carmen,* and *La Boheme*. As though it wasn't enough to be dancing on the stage of the Met, I actually *sang* at the Met. My singing debut came in the second act of *La Boheme*. I was supering as part of the children's chorus. In the scene, Parpignol, the toy seller, makes his entrance and hawks his wares to the children. The children sing "*Voglio la tromba, il cavallin! Il tambur, tamburel …*" ("I want the horn, the toy horse! The drum, the tambourine …"). Their voices rising to a fever pitch. Suddenly the music stops, and one child cries out, "Vo la tromba, il cavallin." Enter Nancy King. Yes, I was chosen to sing that line in much the same manner that I was tapped to deliver a one-liner in *The Girl in Pink Tights*. Luck and preparation had converged. For months I'd been studying voice with a teacher who worked with musical theater performers. I was taught how to project my voice—to belt, as it's called on Broadway. When I was asked to sing the tromba/cavallin passage, I applied my freshly acquired knowledge, belted it out, and landed the part. Brief though it was, I had a genuine vocal moment. It was thrilling. Not only could I say I was dancing on the Met stage, but I could add that I sang there as well. The few seconds of my aria were *a cappella*. Belting or not, I don't think my voice would have gotten past the prompter's box had the orchestra been playing. The whining little boy in Boheme wasn't my only non-dancing role. I was cast in the role of Ida in *Die Fledermaus*. It was an acting role—in the final scene I pretended to play a flute and sang a "ta ta ta tarum" accompaniment while Roberta Peters sang.

It's hard to believe, but we dancers were sometimes called upon to sing. On one of those occasions, Dimitri Mitropoulos was conducting Mussorgsky's *Boris Godunov* when we were pressed into service. We rehearsed separately and then came on the stage for a rehearsal. Mitropoulos raised his baton, and we sang for about thirty seconds when he stopped conducting. He bowed his head, shook it side to side, and waved us off without looking up or saying a word. We were herded to the rehearsal room where we spent many more hours setting things right. A grand moment for me occurred during a production of Flotow's opera, *Martha*. I played Queen Anne, a nonspeaking role. I waited in the wings, costumed in a fabulous black velvet riding outfit and a gorgeous black hat and seated sidesaddle on a beautiful white horse. On cue, I rode out of the wings, paused center stage while someone took my hand and kissed it, and rode off. I was living a fairy tale. The episode lasted less than ninety seconds, but I was mentioned in a review, "There was a King who would be queen," wrote one critic. When I performed a solo in a production of Massenet's *Manon,* Walter Terry wrote, "Miss King danced very well indeed, and on top of that was ravishing to look upon." Needless to say, I died and went to heaven when I read those words.

One of my favorite appearances was in Offenbach's *Tales of Hoffmann*. I loved it because we had so much to do, starting with the opening tavern scene. We were lying on our backs underneath a raised platform at the back of the stage, our arms thrust out of holes cut into the platform. We were holding golden goblets in our hands and waving our arms in time to the music. All quite surreal, all quite uncomfortable, but still fun. I also loved appearing in *Aida*'s triumphal scene. We dancers were scantily clad and our bodies had to be covered in paint. The stagehands brought up buckets of it and we sponged the paint all over each other. A messy business, but we earned an extra three dollars. After each performance, we headed to the showers and helped each other scrub off the coating. (In addition to receiving three dollars for painting our bodies,

11.4 Nancy as the circus ballerina
in *La Perichole*, 1957

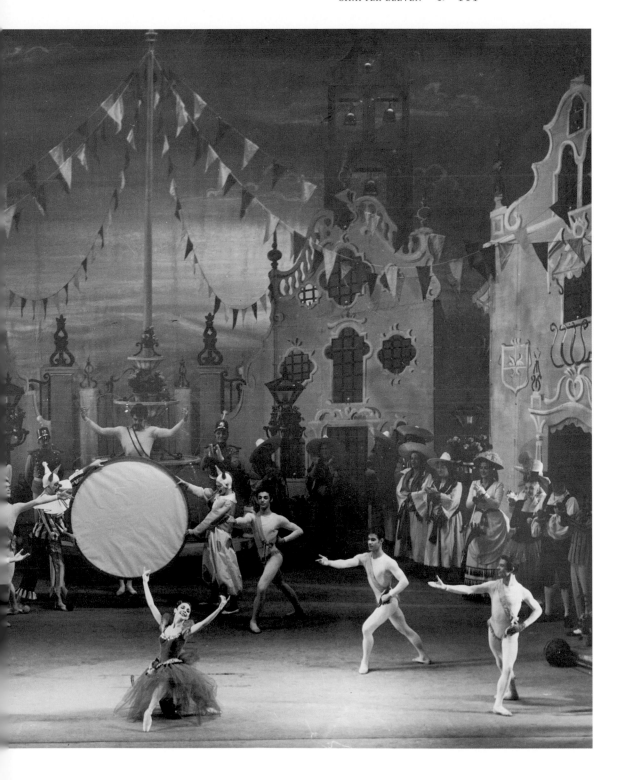

we could increase weekly checks by two dollars for any super work and five dollars for singing a solo line.) I remember only one instance where an appearance of mine didn't go smoothly. It was in Verdi's *Don Carlos*. I had a snippet of a role as the Countess of Aremberg. The Countess is onstage for a few minutes, long enough for King Philip to banish her and for her to exit with her head bowed. I came onto the stage and Cesare Siepi, as the King, exiled me. I exited, head bowed. It was the first time I'd done this role and I thought I did pretty well. Cesare thought differently. Later, he let me have it.

"What's the matter with you?" he demanded.

I honestly didn't know until he explained.

"You come out and you stand so far behind me, I have to sing into the back of the stage! What were you thinking?"

I had committed a cardinal sin. The last thing a singer wants is to turn his back to the audience and sing into the set. I had forced Cesare to do that by standing in the wrong place. He was upset but he got over it, and I never made that mistake again.

Whatever the opera, there was always a robust feeling of comradery in the company. Whether you were a star, a comprimario, a chorister, a dancer, a musician, a stagehand, or a technician, we shared common ground—we all entered and left through the stage door. One of my treasured memories is seeing Renata Tebaldi at the stage door. She never failed to greet me. I can still hear the heavenly sound of her mellifluous, "Hello, Nancy," as she brushed by. We dancers had lots of fun, but we took our work seriously. When you were in a production, either dancing or as a super, even in the back row with almost no chance of being seen by anyone in the audience, you acted your part. You felt as though you were vital to what was going on, not just a piece of scenery. Nobody stood around looking lost. There was real interaction going on and, believe me, it added to the performances. Opera used to be referred to as grand opera, and it was a spectacle to behold. Many operas in the repertoire were elaborate amalgams of sets, costumes, music, and dance. The whole effect was eye- and ear-popping. Little more than a

decade after I left the company, productions began to change. It start-
ed when John Dexter was appointed director of productions in 1975.
Dexter came from England and was innovative with an iconoclastic
presentational style. I think that he, and other directors who came in at
that time, wanted to trim the fancy feathers and present more realistic
staging. They didn't want over-the-top staging where party guests sing
and then sit around as the corps de ballet comes in to entertain them
with a lengthy and extravagant ballet, surrounded by choristers and
supers. In time, great ballet scenes such as the Cours la Reine were
eliminated. Streamlining cuts costs, and management rarely begrudges
saving money. Even though there was still a corps de ballet, directors
wanted to bring in their own choreographers. It's one thing to have a
ballet master like Zachary Solov who knew opera inside and out and
who knew the dancers inside and out, and quite another to be presented
with a series of choreographers who knew what they wanted but were
not steeped in the tradition. A lot of the spectacle that is grand opera
began to be pushed aside. Although the Met continued to maintain a
ballet company, it grew smaller, decreasing from forty dancers to fewer
than a dozen. Outside dancers were hired for performances to augment
the decimated corps; they came, they danced, they left. They were on-
stage and did what they were hired to do—with an attitude in total
contrast to the resident corps de ballet. Whether we were priestesses,
peasants, or prostitutes, whether we were Italian, French, German, or
Russian, whether we were dancing or standing around, whatever we
were doing, we were always present. We put ourselves completely into
the operas. We were there. Although it was not surprising, it was still
a shock on May 20, 2013, when I opened the *New York Times* and
saw this headline:

"Met Opera Dismantles Its Ballet in Buyouts"

I felt as though I'd been kicked in the stomach. Half of my life was
erased by that headline. I'm not being dramatic. Even today when some-
body asks about my career, and I say I danced with the Metropolitan
Opera Ballet Company, the usual response is,

"Oh, I didn't know the Metropolitan Opera had a ballet company."

Or they say,

"That's nice," as though it signified nothing.

Beth Bergman, an official photographer at the Met for more than forty years, told me that after the ballet people left, everything felt different, detached, disconnected.

"There's no *there* there, anymore," she sighed.

When I was working at the Metropolitan Opera, there wasn't a shadow of a doubt that the ballet company was a necessity. We felt secure. And now it's gone. The idea that the Metropolitan Opera Ballet doesn't exist continues to haunt me.

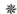

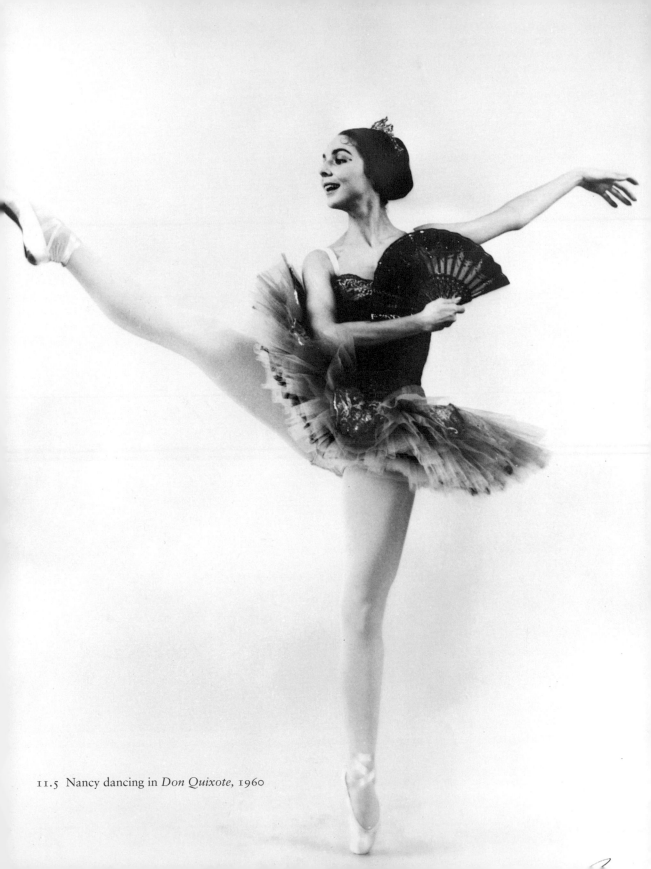

11.5 Nancy dancing in *Don Quixote*, 1960

Chapter Twelve

MY TIME AT THE MET was made that much brighter by Louellen's presence. The two of us were thick as thieves, but as chummy as we were, we never lived together. While each of us had her own apartment in the city, we always shared quarters on tour and on trips to Europe during the Met's off season. Touring with the Met was one of the great experiences of my life. I don't think I could have enjoyed being a member of a regular ballet company. Why? Because back then, companies like ABT and the Joffrey weren't in situ; they were on bus and truck tours most of the time. We were situated in the Metropolitan Opera House with a great orchestra in the pit, great conductors, great directors, and great singers. When we toured, we traveled on two trains, stayed in grand hotels, and were feted all across the country. We were members of the corps de ballet, not stars, but we were treated like prima donnas. It was such richness compared to the hardscrabble life in regular ballet companies. I remember one male dancer in our company who couldn't wait to get into ABT. He auditioned a few times and finally made it. Years later, I spoke to him about the switch.

"I really shouldn't have wished for it," he said. "What I had at the Met was so wonderful. I didn't appreciate it enough."

As content as we were, Louellen and I had a moment when we thought about jumping ship. It happened in Naples. On a whim, we auditioned for the de Cuevas company and were both offered contracts. That night when we walked into our hotel room, I turned to Louellen and she turned to me. We shook our heads and laughed. We couldn't leave the Met. As fantastic as it would be to dance in a stand-alone company, we belonged right where we were. There's no place like home, and the Met was home.

When Louellen and I set sail on the *Ile de France* for our first European jaunt, we were weren't in first class, but we weren't in steerage, either. We were in cabin class, which was a nice way of saying second class. Our cabin had three bunks, and a spinster schoolteacher was assigned to share with us. Louellen and I were sent off grandly with tons of telegrams, lavish bouquets of flowers, and a case of champagne, all of which filled the cabin, and all of which the teacher eyed suspiciously. That first night, the three of us got ready for dinner. As we left the cabin, Miss Gulch, as Louellen and I named her, put on a fur stole. Louellen, true to her kind nature, said,

"My, that's a pretty wrap."

Miss Gulch glanced over at the flowers and the champagne filling the cabin, then turned her gaze on us.

"Yes, it is. And, you know," she said, her voice weighted with innuendo, "I bought it myself."

Brava, Miss Gulch. Touché to your cabinmates and to all the ways they might have earned their flowers and champagne.

The next morning, one of the ship's officers called and asked to speak with us. We met him on deck and after the required pleasantries, he got to the main subject. Louellen and I were listed as dancers on the ship's manifest, and he asked if we would take part in the gala evening.

Louellen and I were not only willing, we were able. We'd worked out a routine and rehearsed it for weeks. We sang and danced to two numbers, "Diamonds are a Girl's Best Friend," Marilyn Monroe's memorable number in *Gentlemen Prefer Blondes*, and "Monotonous" which Eartha Kitt had introduced in *New Faces of 1952* on Broadway. We were a hit. The following day, the officer called to tell us they were so pleased with our show they were going to move us to a first-class cabin. I can only imagine what Miss Gulch thought of our sudden ascendency. That wasn't the only time we got bumped up. Any time we sailed and performed, if there was an unoccupied first-class stateroom, we'd be relocated. We got smart. On the chance that there would be an upgrade, we didn't unpack until after we'd performed. We had the best time on those voyages. Crossing the Atlantic on an ocean liner was a glorious experience. Alas, once jet planes took over, people didn't want a glorious experience—they just wanted to get where they were going.

After a couple of years with the company, Louellen and I began to receive invitations to parties, big and small. Many of them were hosted by Met supporters in the cities we toured. It became obvious to us that most of the parties were going to be dressy affairs. Louellen and I had to bring additional wardrobes, specifically, gowns. Off we went to a luggage store where we bought a secondhand wooden trunk large enough to accommodate our finery. On the trunk's maiden voyage to Boston, Louellen and I carefully packed our gowns amid layers of tissue paper. When we finished, we took a break and shared a bran muffin. We were addicted to bran muffins. Why? Because we were dancers, and staying thin was part of our regimen. We had to watch every single morsel of food that went into our mouths, and in that pursuit, we were habitués of health food stores. Bran was a big deal, the last word in healthy eating. Sometimes it was all we ate. That afternoon, when we finished packing, Louellen looked into the trunk.

"There's a little room left," she said. "Why don't we get a supply of muffins to take with us?"

Why not, indeed. We went to the health food store, bought thirty muffins, wrapped each in tinfoil, and put them in the trunk with the dresses. When we arrived in Boston, the trunk was stored with the other large luggage under a tent in the theater's courtyard. After a couple of days, Louellen and I went to the tent to replenish the muffins we'd brought to the room. We unwrapped the tinfoil and discovered they'd turned green. At least the dresses were OK. We took all the muffins to our room and scraped off the green coating. Mind you, we ate those muffins because we thought we were saving calories. When I finally looked it up, I couldn't find any variety of bran muffin that was under 400 calories.

A lot of crazy and wonderful things happened during those Met years, both at home in the opera house and on the road. You have to remember, though, no matter how much fun we were having, we were always hard at work. I emphasize that fact because we could get so wound up that we'd let go with abandon. Our schedule was grueling, but we were healthy. I recall only one time when I fell ill. We were in Boston on tour and unwinding at a private party after a performance of Offenbach's *La Perichole*. *Perichole* was directed by Cyril Ritchard. He not only directed Mary Martin's *Peter Pan* on Broadway, but portrayed Captain Hook. Cyril took on triple-duty in *Perichole* by directing, singing, and acting. He laughingly said that he was "the only performer who had ever been engaged by the Metropolitan Opera in spite of his voice." The party was one of those exclusive gatherings consisting of administrators, cast members, and a sprinkling of local Boston Brahmin sponsors. Louellen and I were there with Mr. Bing, a few of his staffers, the featured singers, and Bruce Marks with whom I was often partnered onstage. At one point everyone was gathered around Cyril. He was always the life of the party. Suddenly, a wave of nausea came over me.

"I don't feel good. Get me out of here," I whispered to Bruce.

Bruce took my hand, put his arm around me, and led me to the door. I remember thinking to myself, keep your head up, walk carefully, smile. As always, I wanted to be in complete control. When Louellen

told Cyril the reason for my hasty departure, he said,

"I never saw someone who was so sick being led out as though she was about to dance a pavane."

Looking back, I think what transpired in Detroit one evening may top the list of colorful events in my Met touring life. *Carmen* was on that night, but I wasn't in the cast. I was hanging around backstage waiting for the performance to end when I was approached by Tony Bliss, the president of the opera board.

"Can you help us out, Nancy?" he asked. "Would you come out front and have a drink with me and Henry Ford? He really doesn't want to watch the opera."

I knew that Mrs. Henry Ford II was a dedicated subscriber and contributor. The Met wanted to keep her husband happy. I agreed and went to the lobby where I had a drink with Tony and the reluctant operagoer. We chatted and laughed. Everything seemed to be going well because Mr. Ford turned to me and asked,

"Are you coming to the party tonight?"

I shook my head no.

"Well, I want you to come," he said as he reached into his pocket, took out a twenty-dollar bill and handed it to me.

"Take a cab."

I shot a quick glance at Tony. He nodded his head, and I took the twenty. I returned to my hotel, hung up a dress in the bathroom, turned on the hot water in the shower, drew the curtain, and went out leaving the dress to steam. After I did my makeup and fixed my hair, I put on the dress, which was beautifully unwrinkled, and headed back to the opera house. Always practical, instead of using the twenty dollars for a cab, I decided to take the company bus. The party was at a home in Grosse Pointe. By the time I arrived, Mr. Ford was well in his cups and decidedly mellow. He greeted me warmly, took me over to a sofa in a far corner, sat me down, and plopped down beside me. He smiled sweetly, then took my hand and placed it on his crotch.

"I want to f-- you," he said.

I didn't know what to say. I didn't know what to do. I looked around and spotted Herman Krawitz, one of the Met administrative executives.

"Just one second," I said, as I pulled my hand away. "I'll be right back." I jumped up and ran over to Herman.

"Please," I begged him, "you've got to come and sit with me and Henry Ford." When I explained why, Herman followed me to the sofa where Mr. Ford was still seated, still smiling, still mellow. Members of the company did everything they could to keep major subscribers happy. I felt it was my duty, up to a point, to mollify Mr. Ford. I rejoined him but sat on the far end of the sofa. Herman sat in a chair facing us. We made small talk until Mr. Ford said,

"Nancy, I'd like you to come and see my office tomorrow."

"I'd love to," I replied quickly, "but I have a rehearsal."

Mollifying be damned, I was getting into unwanted territory. I had to get away. I stood up and cried out,

"Oh, excuse me, there's someone over there I have to talk to. I'll be right back."

I flew across the room and inserted myself into a conversation between two complete strangers. I did not return to the sofa. Herman Krawitz had to fill in. Later, he told me that Mr. Ford strolled around the rest of the evening asking, "Where's Nancy?" He walked through a screen door because he thought I was behind it. I swear I didn't do anything to bring this on. In those days if a powerful patron went after you, you had to put up a friendly front. For the sake of the company, I felt obliged to patch up the situation. The next day I sent Mr. Ford a note.

12.1 Nancy on tour with the Met

One night after the performance, I left the Met carrying the roses that had been sent that evening. I reached the subway entrance and noticed a man standing there. As I started down the stairs, he tipped his hat, leaned forward, and said,

"Are you Miss King?"

I looked at him. He was of medium height, not handsome, but with a pleasant aspect, and somewhere in his forties. I knew in an instant that I was face-to-face with my secret admirer.

"Yes," I answered. "Are you the gentleman who's been sending me all the flowers?"

"I am," he replied. "Would you like to join me for dinner?"

He hailed a cab, took me to my apartment, and waited downstairs while I went up and changed my clothes. We went to the Rendezvous Room at The Plaza, exactly the place to go. Cozy. He was a great talker but circumspect at the same time. I enjoyed his company yet never once asked his name. After that first evening, we saw each other a dozen or more times. One night, he told me to call him Richard. We went on like this for a while. The Lone Ranger nature of our relationship appealed to me. His identity was masked, and I thought it was a good thing that I didn't know who he was. I felt that if I did, I'd probably have to stop seeing him. Richard was captivating, well-read and well-spoken. He gave me classic books to read and introduced me to writers like Saki, whose irreverent, witty stories delighted me. He also presented me with a copy of Charles Darwin's *The Voyage of the Beagle*. He had a big influence on me. We had deep talks about books and about life. He introduced me to wonderful restaurants. I didn't have to do anything but enjoy myself. It's great to be admired and not to have to pay back. Over the eight months or so that I was seeing him, I learned a lot about him, except for his last name. The way he looked, the way he dressed, the way he spoke—he was a man of substance. One evening, I learned why he'd selected me from the other deportees in *Manon Lescaut*. Richard was fixated on women's hair; it was his

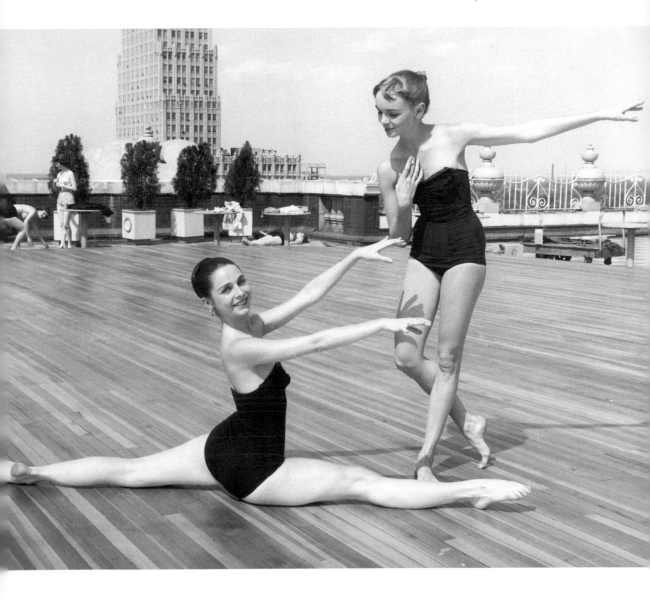

12.2 Tour photo with Louellen in St. Louis

fetish. I had worn my long hair loose at the performance and it caught his eye. He made no bones about his obsession and talked about it at length. He even taught me how to comb my hair in the best way and bought me wonderful hair pins that I still have.

One day, he presented me with a beautiful, blue silk Gucci bag. I hesitated about taking it. Books and flowers were one thing, but an expensive gift to someone who wasn't granting any favors, and didn't intend to, was another. I told him I didn't think it was appropriate for me to accept it.

"Nancy," he said with a smile. "You don't know who I am, and I'm not asking anything of you. I love your company. I wish I could take you away somewhere. I want violins and rose petals for you. But we can't do that so, please, take the gift. There are no strings attached."

And so, I took a few expensive gifts from Richard, including the Buccellati ring, which was my introduction to the Milan jeweler.

We were on tour when I found out Richard's last name. I also found out that he was married to one of the Met's major mezzos, Blanche Thebom, which made sense. Thebom was an attractive woman and famous for her long hair. It had never been cut. Photos of her and her flowing locks were in newspapers and magazines. I read an article about her in LIFE that said she was five feet, seven inches tall and her hair was six feet long. We never talked about his wife, but I felt certain they were in an open marriage. Richard and I were together for eight months, and even after we parted, we remained friends. He got divorced and married again. I married Bill Zeckendorf and the four of us socialized on a few occasions. One time, Bill and I showed them around Santa Fe. While it lasted, I had a wonderful time with Richard. Having flowers sent regularly, being feted at fancy restaurants, learning new subjects, reading great books, receiving gifts from famous designers—what was not to like?

During the time I was seeing Richard, I had another swain, a gentleman named Jerry Taishoff. He had seen me in a production of *Carmen*

directed by Tyrone Guthrie. We gypsy girls wore skirts that came a little below our knees, and when we were swishing those skirts, a lot of leg was revealed. Jerry turned out to be a leg man. He loved looking at women's legs and he zoomed in on mine that night at *Carmen*. Jerry asked his friend Francis Robinson if he knew the girl with the great gams and could he arrange an introduction? Francis introduced us, and it was the beginning of a beautiful friendship. Jerry had an elegant apartment in the Savoy-Plaza Hotel on Fifth Avenue, across the street from The Plaza Hotel. Jerry's apartment had Chippendale furniture on the floor and J. M. W. Turner paintings on the wall. Apart from those elegant details, he came across as a grown-up street kid. I learned that he'd made his money either in scrap metal or transistors or both. Like Richard, Jerry was a gentleman, but with rougher edges. His voice and manner were gruff whereas Richard's were genteel. When I met him, Jerry was divorced from his first wife. He was single but not young, in his late forties. (Later, in one of those topsy-turvy turns that peppered my life, I was introduced to his ex-wife, an artist who, I believe, left him for another woman. She and I became friends and she wound up painting a full-length portrait of me.) My relationship with Jerry revolved around opera. He went to the Met on Monday nights and had two seats on the aisle in the front row of the orchestra. Whenever I was not appearing onstage, I'd go with him. I got a kick out of being on the other side of the footlights and watching my friends go through all the motions that I had to go through when I was onstage. I loved luxuriating in the full experience of attending an opera rather than performing in it. Monday was dress night at the Met; men wore black tie and ladies were in ball gowns. Before the opera, I'd meet Jerry at the Savoy-Plaza for a drink. We'd have our cocktail and go to the hotel entrance where the doorman would hail us a cab. The doorman, however, didn't merely hail cabs. He acted as an arbiter of taste. When I stood beside him, he'd look at me and say, "Nine." I learned that if he didn't say "nine," that meant I wasn't dressed to his standards. I knew how to dress and I had a decent

wardrobe. Even so, this doorman's approval carried a lot of weight. One night, I was all decked out and wearing a tapestry coat. Jerry and I had our drinks, but before we left, Jerry asked me to give him my coat. As I handed it over, he said,

"I've got a fur stole in my suite and I want you to wear it tonight."

I was a bit flustered, but I consented. He went to his room with my coat and returned with a mink stole which he draped over my shoulders.

"It's not a gift," he quickly noted. "It's to wear for tonight. I want to make certain the doorman gives you a nine."

We went to the front of the hotel, and as the doorman helped me into the cab, he leaned over and said, "Nine" with more enthusiasm than I'd ever heard before. The mink stole did it, I'm sure.

After the opera, Jerry and I always went to the 21 Club for dinner. When the evening ended, Jerry would drop me off at my apartment. That night, we got into the cab and Jerry said to the driver,

"We're going to the Savoy-Plaza."

"No, we're not," I interjected. "We're going to 253 West 55th Street."

"Savoy-Plaza," said Jerry.

"253 West 55th," said I.

The driver turned around and looked at the two of us.

"OK, folks, let's get together on this. What'll it be?"

Jerry shrugged his shoulders and said,

"You heard the lady."

And off we went. We arrived at my place. Guess what? I realized that my keys were in my tapestry coat.

"Savoy-Plaza," Jerry told the cabbie, who never said another word. None of us did.

Because it was so late, I spent the night at Jerry's on the sofa in his living room. I knew Jerry wanted to sleep with me, but I also knew he was a gentleman. We had a lovely friendship. He wanted to take me to the opera, fine, but I wasn't going to bed with him. He accepted it. Richard had accepted it and enjoyed his role as my secret admirer. Jerry

was an admirer of a different sort. He didn't give me gifts, but he took me to the opera and was a friend, although, like Richard, if I'd been amenable, he would have ended the friendship in favor of a relationship. It all sounds so quaint, but don't forget, it was the 1950s.

During those early years at the Met, I did a bit of commercial work on TV as well as newspaper and magazine advertisements. One print ad shows me presiding over a table elegantly set with Lenox china. At the other end of the domestic scale, I was in a television commercial that had me pushing and praising a lawn mower. I appeared on television variety shows such as *The Colgate Comedy Hour* and *The Ed Sullivan Show*. I worked with a number of the creative geniuses of early television such as Rod Alexander, who was both a dancer and choreographer. I met him during the filming of the lawn mower commercial, and he asked if I'd like to do some dance numbers with his group. I wasn't a Rod Alexander-type dancer, as he favored jazz, which was not my specialty. He choreographed two wonderful numbers. One was to "When the Saints Go Marching In" and was filmed in Eddie Condon's club in Greenwich Village. The other was "Standing on the Corner," which was shot in a Walgreens drugstore on Broadway. Both Condon's and Walgreens were cleared of customers when we filmed. Rod took me under his wing and introduced me to a lot of people who introduced me to other people. I also got to know Paul Draper, a popular dance performer and a nephew of Ruth Draper, a venerated actress known for her monologues and monodramas. Paul invited me to dinner and took me to Quo Vadis, one of New York's top restaurants. He invited me to go dancing at the Starlight Roof at the Waldorf Hotel where they had a big band in residence. The next day, Paul invited me to go bicycling in the park. Much as I liked him, I had enough admirers to fend off. I didn't want to play games either. Maybe some of the guys I met could have helped my career, who knows? I wasn't going to get involved in any casting-couch scenarios. As far as I could tell, such activities didn't seem to be going on, at least not in my world. You went

12.3 On the Ile de France in 1957 with Louellen

out with someone because you liked him, not to advance your career. I will admit that somewhere in this period of time, I lost my virginity. It wasn't to advance my career and it wasn't a grand romance. I simply wanted to get it out of the way and get on with the rest of my life.

✳

Chapter Thirteen

WHILE THE METROPOLITAN OPERA was my official home for almost ten years, for two of those years, during the summers of 1961 and 1962, I was also a member of the Santa Fe Opera—a company which came to mean as much to me as the Metropolitan Opera. I spent ten years of my life with the Met, but I was with the Santa Fe Opera for fifteen. The company was founded in 1956 as a summer music venue by John Crosby, a musician, conductor, teacher, and impresario from the East Coast. In his youth, Crosby suffered from severe sinus problems attributed to asthma. After an illness-ridden freshman year at the Hotchkiss School in Connecticut, young John was enrolled at Los Alamos Ranch School in New Mexico, where he spent his sophomore year. The school, thirty miles northwest of Santa Fe, later became the site of the Manhattan Project. The dry climate worked wonders for John's sinuses. At the same time as he was thriving physically, he fell under the spell of New Mexico, especially Santa Fe. He returned to Hotchkiss to finish his studies and graduate, enrolled in a summer session at Yale, joined the Army and saw active duty in France and Germany. When World War II ended, he returned to Yale and changed his major from pre-med to music. John was an accomplished

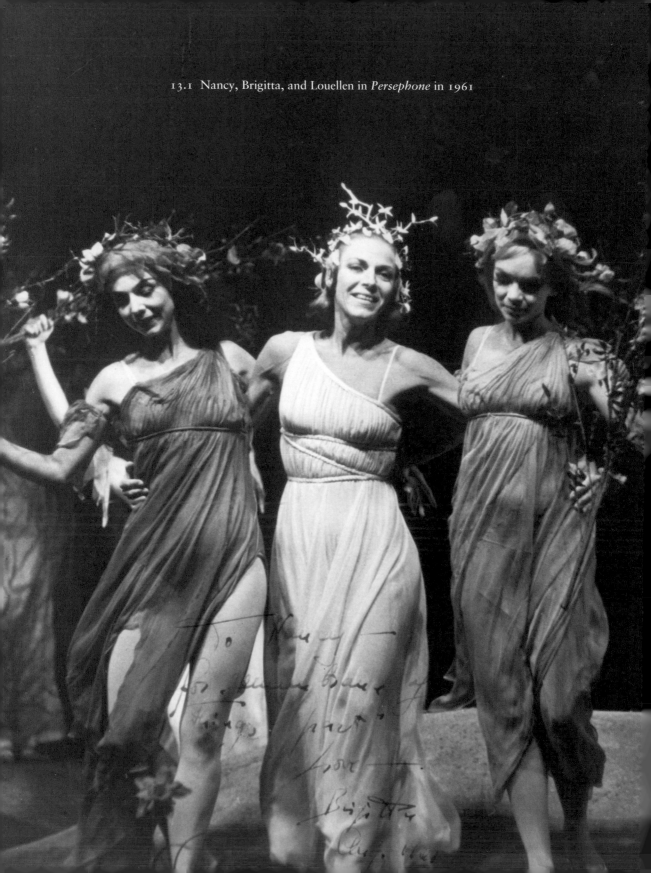

13.1 Nancy, Brigitta, and Louellen in *Persephone* in 1961

musician and could play a number of instruments, including the violin. After graduating Yale in 1950, he attended Columbia University where he developed his conducting skills, among other endeavors. While living in New York, he became a regular at the Metropolitan Opera House and fell in love with opera. He claimed that his passion for opera came directly from viewing the dazzling works presented under Rudolf Bing's aegis. He particularly admired Bing's productions of Verdi's *Don Carlos*, *Macbeth*, and *Otello*; the *Carmen* directed by Tyrone Guthrie; and Mozart's *Cosi fan tutte*, directed by Alfred Lunt. The idea of establishing an opera company in a southwestern town with a population of 23,000 inhabitants was more than daring, it was madness. The audience was comprised of New Mexico residents from the northern and southeastern parts of the state and visitors from adjacent states Texas and Colorado. Even with a local audience, Crosby's programming was more adventurous than directors of the great opera capitals of the world. Of the five or six operas per season, there would be a few reliable classics, always including a Strauss (Richard, not Johann). John was crazy for Strauss. He'd also feature one or two avant-garde works. In a short amount of time, he had developed a provincial audience into concertgoers willing to attend operas by Paul Hindemith and Igor Stravinsky.

My involvement with John Crosby and his company was set in motion when the SFO announced its 1961 season, which included two of Igor Stravinsky's works, *Oedipus Rex* and the American premiere of *Persephone*. As a bonus, the composer himself agreed to a residency during which he would conduct his operas. This, however, was not Stravinsky's first appearance in Santa Fe; he was at the SFO's inaugural season in 1957. When the operas for the premiere season were announced, *The Rake's Progress* was among them. Miranda Levy, a local resident, had read in the newspaper that John Crosby was an ardent Stravinsky fan, so she called him.

"I hear you're going to do *The Rake's Progress*," she said. "Would you like me to call my friend Igor Stravinsky and see if he'd come?"

I can imagine the look on John Crosby's face when that question was posed. Miranda called her friend, explained the situation, and invited him to come.

"Is there an opera house there?" asked Stravinsky.

"No," Miranda answered, "but there will be by next year."

And there was. And Igor Stravinsky was there to give the Santa Fe Opera a prestigious inaugural boost.

Persephone is a musical amalgam featuring a speaker, a solo singer, chorus, dancers, and orchestra, with a libretto by Andre Gide. Written for Ida Rubinstein and her dance troupe, it premiered in Paris in 1934. Having *Persephone's* American premiere, in addition to the presence and participation of its composer, was an outstanding coup for John Crosby and helped put his company on the map. There was, however, a stumbling block. In its three years of existence, Santa Fe Opera had not yet presented an opera that called for dancers. Dance was an integral component of the Stravinsky work, and Crosby had to fill the bill. To that end, he consulted with Walter Terry, dance critic of the *New York Herald Tribune*. He explained the situation and closed the conversation with a direct appeal.

"I need some dancers, Walter. What do I do?"

Terry pondered and came up with a possible solution. He thought highly of the work of Thomas Andrew, a member of the Metropolitan Opera Ballet, and suggested Crosby contact him. Crosby did, and Tommy took over.

"No problem, Mr. Crosby," he told the impresario. "I'll put together a group of dancers for you. I think five men and five women should do it."

Relieved, Crosby gave his assent, and Tommy Andrew was off and running. The next day during a rehearsal at the Met studio, he started putting together a ballet company. I was at the barre when he approached me.

"How'd you like to dance with the Santa Fe Opera this summer?" he asked.

I liked it fine, and quickly agreed to do it. I had nothing on that summer and was delighted to pick up work. The Met was closed because there was no air conditioning. Singers and dancers were fancy-free until the beginning of the new season in the fall. That gave us four months to find part-time employment or to kick up our heels. In the past, I'd done summer stock and earned my keep or, if it was offered, I'd take those European jaunts with Louellen or other friends. When I couldn't find work, I'd collect unemployment. I had never been to Santa Fe and was delighted to have a paid destination summer. No surprise, Louellen was also chosen. And so it was that Tommy, Louellen, I, and seven of our corps de ballet pals became the Santa Fe Opera Ballet. When Rudi learned what his dancers were up to, his sole comment was,

"Santa Fe? Where is Santa Fe?"

He wasn't being facetious. The Santa Fe Opera was barely five years old and had yet to take its place as a world-class opera company and one of the most inventive and forward-looking companies ever. John Crosby had created more than another opera company; he created something unique, something that had not existed before in our country—an opera apprentice program. Formerly, any young and ambitious opera singers had to think seriously about moving to Europe. There was no place for them to train in America until John Crosby made a place for them. He also created an apprentice program for technicians. They weren't paid, but they had housing and the opportunity to take classes, even master classes, from established artists and acquire experience. It was a brilliant concept and a great boon to everyone involved. The neophyte singers and technicians received on-the-job education and training, and the Santa Fe Opera got a built-in chorus and an abundance of eager technical workers. John Crosby was ever the pragmatic visionary. He slated the SFO season to start around the Fourth of July and end a week or two before Labor Day. People asked John why he didn't extend the season into September and his answer was, "The summer is over and the visitors have gone."

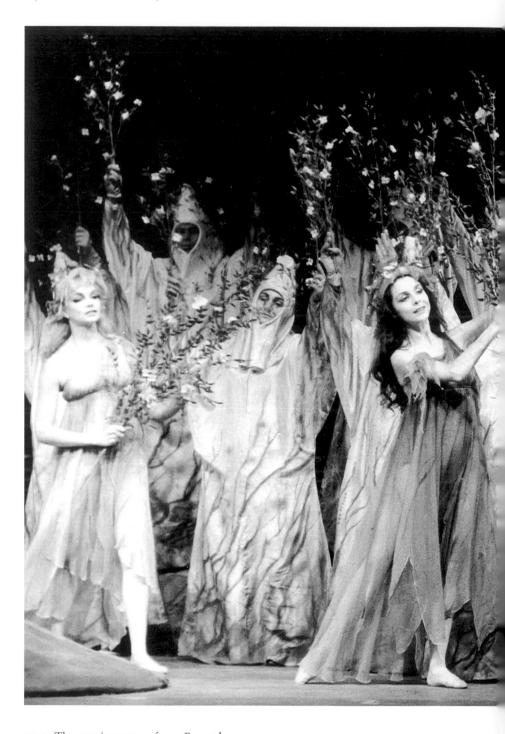

13.2 The cast in a scene from *Persephone*

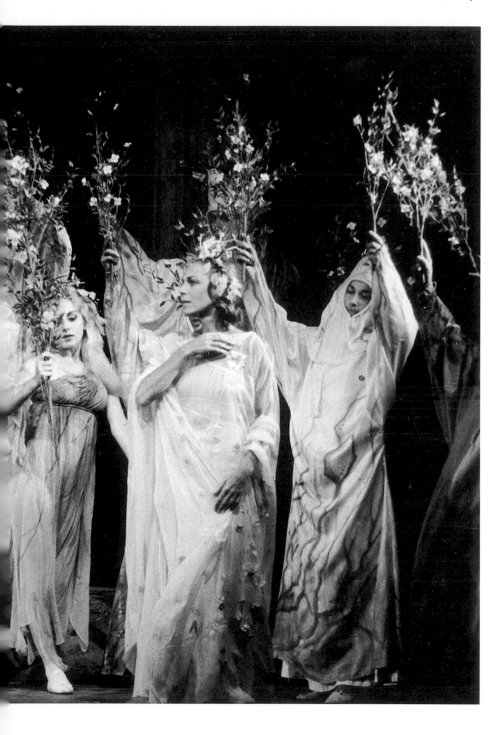

We flew to Albuquerque in mid-June. I remember being surprised that TWA had a direct flight from New York. (Later, Bill Zeckendorf would speculate that "someone high up in TWA must have had a house there.") It was my first visit and all I knew about the area was that Georgia O'Keefe painted pictures in the desert, and Mabel Dodge patronized the arts in nearby Taos. The moment I stepped off the plane, I was hooked. There's something special in the dry, crisp, clear air, the patches of desert with their distinctive shrubs and trees, the rocks, and the lighting on the surrounding hills. The Native American presence is a strong and spiritual influence that permeates the very ether. Driving into Santa Fe for the first time reminded me of Greek villages that I'd visited, except that the houses were brown instead of white. It's a place where you come up to who you are and you have to face what's going on inside. At that point in my life, having been involved with Baba, I was more inclined toward the spiritual. I was so open back then. With a few modifications, I like to think I still am.

The minute I came to Santa Fe I knew I was going to like the place. I wasn't as certain of my feelings about John Crosby. Unlike the landscape, he was not accessible. Even before we met, I got some measure of the man through our negotiations. John Crosby was a mathematical whiz. He was careful about everything, especially numbers. Cost Control was his middle name. I realized this when I read the terms I was being offered. His microscopic attention to detail was evident in the paragraph at the bottom of my contract:

> Employer will provide air transport NY to Albuquerque, $190, excess baggage allowance to include one makeup kit, one pair dance slippers, allowance 7 pounds at 74 cents, total $4.48. If makeup kit and dance slippers weigh more than 7 pounds, Nancy must present items for weight checking at airport to claim additional reimbursement.

That clause is so John—everything accounted for, down to the last penny. I made it my business to stay within the limits, but I would have danced for nothing, as I later told him. I wasn't kidding. I'd have paid to dance with the Santa Fe Opera. It was a privilege. Another detail from that first contract caught my eye. John Crosby wrote his name in exceedingly tiny letters, almost as though he didn't want his signature to be noticed. He was an important man and yet his signature was that of a child. There was another important man in my life who had a surprisingly minuscule way of signing his name, Bill Zeckendorf. If there's one thing I didn't have, it was a miniature signature. I had to write so many fundraising letters for the Santa Fe Opera that I learned to scrawl my name in an oversized scribble. Why did I do it? I thought it looked impressive.

Everyone at the Santa Fe Opera was in awe of John Crosby, but we didn't have much interaction with him. Decades later, when I was on the SFO board of trustees, I still didn't know him. I knew he was an astute businessman, but he remained an enigma. John was a loner. He could be difficult to get along with and there were flare ups over the years that hurt some long-term friendships. Not ours, though. I would learn how to deal with John Crosby because of an extraordinary woman I met my first summer in Santa Fe. Her name was Brigitta Lieberson, and I fell in love with her the first time I laid starry eyes on her. Seventeen years older than I, she was talented, cosmopolitan, and beautiful. We became friends, and our friendship continued until she died in 2003. By then, Brigitta and her husband, Goddard Lieberson, a composer, and former president of Columbia Records, had a home in Santa Fe. Both of us were living there. Brigitta and I became close. We talked on the phone every day and had dinner together a few times a week. I idolized her. To this day, I can't get over the fact that she befriended me. Let me explain. Like me, Brigitta was hired to appear in *Persephone*, but not in the corps de ballet. Brigitta was the star of the show under her professional name, Vera Zorina. For those of you who might not know of Zorina, it's some story.

13.3 The original Santa Fe Opera house in 1957

Eva Brigitta Hartwig was born on January 2, 1917, to a Norwegian mother and a German father, both of whom were professional singers. Although she was born in Berlin, Brigitta was raised in Norway and was always referred to as Norwegian. On the other hand, Vera Zorina, in Brigitta's own words, "was born, aged seventeen, at Covent Garden in London." On that occasion, Brigitta Hartwig, about to make her debut with the Ballet Russe de Monte Carlo, was ordered to change her name to a more Russian one by the company's director. When Brigitta asked why, he replied,

"Because my dear, if all the members of the Ballet Russe who are not Russian kept their original names, the company is not Russian ballet anymore. You understand?"

He handed her a list of names from which to choose. She maintained that she chose Vera Zorina because it was the only name on the list that she could pronounce. After two years she left to star on Broadway in Rodgers and Hart's *On Your Toes*. The choreographer was George Balanchine. Brigitta and Balanchine were invited to come to Hollywood for *The Goldwyn Follies*, a prestige musical film with words and music by George and Ira Gershwin. Balanchine choreographed a water nymph ballet for Brigitta which showcased her balletic skills and her innate sensuousness. The film wasn't a financial success but helped to popularize ballet in the movies. In 1938, Brigitta returned to Broadway to star in another Rodgers and Hart musical, *I Married an Angel*, again with choreography by George Balanchine.

At this point, the ballerina and the choreographer got married and were together until their divorce in 1946. Brigitta did a lot of dancing in films and in musicals while expanding her career to include acting. She successfully auditioned for the role of Maria in the movie version of Hemingway's *For Whom the Bell Tolls*. You might remember that Ingrid Bergman later stepped into the part and was a sensation. Undaunted, Brigitta continued her dual careers, dancing and acting. After portraying Ariel in a Broadway production of *The Tempest*, she

was hired by the New York Philharmonic to appear as performer-narrator in dramatic oratorios. She was Joan at the premiere of Honegger's *Joan of Arc at the Stake,* which became one of her signature roles. In time, Brigitta added a third career, directing. She directed operas for the New York City Opera and the Santa Fe Opera. In the mid-1970s, she was scheduled to take over as director of the Norwegian National Opera and Ballet but withdrew when her husband became ill. She tended to him until his death in 1977. In 1991, Brigitta married harpsichordist Paul Wolfe, another Santa Fe resident who had worked with John Crosby at the Manhattan School of Music. Vera Zorina had an illustrious and varied career. When asked to explain her longevity, Brigitta Hartwig answered, "I've never been interested in standing still in one medium."

That a star of Brigitta's magnitude wanted to be my friend astonished me, but it was only one of many implausible delights that summer. One, having nothing to do with dancing or opera, occurred during the first week and carried over both summers. I was strolling around the opera grounds, which contained a theater and a couple of rehearsal halls that had been erected after John bought the property. When I came to the original ranch house, I walked in, took a look around and saw a bookcase containing a six-volume edition of Proust's *Remembrance of Things Past*, which I intended to read but hadn't gotten around to doing. I plucked the first volume off the shelf and took it with me. At the same time as I was dancing at Santa Fe Opera, I was also reading Proust. They went together well. I've always been an inveterate reader, coming from a generation where movies and theater were rare treats. Radio was OK but it wasn't the seductive temptation that television later posed. Even now, I'm more a reader than a watcher. My love for books is as passionate as my love for music.

Performing *Persephone* was an absolute dream and a lucrative one. Summer stock paid $80 a week, but our Santa Fe salary was the same

as we got at the Met, $100 a week. In Santa Fe, we didn't have to pay for lodging because people volunteered to house us. We stayed in town and rehearsed in a little studio. Getting to the theater was a fifteen-minute drive. They gave us a car which we named Stravinsky. Our expenses were minimal, and I was pleased to be saving money. I didn't think things could get any better. A publicity photo for *Persephone* of Brigitta, Louellen, and me was taken and widely circulated. I still smile when I look at it. Our hair was down and on our heads were crowns of intertwined flowers and twigs. The costumes looked like something out of Botticelli's *Primavera*. We wore loose flowing, off-the-shoulder, pastel shifts that were light as air. Brigitta's gown was off her left shoulder while Louellen's and mine were off our right shoulders, I guess to distinguish her from us—as if anyone would have had a doubt which of the trio was Zorina. Stravinsky and his assistant Robert Craft alternated conducting the performances. Brigitta warned me that their tempos would differ. When Craft was in the pit, she'd say,

"Take everything a little faster."

On the nights when the composer took up the baton, she'd lean over and whisper to Louellen and me,

"Remember to take it slower, kids."

Because the entire back of the stage was open, the audience could see the sunset and the lights of Los Alamos in the distance. (The opera house has been rebuilt twice and all three buildings have been open air.) The setting, the music, the scenery, and the entire experience of dancing on that stage was ethereal. I cannot remember a more glorious moment in my career than being on the stage of the Santa Fe Opera with stars shining overhead, the sparkling lights of Los Alamos, and Igor Stravinsky conducting in the orchestra pit.

One incident that summer did not qualify as ethereal. It seemed that the sight of men from the opera ballet in form-fitting white tights proved too much for members of one church group. After the performance, the parishioners swarmed John Crosby, demanding more

modest costumes. Another person may have capitulated, but John stood his ground and managed to convince the good folks that this was art. So, the boys stayed in their tights, and the ballet was allowed to continue. That was one of John's strengths—he could rise above his natural reticence and meet any occasion, especially when it concerned his beloved opera company. John was nimble and strategic. He once told me that whenever he scheduled an opera with dancers for the season, he'd schedule other operas that also called for dancers.

"Get it?" he said with a smile. Of course I got it. Yet another example of John killing a few birds with one stone.

John was a reserved man, and he could seem stand-offish. Whenever I saw him come into a roomful of people, he would go directly to a corner and not speak to anyone. Some attributed his behavior to ego. I think they were mistaken. John worked extremely hard. In his day, he was a famous person, but he was not egotistical. In all the years I knew him, I never heard him say a boastful word. He was focused on one thing, opera, especially the Santa Fe Opera. His guard was always up. When he let it down, and you became his friend, the invisible protective shield could rise at the drop of a hat. Brigitta and he had a strong bond dating from her appearance in *Persephone,* which was the first time they met. The two of them became even closer after Brigitta moved to Santa Fe. In his book, *A Vision of Voices: John Crosby and the Santa Fe Opera*, Craig A. Smith relates the following story told by Paul Wolfe:

> At a big cocktail party before one opera season opened … Brigitta was sitting in the living room of the house. Crosby came in and the pair remained alone for some time. They were preparing to go outdoors to join the party when Zorina suddenly said, "You know, John, I love you." He replied, "You know, Brigitta, I love you, too." And they both then fled the room in different directions, as if the revelation had been too much to bear.

In later years, after I'd joined the Santa Fe Opera board and had to deal with John Crosby directly, Brigitta gave me a piece of advice that laid the groundwork for my relationship with him. As a fundraiser and board member, I had many occasions to confer with John. It wasn't easy, and I confided to Brigitta that talking with John Crosby, especially on the phone, was arduous. Whenever I called, he'd answer mumbling, "Hello," and then silence. It was very off-putting. Brigitta laughed.

"Look, that's the way he answers the phone. Don't let it throw you. Talk right through it."

Talking right through it was the magic formula. The next time I called John, I didn't even wait for him to say hello, I commenced talking. It worked. That doesn't mean that the next time I phoned him his greeting changed. It never did. I simply got on with what I had to say. John Crosby was a challenge, but I met the challenge and was rewarded immeasurably. He was one of a handful of men, starting with my father, who were powerful influences in my life. The fifteen years I was at the SFO were the most stimulating and exciting years of my life.

※

Chapter Fourteen

WHEN I JOINED the Metropolitan Opera Company in 1954, Rudolf Bing had been the general manager for four years. Born and raised in Vienna, he'd had a successful career running opera houses in Germany. Then the Nazis rose to power. Bing, who was Jewish, emigrated to England in 1946, where he became a naturalized British subject. Soon after, he was appointed general manager of the Glyndebourne Opera. In 1947, he was a cofounder and the first director of the Edinburgh International Festival. In 1949, after meeting with Mrs. August Belmont Jr., an influential member of the Met's board of trustees, he was named general manager of the Metropolitan Opera beginning with the 1950–1951 season. Eleanor Robson Belmont, English by birth and actress by profession, was a remarkable woman. George Bernard Shaw allegedly wrote *Major Barbara* for her. She, however, was unable to create the role because of a prior contractual agreement. In 1910, she married the widowed American millionaire, August Belmont Jr., who was many years her senior, and made her home in New York. Noted for her philanthropic works, she became a driving force for the Metropolitan Opera. Among other contributions, she founded the Metropolitan

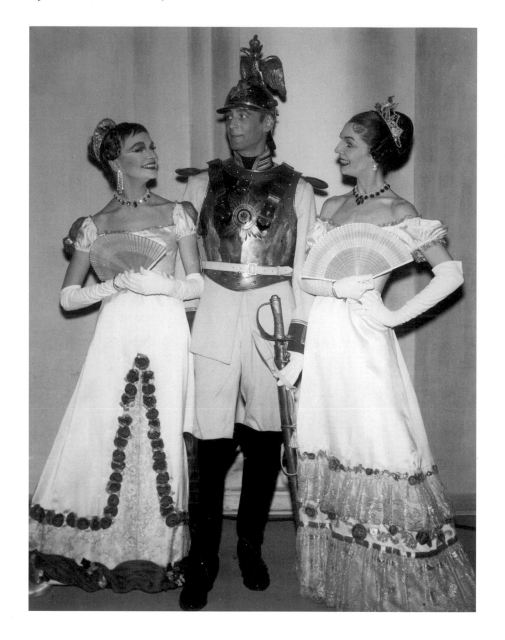

14.1 Met general manager Rudi Bing appearing in costume in *Eugene Onegin* with Louellen and Nancy

Opera Guild, which remains the company's strong right arm. I can recall seeing her at the opera house—a beautiful woman with snow-white hair and an indelible air of elegance. She died at the age of one hundred, having survived her husband by more than half a century. The Belmont Room, located on the Met's Dress Circle and maintained by the Guild, is named in her honor. It was Mrs. August Belmont who championed Rudolf Bing.

After he took over, Bing did a lot of overhauling. He thought the Met's operas were apathetically staged and he hired a number of directors from theater and cinema to upgrade the dramatic potential. He also hired the Met's first woman director. Margaret Webster was a Shakespeare specialist. Bing gave her two Verdi operas to direct, *Aida* and *Don Carlos*. The latter, a favorite of Bing's, had not been heard at the Met in twenty-seven years. *Don Carlos* opened Bing's first season and was televised over the ABC network. While it's no big deal to televise operas today, this was a happening in 1950. *Don Carlos* was a great success and took its rightful place in the repertoire, thanks to Rudolf Bing. Bing was also forward-thinking when it came to casting. In 1955, he hired Marian Anderson to sing Ulrica in *Un Ballo in Maschera*, and the legendary contralto became the first black woman to sing at the Met. She wasn't, however, the first black woman to perform on the Met's stage. That event also took place during the Bing regime. Four years earlier, in 1951, when Webster's production of *Aida* was taking shape, Zachary Solov asked Bing if he could hire Janet Collins as the principal dancer.

"Absolutely," Bing responded.

While it's one thing to be a legendary figure like Marian Anderson, it's a different story for a respected yet relatively unknown performer to get her due. Janet Collins was classically trained and studied with Mia Slavenska, among others, but because of her color, her career was more centered on theater than ballet. Janet Collins, not Marian Anderson, was the first black woman to perform a principal role, albeit

a non-singing one, at the Metropolitan Opera. In the same performance, Robert McFerrin, an African American baritone, sang the role of Amonasro, Aida's father, thus becoming the first black male to sing a principal role at the Met. Bing was asked by the press how he felt about putting blacks on the Met roster. His answer was swift and succinct,

"I have no objections to hiring Negroes."

The quote was published, and one operagoer wrote a letter protesting Bing's announced intent to hire artists regardless of race. Bing wrote back.

"I don't think that I will have any Negro singers in the next season's roster as … the roster is complete, but I am afraid I cannot agree with you that as a matter of principle, Negro singers should be excluded. This is not what America and her allies have been fighting for."

Disregarding the now-discarded appellation Negro, it's clear that Rudolf Bing saw artists, not color. During his auspicious tenure, he reshaped the Metropolitan Opera and became one of the leaders of New York City's cultural life. From 1950 to 1972, Rudolf Bing ran, arguably, the most renowned opera house in the world. And from 1956 to 1963, Rudolf Bing and I were lovers.

There was a lot of hanky-panky going on in the Met, which was not uncommon in performance groups, but it was carried out in an old-fashioned manner, marked by civility as well as lust. In the opera house, then, as now, tenors had the raciest reputation. In reality, tenors are hampered. Most don't like to have sex before they sing; they believe it affects the voice. In my experience, tenors weren't the true Lotharios. I was warier of baritones and basses—and conductors, too. No question, we ballet girls had to be on our toes when it came to the guys in the company, the ones who were interested in girls, that is. We were naive in some ways, but savvy in others, and, in general, the atmosphere wasn't threatening. If someone wanted to kiss you, OK, you kissed him or you didn't. As far as sleeping together, I don't remember any of

us being forced to do anything she didn't want to do. People had their dalliances, and there wasn't any weight attached to it. I flirted, but when it came down to the wire, I was always a one-man woman, and for seven years, that one man was Rudi Bing. Before now, I have never publicly acknowledged my affair with the Metropolitan Opera's general manager. I only shared my secret with a few close friends who I knew would keep mum. I'm revealing it now because it was a major event in my life. Except for me, there's no one alive who would be affected by the revelation. There's another reason I'm writing about him—Rudolf Bing is a forgotten man, and he deserves better.

During the time we were together, Rudi and I conducted ourselves with decorum for many good reasons, not the least of which was that he was married. He dearly loved his wife, a Russian dancer named Nina Schelemskaya-Schlesnaya. (Now that's what I call a name for a ballerina. You could fit almost three Nancy Kings into one Nina Schelemskaya-Schlesnaya.) She was a lovely person, and yet another of those melancholic Middle-European ladies; gloom lurked in the background. Mrs. Bing wasn't a public persona and was rarely seen outside of major openings at the Met and occasional galas. Rudi was protective of his wife. The last thing he wanted, and the last thing I wanted, was to upset her. Another plus for us, the Bings were Europeans, and in time-honored tradition, a husband frequently had women on the side, often with the wife's knowledge and assumed acceptance. Still, Rudi was as discreet as possible because of his wife's fragility. She always came first for him, and I didn't flaunt or use our relationship to further my career. The few members of the Met company who knew about us respected our privacy and never betrayed us to the media. In all the years Rudi and I were together, to my knowledge, there was only one public leak. "There's a lovely young lady at the Met that Mr. Bing has been paying some attention to," wrote Dorothy Kilgallen in her syndicated newspaper column. No name was attached and no reference to the young lady being a member of the ballet. Thank goodness. Had I

been identified, I couldn't imagine how my parents would have react-ed, or maybe I could, which was worse. At the very least, they'd have disowned me. By the way, I wasn't the first dancer with whom Rudi dallied. Before I arrived on the scene, he'd had brief encounters with two other members of the Met ballet, one of whom he was squiring around during the early stages of our liaison. He had a penchant for dancers. In our case, though, you have to admit that a seven-year run hardly classifies as a trifle.

Let it be noted that I never received special attention inside or outside of the Met because of my affiliation. I made some outside appearances, but those were booked before Rudi and I became an item. One was on *The Ed Sullivan Show*. I was in a scene from Verdi's *Rigoletto* with the great Swedish tenor, Jussi Björling. He sang "La donna e mobile" as I gazed seductively at him. Someone told me it's on YouTube.

The whole Rudi situation was handled the way I wanted it to be han-dled, that is, not to hurt anybody. It was purely and simply a romance. Rudi loved me, and I loved him, in my fashion, which is to say, I never thought of it as a permanent alliance. Marriage was out of the ques-tion. It was understood that he would not divorce his wife, which was fine with me. I admit I enjoyed being admired by an older man, but I didn't want to get married. It was safe being with him, no pressure. If you ask me, that's why a lot of women go with married men. Anyway, how could I marry someone who would change my name to Nancy King Bing? Please. More to the point, Rudi was fifty-one and I was twenty-two with a career as a dancer in an opera ballet company.

So, how did a girl from Tidioute get together with a distinguished gen-tleman from Vienna? Here's how. When I started out at the Met, I was one of many young women dotting the premises. Like everybody else, I saw the general manager around, but I had nothing to do with him. It was, "Hello, Miss King" and "Hello, Mr. Bing" when we passed

each other in the opera house or at parties. He knew my name, but he knew everyone's name. I'd heard rumors that Mr. Bing had companions who were from the company's ranks, but whether he was sleeping with them or not wasn't clear. I don't think he had his eye on me particularly, not at all. The same thing could have happened to anyone who found herself in my situation. Our getting together was by chance, and the chance happened in Philadelphia.

From the company's inception through 1986, touring was an integral part of the Metropolitan Opera's schedule. When I was there, the Met touring company visited cities all over the country, including Cleveland, Boston, Atlanta, Birmingham, Memphis, Dallas, Minneapolis, and Chicago. We even journeyed beyond the border to Montreal and Toronto. After I was gone, the company went overseas to Paris and to opera-crazy Japan. Touring was always fun. We were far from home and whatever happened on tour, stayed on tour. Discretion held sway at home in New York, but on the road, it was a different story. The hotels we occupied recognized that we were a theatrical group, and no one questioned what was going on. I can recall just a single instance where the proverbial item hit the fan. We were at the Curtis Hotel in Minneapolis. My friend, Didi (clearly a pseudonym), another dancer, was going with one of the staff who was married. On this evening, Didi was in his room. Suddenly, hotel security was banging on the door, demanding to be let in. Didi leaped out of the bed and ran into the shower while her friend let in the house detectives. They said her transgression was that she was not registered in that room. It was against the law. Sounds ridiculous today, but it wasn't only happening in Minneapolis. The same kind of law existed in Europe. I remember staying in a Milan hotel where male friends weren't allowed up to my room because they were not related to me. We all knew the law, but the incident in Minneapolis was the only time I can recall anyone enforcing it. The Curtis was a family-run hotel, and I think the hotel management was attempting to prove a point rather than make an arrest. There were plenty of people in the wrong rooms

that night, but they zeroed in on poor Didi. The police weren't called, but she was extricated and escorted to her own room. When Rudolf Bing was informed, he contacted the management.

"We are a theatrical company," he told them. "If you don't understand how we operate and stay out of it, then we're never coming back."

They didn't, and we didn't. It was the last time the Met lodged at the Curtis Hotel. I loved the way Mr. Bing handled the situation.

Another time we were staying at the Stoneleigh Hotel in Dallas. Late one night, a bunch of us (Louellen and I, Rosalind Elias, the young mezzo star, Tommy Schippers, the conductor, and Bobby Bishop, who was a dancer then, but went on to become director of the Museum of American Folk Art) broke into the hotel swimming pool. We were paddling around in the water when the lights were turned on and we were turned out. Schippers joined us for a few Met tours. We all liked him, but there was a flaw. When he conducted Zachary Solov's ballet, *Soiree*, he took an extremely fast tempo, and we were all upset. We wanted him to slow down but didn't know how to approach the subject. Louellen had one of her brainstorms. We took a toe shoe and filled it with nails. We splattered it with blood-red paint and let the paint dry. We put the shoe in a box and sent it to Tommy's dressing room. It was not a subtle message, and he never acknowledged it. He continued to conduct too fast.

On the podium, Thomas Schippers may have been serious, but off it, he was full of mischief. He loved to play intriguing games. In one of them, a person who was *It* was blindfolded. Each of the game's participants had to kiss the blindfolded person, who then had to guess who the smoocher was. It was a variation on spin the bottle, but it wasn't solely boy kissing girl, it could be girl/girl or boy/boy. As though the game wasn't risqué enough, Tommy had another game. He divided everyone into two teams, then one team was sent out of the room. A member of the remaining team got into the bed and was covered with blankets,

exposing only a small part of the body. The first team re-entered the room, went over to the bed, and tried to guess which part of the body was being exposed. It wasn't as easy as one might imagine. In close-up, perfectly respectable creases appeared to be not so respectable. You'd be surprised what an armpit can look like. In today's world, this would be tame stuff, but we thought we were being wild and naughty. We had a lot of innocent fun. There were never any drugs involved, which suited me, since I never had any interest.

Touring thrived while I was at the Met. Among them were mini tours, such as day trips to Philadelphia. Four to six times during the Met season, the company took a train to the City of Brotherly Love and returned after the show. On one of those Philadelphia visits, we performed *La Perichole*. After the opera, Henry McIlhenny gave a party at his home in Rittenhouse Square. What a house and what an art collection—a Van Gogh hanging in the powder room. We were a small group, Cyril Ritchard, the director, Louellen and I, Zachary Solov, Mr. Bing, and a few others. Nobody drank that much, we rarely did, including Rudolf Bing. I never saw him overindulge. All he had was a glass or two of wine, no hard liquor. At the party, everyone got champagne silly, and by the end of the evening, really silly. As we were leaving, Zachary grabbed Louellen and me and hurried us over to Mr. Bing.

"Here, Rudi," he ordered, "Take these ladies in your taxi."

The next thing I knew, we were in a cab on our way to the hotel. Louellen and I were totally giddy, giggling like schoolgirls. When we reached the hotel, Bing took us up to his suite where two queen-size beds stood separated by a night table with a large lamp on it. Neither of us questioned what was going on. We followed our leader's lead. Nothing to be concerned about; after all, there were two of us. Louellen and I staggered to one of the beds, pulled off our dresses, and got under the covers in our undies. The last thing I saw before I conked out was Mr. Bing slipping into the other bed and switching off the light. In the middle of the night, I awoke. Though I fought to stay where I

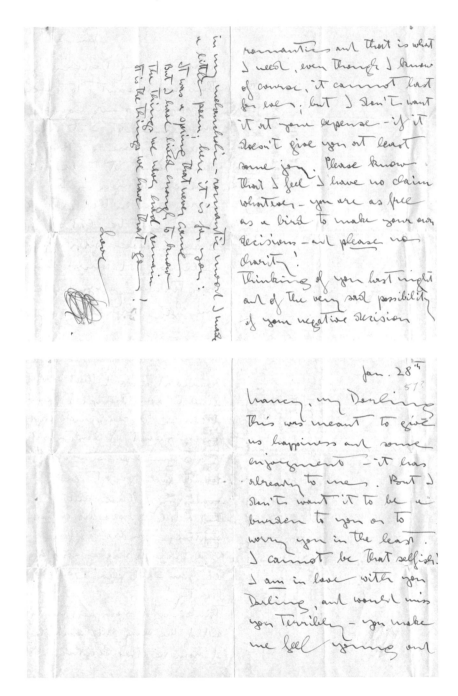

14.2 A letter from Rudi Bing to Nancy

was, Mother Nature would have none of it. I got up and tiptoed to the bathroom and went in. On my way out, I took a quick look in the mirror over the sink, turned out the light, opened the door, and stepped out—right into the arms of the general manager of the Metropolitan Opera. He'd been waiting for me. And that's where it all started, in a suite at the Bellevue-Stratford Hotel in Philadelphia, Pennsylvania.

Louellen slept through the night and was amazed to hear what had occurred when I told her the next day. She was delighted. At the time, Louellen was dating Cesare, but sometimes I wondered if it had been Louellen who had awakened that evening, might she have been the chosen one? Incidentally, Rudolf Bing did not seduce me. The truth is, while I was taken by surprise, I knew what I was doing. I was flattered by his attention. The idea that he desired me was astonishing. He was exciting, smart, funny, handsome, famous, and charming. I didn't know what he saw in me. I was a pretty girl, but all the girls in the ballet were pretty. I became a more interesting person as I matured. I wish I could have known him the way I am now. (Come to think of it, he probably wasn't looking for maturity.) For a while, I wavered about allying myself with Rudi. One of the reasons was my relationship with Richard. "Richard loves me," I wrote in my diary … "and maybe I love him." I loved him but ours wasn't a sexual romance. I didn't want to give up Richard, but I had to if I wanted to be with Rudi. I didn't want to be juggling two men at the same time. Adding to my quandary, I lived in constant fear that somehow my parents would get wind of what I was doing, especially with Rudi. It helped that Richard didn't know anything about Rudi and me. Finally, I told Richard I had to stop seeing him. I didn't see him for weeks. Everything came to a head in the winter of 1957.

The Met was doing a new version of Wagner's *The Ring of the Nibelung*. Herbert Graf, the director, went to see the musical *Peter Pan* on Broadway and was impressed with the way Mary Martin flew effortlessly above the stage while attached to a wire. He got an idea. In

Das Rheingold, the first of the four operas that make up *The Ring*, the curtain rises on three Rhinemaidens swimming in the river and singing. To create the effect, the three maidens were placed in baskets attached to wires. The baskets were hoisted up behind a screen on which the waters of the river were projected.

The effect was OK, but Graf realized that if the maidens were individually strung up a la Mary Martin, it would create a better effect. He consulted with the man doing the rigging for *Peter Pan*, and the Met approved of switching to harnesses. However, having Mary Martin flying around is different from having three opera singers doing the same. Accordingly, three of us from the corps de ballet were chosen to stand in (aloft) for the singers. While the maidens sang on the ground, we three were hitched up to rigs that sent us rising and dipping across the stage, all the while doing air versions of the crawl, breaststroke, and sidestroke.

It happened that Richard was at the *Rheingold* rehearsal because his wife was singing in the production. I was standing in the wings when he came up to me and said he wanted to talk. While his wife was getting ready in her dressing room, he was quietly pressuring me to come back to him. In the middle of our conversation, I was called to the stage and put into the harness. The next thing I knew, I was scooped up to the rafters. I looked down and there was Richard standing in the wings, stage right. Then I swam over to the other side of the stage. I looked down, and standing in the wings, stage left, was Rudolf Bing. For half an hour, while the maidens were singing, I was swinging between the two men in my life, and all I could think was, where is the pendulum going to stop? Who is it going to be? The scene ended. I was lowered onto the stage and unhitched. Rudi had left, but Richard was still there. He came over, handed me a dime, and said,

"Call me when you're ready."

I know he thought that I'd go back to him. I took the dime, but I never used it. My heart was with Rudi.

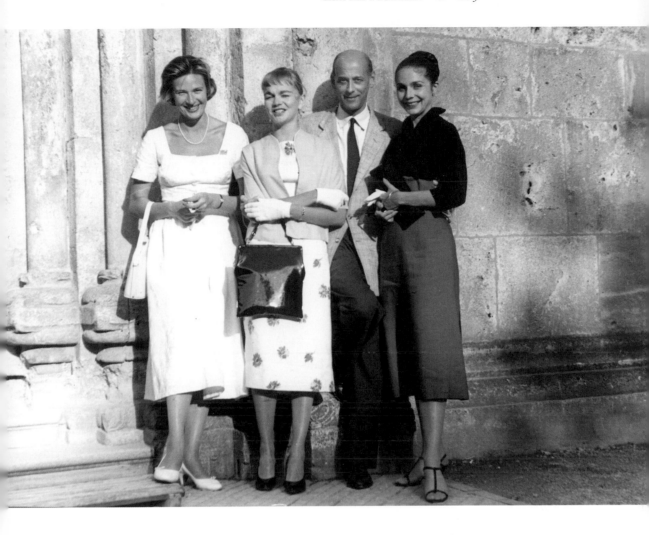

14.3 A friend with Louellen, Rudi Bing, and Nancy in Vienna in 1957

And so it was that I embarked on a love affair. Let me be clear, I was never a kept woman. Rudi never supported me. No man, other than my father and my husband, ever did. I don't think Rudolf Bing would have had a bona fide mistress because a mistress costs money. Rudi was not a big spender. An occasional bouquet of flowers was sent my way, but he wasn't the kind of man who lavished gifts. I already had an admirer who was that kind of man. Richard was generous when it came to tokens of esteem, which were strictly for my company, not for sexual favors. No one ever bought me. I paid my own way, including my rent. My apartment was a lovely, furnished second-floor walk-up, and I lived there for nine years. The rent was $73.58 a month and included fresh linens once a week. I was a few blocks from the Essex House on Central Park South where Rudi lived. He loved my little place, and he loved being there. He'd come over early on Saturday mornings for our trysts, and I had to get him out in time for my point class at 10:30.

The morning after our first night together in Philadelphia, Rudi and I took an early train back to New York. I was thrilled. And I was upset. I couldn't shake the feeling that I was getting into something I might not be able to handle. Bad enough that I was involved with the boss, but he was a married man to boot. Not that he was the first married man I'd gone out with, but those were platonic affairs. It was all too much, and when I got home, I wrote him a letter expressing my concerns that ended, "I don't think I can do this. It doesn't seem right." He responded with a letter of his own. I'm struck by how innocent each of us was. We put everything down on paper throughout our years together. Rudi sent me many letters, especially during the summers when he was in Europe. I'd race to my mailbox every day looking for his correspondence which was filled with expressions of love. After Bill Zeckendorf came into my life, I burned nearly all of Rudi's letters. I'm glad that I saved the one meant to calm me down.

Nancy, my Darling

What we were doing was meant to give us happiness and some enjoyment—it has already to me. But I don't want it to be a burden to you or worry you in the least. I cannot be that selfish! I am in love with you, Darling, and would miss you terribly.

You make me feel young and romantic and that is what I need, even though I know, of course, it cannot last forever; but I don't want it at your expense, if it doesn't give you at least some joy. Please know that I feel I have no claim whatsoever—you are as free as a bird to make your own decisions—and please no charity! Thinking of you last night and of the very real possibility of your negative decision, in my melancholic-romantic mood I wrote a little poem; here it is for you:

It was a spring that never came
But I have lived enough to know
The things we never had remain
It is the things we have that go.

Rudi was persuasive and charming, and I adored him. I allowed myself to believe that it could work. And it did. Of course, I never felt there was anything lecherous about him. If I had said no that first time, he never would have gone any further. Never. Rudi was a gentleman. How I loved being with him. He was fun, such a remarkable contrast from the way the public saw him. He was perceived as dour when in fact he was delicious. One thing, though. He never talked business with me. Maybe because I was his girlfriend and so much younger. He probably thought I wouldn't be interested. However, he did discuss business with his colleagues in my presence. I never spoke, but I listened, and I learned, and by the time I married Bill Zeckendorf, I knew a thing or two.

Our romance continued steadily. We had our Saturday mornings, and we were able to get together on tours. The hotels we stayed in were beehives of after-hours activity, involving many members of the company. Often, especially when I was not performing, I was ghosting. Back then, ghosting meant you weren't paying for a room, but you were staying there with someone. Other times you'd register in a room with another girl or two, but you didn't sleep there. It was for appearances only. You'd take the elevator to your registered room and use the back stairway to go up or down to your trysting quarters on another floor. Party over, you'd reverse the procedure. It was like an aristocratic English country house on a weekend. It was delightful being with Rudi. He was a wonderful conversationalist and could talk about almost anything with knowledge. Amusing and thoughtful at the same time, he was justly celebrated for his acerbic wit, although he said,

"You don't need wit to run an opera house, you need style."

And he had style. Even in the way he dressed. He was perfectly tailored, not a stitch out of place, right up to the bowler hat he always wore to work. His bon mots were quoted in the newspapers. To the general public, he seemed aloof and sardonic, an image he liked to encourage.

"Don't be misled about me," he once said. "Behind this cold, austere, severe exterior, there beats a heart of stone."

His charm was as much in play as his wit. Both were essential in working with singers. He knew how to handle divas. Maria Callas was one of them. As much as I admired her, I knew that Callas could be difficult because you had to get to her through her then-husband. Giovanni Battista Meneghini, a wealthy Italian businessman, twenty-eight years older than his wife, supervised her career. In the early years, before they divorced, she was known as Maria Meneghini Callas, which is how her name appeared on the Met's roster. Rudi didn't relish negotiating with Meneghini. For instance, he was irritated when Meneghini demanded that his wife be paid in cash, which was the custom in Europe. Callas was receiving top fees for performances then, close to $3,000 (nearly

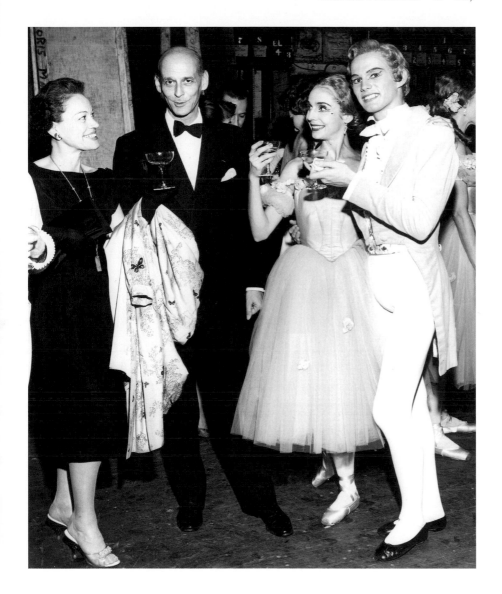

14.4 Matty Gavers, Met ballet mistress, Rudi Bing, Nancy, and Jeremy Blanton

$29,000 today). What did Rudi do? Exactly what her husband asked. When the Meneghinis walked into her dressing room, they found three thousand one-dollar bills neatly stacked around the room. Meneghini never again asked for cash. With a few exceptions, Rudi dealt brilliantly with all his prima donnas. He was especially close to Teresa Stratas. Teresa, a superb artist, was notably quixotic. At one point, she took a break from singing to join Mother Teresa in Calcutta. Rudi and she worked together beautifully. Though he wasn't as close to her, he admired Roberta Peters and jump-started her long and successful career. Roberta was scheduled to make her debut as the Queen of the Night in Mozart's *The Magic Flute*. But when soprano Nadine Conner fell ill, Rudi called Roberta and asked her to step into Donizetti's *Don Pasquale*, on five hours' notice. While she knew the role of Norina, she'd never sung it. She was only twenty years old. Bing convinced her she could do it, and so she did—beautifully. Her debut was a triumph. Both women remained loyal to Rudi all his life. He got along with singers, but there were some with whom he never connected. A redheaded soprano from Brooklyn was one; the other was a mezzo-soprano from the Bronx. He rarely complained to me, but during an exhausting contretemps with the Bronx diva, he groaned,

"It's not easy dealing with that matzo-soprano."

Those two singers, and sometimes Callas, were the exceptions. On a radio broadcast hosted by George Jellinek, Renata Tebaldi expressed the common feelings among artists who performed at the Met during Rudi's reign. Jellinek asked what she thought about Rudolf Bing, and Mme. Tebaldi replied in her delightful mishmash of English and Italian,

"Oh, Mister Bing is the most great manager in the theater. I was too happy to work at the Metropolitan because the discipline then was like a military life. Because you know, many, many people and great names, we work in the same moment, *e come si dice in inglese,* we all are treated the same. *Fantastico.*"

That was one of Rudi's gifts—he treated everyone alike, star or stagehand.

After our initial get-together, I was with Rudi many times on tour, especially on those day trips to Philadelphia. Instead of going back to the city after the show, he'd book a room at the Bellevue-Stratford. Even if I wasn't in the opera, Rudi wanted me to come down and spend the evening with him. I usually did. The opera was over at eleven or so, and restaurants didn't stay open that late in Philadelphia. One exception was a charming Italian taverna Rudi discovered. It was probably a Mafia place, but what did it matter? The ambience was warm and the food was wonderful. I enjoyed having a good dinner. While the rest of the company was on the train heading home, Rudi and I were out on the town. After dinner, we'd go back to the hotel. The next morning, we'd take the train home. Both of us had to get to work. Dining out with Rudi was a particular pleasure for me. We rarely did it in New York. We couldn't risk being seen together. Philadelphia was another story; there, I was the perfect ghost wife.

When the opera season ended, Mrs. Bing went back to Europe about a month ahead of Rudi. They had a place in Italy, in the Dolomites, where they spent their summers. He'd stay in New York and clean up loose ends at the Met. He'd go to a few select cities in Europe to prepare for the next season before he joined her. With his wife out of the picture, I'd sometimes meet him in Milan and Vienna. When I was with him, I would meet people I'd only ever read about. Luminaries of the opera, theater, movies, and concert stage, as well as the occasional politico. On one occasion, Rudi introduced me to the conductor, Herbert von Karajan. Rudi had to do business with him, otherwise he'd never have socialized with von Karajan. The same goes for the soprano Elisabeth Schwarzkopf. Although they both appeared at the Met during his tenure, Rudi knew they were alleged Nazi sympathizers. The night I met von Karajan, I was wearing my Buccellati ring. He took my hand in his and squeezed it so hard that the ring left a deep impression on my finger. It took days to fade. That's what you get for shaking hands with an alleged Nazi sympathizer. Another time in New

York, I was taken backstage to meet the glorious husband and wife acting team, Alfred Lunt and Lynn Fontanne. They were starring in *The Visit* on Broadway. Mr. Lunt greeted me warmly. Ms. Fontanne smiled cordially, looked me over, and said, "Ah, so this is *Miss King*." The way she said my name, I knew she knew whatever there was to know about me.

People knew, and yet they were discreet; nothing was said. As for our appearing in public together, we had a few safeguards. Louellen was one of them. Rudi enjoyed her company. He thought she was funny and often invited her to join us, which she was delighted to do—the classic beard. The three of us would go out on the town. One evening, we walked out of The Plaza Hotel. We were arm in arm with Rudi in the middle. A photographer happened by, recognized the Met's general manager, and took a picture. No alarms went off. There were two ladies, one on either side of him, so it came off as nothing special. I couldn't help thinking it was lucky Louellen was there, otherwise I'd have had some explaining to do back in Tidioute. I didn't realize then how much I depended on the discretion and kindness of others. Aside from Kilgallen's blurb, the only other time I can recall any mention of the two of us together was a brief item in the *Washington Post* about a gala in D.C. The report said that Nancy King, a member of the ballet company, attended the gala, and "Mr. Bing escorted Miss King." They must have put it in for the rhyme.

I didn't flaunt our relationship. I tried to be laid-back and humble, and never pranced around as though I was Mrs. Bing. I never got adverse feedback from the company. They took it for granted that the general manager was going to be with someone and were relieved it was not some tootsie flouncing around on his arm expecting to be deferred to. I kept myself in tight control because I thought it was the right way to act. Exactly as I'd been taught to behave by my parents—though they may not have expected their training applied to these circumstances. I

never nagged Rudi, either. Whatever time we had together, I knew that was the only time he could be with me. It never occurred to me that he could or would leave his wife. Ours was an affair. Yes, if something had happened to her, I probably would have married him, but I wasn't thinking of anything like that. I was going with someone safe, someone who wasn't planning to marry me. I continued to do my best to behave like a lady in an unladylike situation.

We'd been together for five years, and I had never thought seriously about the future. I was satisfied with the present. One Saturday morning, Rudi was on his way out of my apartment when he said,

"Sweetie, I want to talk to you and I hope you'll take it the right way."

From the beginning, Rudi called me Sweetie when we were alone, but never in public. I didn't want to be called Sweetie anywhere, but I let it go. The peculiar thing is, when I hit middle age, I found myself calling everybody Sweetie, and I'm still doing it. I started to speak, but he hushed me and continued.

"I've been thinking a lot about us. About you. You know that I love you and you also know that I can never leave Nina. Eventually I'm going to be leaving the Metropolitan, and Nina and I will be going back to Europe to live. I want to make sure that when it happens, you're OK. I couldn't leave knowing you weren't settled. I think you should start looking for someone, someone who'll take care of you, and you should be looking for someone your own age."

I didn't like hearing this. I'd been living in a comfortable bubble. I had my work and I had my love. The possibility of that changing was chilling. But it started me thinking earnestly about the future for the first time. When Rudi moved on, where would I be? I had friends and admirers, but there was no one I envisioned as a life companion. Who could fill Rudi's place? Except for the age difference and his being married, he was everything I wanted. Now he was talking about leaving and trying to help me get settled. Date eligible young men? Where was I going to find them? Not at work.

And so, it continued. Rudi would return to the same subject. It began to get to me. I didn't say anything to him, but I did speak about it to Larry LeShan, a psychologist whom I saw throughout my years at the Met. Larry and his wife, Eda, were friends of Maritza and Norman. The Morgans introduced me to them. Eda, like Larry, was a prominent author and educator. They were a fascinating couple. Whenever I wanted to talk to someone, I'd see Larry. It was informal, he talked to me as a friend and helped me work my way through some of my life problems. One thing that Larry told me way back then has stayed with me.

"*Shouldn't*," he said, "is a bad word. Don't use it."

For all the time he spent with me, he never charged me a cent. Larry LeShan was another godsend from the Morgans. The Morgan benefits were many. Norman taught me a number of life skills. One was self-hypnosis. That came in handy, not only for personal problems, but with a medical one as well. I got an abscessed tooth that was so painful I couldn't touch my cheek. Rudi sent me to his dentist. During a brief history taking, the fact that I knew self-hypnosis came up. The dentist asked me if I wanted to give hypnosis a try instead of Novocain. I agreed. I remember that he talked to me a bit and asked if I could feel my hand getting numb. I said yes. Then he asked the same about my cheek, which I touched with my hand. I couldn't feel either of them. I sat back in the chair and he drilled right through that abscessed tooth. I didn't feel a thing. That was back in 1955, and ever since I've always been so relaxed in the dentist's chair that I often fall asleep.

Nothing changed between Rudi and me except that Rudi continued to talk about his retirement. He'd stop in the middle of a conversation and announce, "I'm going to leave the Met. I'm going to go to Europe. You have to find somebody so I know you're taken care of." It became increasingly difficult to ignore what he was saying. I didn't need a crystal ball to show me there was no future with him. Rudi kept reminding me of it. And while I still adored him, I was getting older. I knew I needed to think about ending it. Then again, what was the point? Why

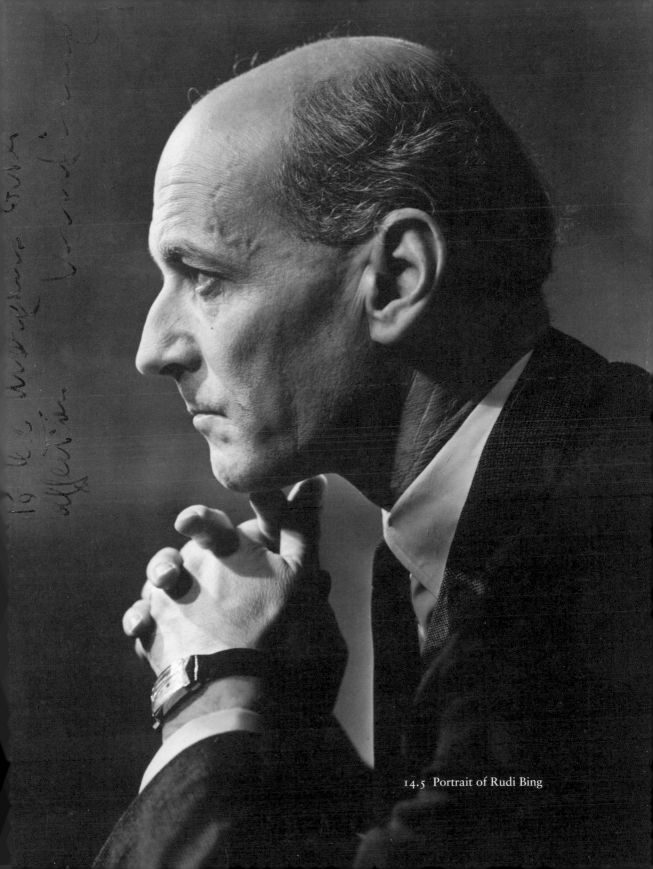

14.5 Portrait of Rudi Bing

not wait it out and see what happened? Despite my apprehension, I would throw my arms around him and assure him that he needn't worry about me, everything would be fine. Whatever the outcome, I'm sure I would have stayed with Rudi—had I not met Bill Zeckendorf.

During the summer of 1962, when I was dancing with the Santa Fe Opera for a second season, Brigitta invited Louellen and me to Bishop's Lodge for lunch. Going there was a special treat. They had a pool, and we could sit there, soak up the sun, and smoke a cigarette or two. We all smoked then because we thought that smoking curbed the appetite. Right. And bran muffins were healthy eating. I didn't smoke much, and I quit when I stopped dancing. At the luncheon, I sat with Irving Kolodin and his wife, Irma. Kolodin, a well-respected music historian and the music critic for the *Saturday Review,* was in Santa Fe to review Stravinsky's *Persephone.* I later learned that Irma Kolodin had previously been married to the real estate entrepreneur William Zeckendorf, with whom she had two children, William Jr. and Susan. The Kolodins were interesting and I enjoyed talking with them. The season ended and I went back to New York. I was rehearsing at the Met when someone from the administrative office came over to me.

"Irving Kolodin called," he said. "He asked you to phone him at this number." He handed me a slip of paper with a number written on it.

I didn't know what to think. I called the number and reached Kolodin. After the hellos, he said,

"My wife would like to talk to you about something. Would you be good enough to call her?"

I said I'd be glad to call her, wrote down her number, and said goodbye. I called Irma when I got home. She began talking about her son, Bill, what a fine person he was and how he was doing such good work—the kind of platitudes a mother heaps on a child when she has a particular objective. I thought she was talking about someone named Bill Kolodin, as I hadn't yet learned who her son's father was. The praises having been sung, she asked if I would like to go to the Bolshoi

Ballet with him. She added that Bill was married, although separated from his wife. I said I'd love to meet him because all the men I meet at the Met are married men on the make and gay guys. Because he was separated from his wife, he was dating a variety of women. Irma wasn't crazy about the variety. After she met me, she decided to introduce us. As I reminded my husband throughout our fifty years together, I was handpicked by his mother.

On our first date, we went with Irma and Irving to the ballet. Irma suggested we go to Sherry's for a drink at intermission. While we were there, both Bill and I excused ourselves and went to make phone calls. During our absence, Irma turned to her husband and said,

"They're both making dates for later."

Not true. I was calling to check on a friend who was staying at my apartment, and Bill had some business to attend to. He always did. I had a great time with Bill Zeckendorf that evening. I liked him. It was not love at first sight. I respected him; I thought his work was exciting. I liked his family. When I think back, my first reaction to him was a feeling that this was someone who needed some help and I wanted to help him. I was nearing the end of my career and ready to settle down. I was looking to marry someone who lived an exciting life and who came from an interesting background. It didn't hurt that Bill appeared to be solid financially. I wouldn't hold that against anyone. Nor would I go after someone just because of it. All of the men I dated during my halcyon days were men of means, but they were also interesting and stimulating to be with, just like Bill. The difference? He was eligible.

When Bill took me home that evening, I was tired and wanted to get to bed. I was so relieved that he didn't ask to come in for a nightcap that I gave him a spontaneous kiss on the cheek. Most guys always wanted to come in, with or without an invitation, and you had to use pat, but polite, rebuffs. Bill never asked. It was refreshing to be with someone who didn't try to come on to me. I thanked him for the evening and said

goodnight. That was our first date. Not long after, we saw each other again. It took a while for Bill to get used to me. I was different from the women he was seeing; I was a working girl. He told his friends he thought I was a nun because I wore all black and my hair was in a tight bun. I did have a rather nun-like devotion to my work. But it didn't deter him and soon we were dating. I must be honest, I wasn't madly in love with Bill Zeckendorf, but I liked him, and Rudi had advised me to seek other relationships. After my fourth or fifth date with Bill, I told Rudi I was seeing someone. Rudi acted unimpressed and said,

"Have fun, Sweetie."

Bill and I continued to see each other and the more we did, the more shared interests we discovered. One thing led to another and eventually we consummated our relationship. When that happened, I knew I could no longer see Rudi. Even though I wasn't thinking of marriage with either of them, I was never inclined to have two things going at the same time.

I wasn't prepared for what happened when I told Rudi that I was seriously dating another man. He was stunned. The man who wanted to see me settled with someone else went berserk. I don't know how much of it was true or merely melodrama, but he claimed that he went down to Greenwich Village, bought drugs, and planned to kill himself. He sent me a black orchid with a note explaining that black orchids represented death. And he told me he'd had a heart attack. He begged me not to leave him. He was desperate and would have said anything. I felt terrible, but, at the same time, I couldn't help thinking he was behaving like a character out of a verismo opera. Eventually, reason prevailed. He pulled himself together, calmed down, and accepted my decision. Rudi truly was a gentleman. While we remained friends, we were never again intimate. I didn't tell Bill about Rudi and me at first, but I didn't want him to hear about it from anyone else. In due course, I informed him. I had to. Bill accepted it, though I don't think he was thrilled. After my marriage, I'd meet Rudi for lunch a few times a year.

The conversation was always interesting, but now we were old friends talking to each other about our separate lives rather than sharing a passionate one together.

I wish I could say that we all lived happily ever after, but we didn't, especially Rudi. Things hadn't been going well financially for the Metropolitan Opera for several years. Even so, in 1971, he was knighted by Queen Elizabeth. Sir Rudolph Bing—it suited him. In 1972, he announced his retirement. When the time came for Rudi to step down, he turned the company over to the new general manager, Göran Gentele, a Swedish actor, opera director, and manager. Everything went smoothly. On his last day at the Met, Sir Rudolf Bing said goodbye to his staff, put on his coat and hat, and walked out the door. He never wore his bowler again. He gave the hat to me. It's in my closet.

After he left the Met, Rudi remained physically and mentally fit. He was pleased to be relieved of all the pressures. Still, he wanted to do something; he needed to do something. He thought he could do a good job managing a hotel, the Navarro, for instance, and asked me to speak to Bill about it. Bill owned a few hotels; the Navarro was one of them. Bill wrote a letter to Rudi which gently disabused him of the idea that being the general manager of an opera house was proper training for managing a hotel. Rudi was disappointed, but accepted Bill's assessment. Meanwhile, Göran Gentele had taken his wife and children on a vacation in Sardinia before his tenure at the Met began. It was a tragedy when he and two of his children were killed in an automobile accident shortly before their scheduled departure from Italy. A frantic search for a replacement began at the Met. Rudi contacted the board and offered to step in until they found someone. His offer was refused. They felt that bringing him in would be a backward step; they wanted someone new. Rudi was deeply hurt. He wasn't trying to make a comeback—he was trying to help the institution that was his home for twenty-two years. I thought then and I still think the Met behaved shabbily.

Despite his avowed plan, Rudi never returned to Europe. He and Nina stayed on in New York City in their Essex House suite. For a while, he taught at Brooklyn College, but realized quickly that he was not cut out to be a teacher. He also worked at Columbia Artists Management and found that more suitable. He even appeared on the operatic stage in a non-singing role in a production of Henze's *The Young Lord* at the New York City Opera. In the decade after he retired, he published two autobiographies, *5000 Nights at the Opera* (1972) and *A Knight at the Opera* (1981). After that, he faded from the public eye. At the same time, his mind was also fading. When Nina Bing died of a stroke in 1983, Rudi was lost. He wandered aimlessly in the streets around Lincoln Center. On one occasion, he tried to enter the executive offices of the Metropolitan Opera House. He was turned away. He fell into the clutches of a lunatic woman who'd been in and out of psychiatric hospitals and married three times to much older men. Rudi was bamboozled. The tabloids were full of stories about their benighted romance, and on January 9, 1987, his birthday, he married her. He was eighty-five, she was forty-seven. She proceeded to drag him from Florida to Anguilla and on to England and Scotland. Everywhere they went, the headlines were sure to follow. He had never made a lot of money (general managers didn't in those days), but he had set aside enough to live comfortably. His maniac wife ran through most of it. Sheer madness reigned, and heaven knows where it would have ended had not a few stalwart friends and his lawyer stepped in. The lawyer determined that an annulment was the only way to get rid of the deranged woman. The case was brought before the New York State Supreme Court in September of 1989. A medical expert testified. The judge ruled that "Sir Rudolf Bing, as a result of the degenerative nature of his disease (Alzheimer's), lacked the mental capacity to enter into a marriage," and the marriage was annulled.

Rudi was transported from his suite in the Essex House, his home for nearly four decades, and admitted to the Hebrew Home for the Aged

in Riverdale, New York. It was a good place for him. When you think of all the horror stories about old folks' homes, he lucked out. The staff was kind and attentive and the premises were clean and neat. He had his own small room which was sparsely furnished with a bed, a night table, a chair, and a little refrigerator. Utilitarian, but that's all he needed. His visitors' list was limited, and if you weren't on it, you had to get permission to see him. I'm sure this was done to block his ex-wife. As far as I know, I was one of a few people who had carte blanche visiting rights, including Teresa Stratas, Roberta Peters, and Lolita San Miguel, a former dancer with the Met. Roberta's mother was a resident at the home, so she was there often. Skiles Fairlie, another Met Ballet member, lived nearby. She and her husband would have him over for dinner. I came to visit every few months. Bill used to have his chauffeur drive me up there, which was a blessing; it was a schlep to get there by public transportation. Whenever I went to see him, I'd go to a deli and buy a half-pound of good, sliced ham. He really loved ham. Rudi always knew who I was and greeted me by name at the door. "Hello, Nancy," he'd say when I arrived. I'd give him the ham, and he'd put it in the little fridge. Then he'd turn and go sit on the edge of his bed. I'd pull up the chair and sit opposite him. He would light up a cigarette. He'd puff on it for a while and put it out. A few minutes later, he'd do the same thing again. He didn't seem to realize he'd already had a cigarette. There was no point in telling him not to. While I was there, I had to talk *to* him, rather than *with* him. It was hard, but that's what you do with people who can't hold a lucid conversation. Physically, he was thin and pale, but that's the way he'd always been. Mentally, he was shot. He had no memory of the Met. It was hard being with someone who had been so vital, so intelligent, so civilized, now reduced to this sad, sweet, dazed old man who didn't know what was going on.

For eight years, Rudi lived a clouded but comfortable life. On September 2, 1997, he died in St. Joseph's Hospital where he'd been transferred a few days earlier. There were no funeral plans. One of the nurses

at the home who was fond of him took over. She arranged for a service at a Catholic church that she attended in nearby Yonkers. I don't think it would have mattered to Rudi. Like me, he wasn't religious. I was among a handful of people that included Herman Krawitz, Teresa, and Roberta at the church to celebrate his life. The ceremony was short—a brief excerpt from the mass after which Teresa sang a song that she and Rudi used to sing together. It's so unlike me, but I cannot remember what the song was. Following the service, Rudi was buried in Woodlawn Cemetery in the Bronx.

For twenty-two years, Rudolf Bing ran the Metropolitan Opera brilliantly and kindly. Except for a few singers, who had their own axes to grind, no one ever said he wasn't a good man. He was a constant presence in the house. It wasn't just his job, it was his joy. The great mezzo Marilyn Horne made her Met debut in 1970 in Bellini's *Norma* singing opposite Joan Sutherland. She tells the following story in her book, *Marilyn Horne: The Song Continues.*

> Dress rehearsal came and, as usual, could have been called dress bedlam. After my final exit, knowing that this would be my opportunity to hear Joan in full regalia, I slipped out into the audience to watch the last act. As I stood on the side of the orchestra in the darkened hall, someone came and stood behind me but I was too involved with listening to acknowledge anyone. At the end of Norma's pleas to her father, I was so moved I said aloud, "My God, sometimes I forget how fantastic she is!"
>
> "You're not so bad yourself, Miss Horne," said the person behind me. I turned and found myself face-to-face with Rudolf Bing.

Yes, that was Rudi, polite, bright, charming, a real gentleman, and funny. And probably the last genuine impresario to run the Met.

In 1960, Frederick A. Praeger published *The Magic of the Opera*, a photographic memoir of the Metropolitan Opera House. Rudi gave me a copy as a Christmas present. He had placed a marker toward the middle of the book. It was a double-page photograph of a scene from *Don Giovanni*. In the photo, Cesare Siepi was seated at a banquet table, and I was standing next to him. I found this inscription on the frontispiece,

To a delightful dancer, Nancy King,
Remembering happy years together at the old Met.
Rudi Bing

I remember, dear Rudi. I remember.

❈

Chapter Fifteen

O N THURSDAY, OCTOBER 24, 1963, at the Hotel Astor in the Times Square area of New York City, I married William Zeckendorf Jr. The best man was his father, William Zeckendorf Sr., who owned the Hotel Astor. Louellen couldn't attend the rehearsal so Sally Brayley, another member of the ballet corps, was my maid of honor. The ceremony was small; the reception was big—two hundred and fifty guests. I'd asked the entire ballet company, and many of them were there. We also invited the staff from Bill's office. Maritza, Norman, and Penny were there and Zachary Solov, Alexandra Danilova, Alicia Markova, Louellen and Cesare, and Tudor. Tudor came for the ceremony but skipped the party. My aunt, Lois McClosky, food editor for the *Philadelphia Inquirer*, was there, too. Unlike my mother, my aunt had pursued a career. She had also been helpful with mine. When *The Girl in Pink Tights* had a pre-Broadway stint in Philadelphia, she arranged for an article about me to appear in the magazine section. My sister Harriet's ex-husband was there; my sister wasn't. My godmother, Marie Karg Hilgeman, a deeply devout Catholic, marched up to me and said, "Wouldn't have missed this for the world." And, though Mr. and Mrs. George Bernard

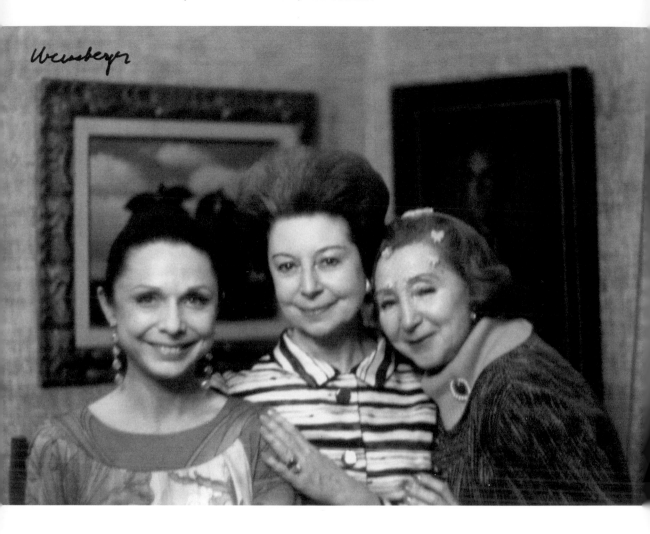

15.1 Nancy, Dame Alicia Markova, and Alexandra Danilova

King had requested the pleasure of everyone's company on the invitation, my mother and father were sitting it out in Tidioute. In their absence, I was given in marriage by my brother, Jim. Jim and his wife Helen were the only members of my immediate family in attendance. Nard would have been uncomfortable at such a gathering; Harriet was in Florida. As for my mother and father, along with my brother Joe, they had received their orders from a higher power. Once Bill and I had decided to marry, Bill had insisted on going to Tidioute to ask for my hand formally. My parents liked him, but he was a divorced man and wasn't a Catholic. They met with their priest to see what they were supposed to do, given that I was going to marry a divorced man who happened to be Jewish. The priest told them what they couldn't do, namely, attend my wedding. I felt bad for Bill that my parents wouldn't come. He'd gone out of his way to make things as right as possible. He tried to get a priest to marry us because he thought it would make them happy. When he couldn't find a priest who'd do it, he tried to find a Catholic judge, but he couldn't get one of them either. In the end, we were married by a Jewish Justice of the New York Supreme Court, a friend of Bill Sr. Bill's being a non-practicing Jew and my being a totally lapsed Catholic never proved an issue in our married life. We had problems, but they were never about religion.

We honeymooned in France, starting with Paris and then on to the Champagne wine region where we had a private dinner with the Taittinger family, friends of Bill Sr. My father-in-law liked Champagne and, through the years, had purchased many bottles from Maxim's—for a dollar each. We went from the Champagne region to Burgundy, home to the Zeckendorfs' wine of choice. Bill grew up drinking great Burgundy wines because his father favored them. Bill Sr. visited the vineyards in Burgundy in the 1920s and became a devotee. He bought from many Burgundian vintners, but he was especially fond of Bernard Grivelet. Grivelet owned a small estate, and Bill Sr. purchased hundreds of bottles from him. During World War II, Grivelet provided

the Nazi occupiers with wine and was denounced as a collaborator. He somehow managed to stage a comeback and thrived until 1979 when he was indicted for labeling ordinary red wines with famous names, such as Chambolle-Musigny and Chambertin, and flooding the American market with them. My father-in-law didn't live to see that day. During our honeymoon, Bill and I were wined and dined by some of the best wine producers in the world. Because of my husband, I became a Burgundy person, too. Bill held the top position as Grand Sénéchal of the Tastevin Society in New York for many years. Although I still belong to an informal Burgundy wine tasting group, when I dine at home, I'm happy with a glass of rosé. I don't deal with vintners; I buy my rosé from Trader Joe's.

The honeymoon was great. I returned to New York and to a new life. I was no longer a working girl. I had become a society matron. The girl from Tidioute, previously involved with a distinguished gentleman from Vienna, now found herself allied with the scion of a legendary real estate dynasty. I'd honored my adolescent vow. I did not marry someone I went to school with, nor did I settle into a nice, little house. Not by a long shot. As far as my family and the people of Tidioute were concerned, the man I had married could have come from another planet. My English and Scandinavian ancestors were stolid; Bill's forebears were fascinatingly different. In the mid-nineteenth century, the Zeckendorfs had emigrated from Germany with a half a dozen other German-Jewish families, all of whom went west. The Zeckendorfs settled first in Santa Fe, then moved to Tucson, Arizona. Bill's great-grandfather became a merchant like other Jewish settlers who came to America. By the time Bill's father, Bill Sr., was born in 1905, the family was living in Paris, Illinois. Not long after, they moved to Long Island, New York, where Bill Sr. was raised. A maverick from day one, he grew bored with high school, went to Clark's School for Concentration, completed sixteen Regents' exams in one week and entered New York University at seventeen. "The social life was pleasant,

but classes were dull and a waste of time," he wrote. "Anxious to be in the real world of business." He left college in his junior year and went to work for his uncle, Sam Borchard, an important New York real estate investor and builder. William Zeckendorf's career was launched.

My husband was born (October 31, 1929) and bred in Manhattan and he loved the city. Why wouldn't he? His father and he, and later, his sons, helped change the face of it. Bill was proud of being "born into the trade." Toward the end of his life, when my husband was living in crushing pain unrelieved by a series of surgeries on his back, he wrote his autobiography, *Developing My Life,* which was published posthumously. In the introduction, Bill wrote,

> In his heyday, my father, William Zeckendorf Sr., was the most famous and successful developer in America—a larger-than-life presence who reshaped the skyline from one coast to the other.

Granted those words came from a son speaking of his father, yet it's not an overstatement. Others were of the same opinion. According to Le Corbusier, one of the founders of modern architecture, "William Zeckendorf did more for American architecture than anyone else." And I.M. Pei, another design genius, got his start as Bill Sr.'s in-house architect. He designed his employer's office, a "windowless teakwood igloo set in a white marble lobby." Asked to explain the bizarre setting for his employer, Pei rationalized, "It would be ridiculous to create any environment for him other than one consisting exclusively of himself." Outside his spartan, igloo office, Bill's father loved to be among people, especially beautiful women. Appearances were everything to him, and he had good taste. He was married four times. Irma was his first wife and the mother of his children, Bill Jr. and Susan. He was married to his second wife, Marion, when I met him. After she died, Bill Sr. remarried twice.

William Zeckendorf Sr. was a colossus, a smart, flamboyant, exuberant, charming wheeler-dealer and that made him a tough act to

follow. Except for the shared love of their profession, the two Bills could not have been more unlike. Bill Sr. was an extrovert while Bill Jr. was an introvert. By his own admission, my husband was never the showman his father was. It wasn't in his nature. And yet nothing thrilled him more than making a deal, and in the 1980s, at the height of his career, Bill Zeckendorf Jr. was the busiest developer in New York. Our good friend, Herbert Kasper, the American clothes designer, knew both Bills and saw them clearly. According to Kasper,

> Bill Jr. learned from a master. William Zeckendorf Sr. was a genius in his field. I always thought of Bill as the silent one. I felt he was overwhelmed by his father. But Bill had a lot on the ball and really came into his own after Bill Sr. was gone.

How right he was. From my vantage point, I saw how the two Bills interacted, and most of the time it was a roller-coaster ride for my husband. Bill and his father were close, but there was a manic side to Bill Sr., and it worsened as he grew older. He'd hatch a brilliant plan and Bill would go about raising the money. Once the money was in hand, Bill would turn it over to his father who, as the years passed, would just as likely take the cash and buy a yacht or private jet instead of putting the money into the project. Bill would go berserk when he discovered that his father had squandered the funds, then turn around and attempt to raise them again. Oddly, Bill Sr. never tried to hide what he'd done. On the contrary, he'd call Bill to come over and see his newly acquired limo, yacht, or jet. The ups and downs of working with his father were never-ending. The pattern was set from the beginning.

You have to have nerves of steel to be in the development business. It's the very definition of razzle-dazzle. You're always looking for money to get the banks to back you, and you do that by gathering investors to parade before the bankers. Generally speaking, when big deals are being made, developers try to protect themselves by not making

personal guarantees. That way, if things go bust, their money is safe. The Zeckendorfs had a different ethic. As opposite as they were in personality, Bill and his father shared a trait that shaped both their destinies: each personally guaranteed his loans. If a deal went sour, they were obliged to use their own money to pay back investors. As a result, their own pocketbooks were vulnerable. They could go from fabulously wealthy to millions of dollars in debt in the blink of an eye. That's how Bill Jr. was raised, and it isn't surprising that he had a rough childhood.

After their parents divorced, Bill and his sister lived with their mother in a walk-up apartment on the West Side and moved to more spacious quarters in the neighborhood later. Irma married Irving Kolodin soon after the split with Bill Sr. It wasn't a particularly happy marriage with Irving, and she was depressed a good deal of the time. She didn't want to go through another divorce, though, and stuck it out. Things improved, and they lived together without rancor. She made it work because that's what you did back then. Irving wasn't cut out to be a stepfather. He was aloof, and Bill grew up hating him. After Bill and I married, they came to respect each other. Emotionally, Bill was a starving child. His mother didn't provide the solace he needed nor did his father pick up the slack. Bill Sr. wrote that he tried to see his children at least once a day and that they stayed with him during the summers. He may have tried to see them daily, but how successful he was is open to question. There was a slapdash quality to their visits, evidenced by an excerpt from *Zeckendorf*, Bill Sr.'s book:

> Thanks to Depression prices, I picked up a thirty-foot, gaff-rigged sloop for one thousand dollars. It was a beamy comfortable boat, with hospitable below-deck space, which we moored at a club on Long Island Sound. One summer we lived in the clubhouse, the next we rented a nearby apartment. I kept the children in good private schools but my road to affluence was

erratic. I was often in debt, sometimes little more than two jumps ahead of the sheriff and forever scrambling for some way to turn an extra dollar.

Bill attended Collegiate on the Upper West Side and lived in fear that his tuition would not be paid. At thirteen, he was sent to Lawrenceville School in New Jersey, where he spent a miserable first year. Scholastically, he scraped by; socially, he did worse. Lawrenceville provided his first encounter with anti-Semitism. Lumped together with the few other Jewish boys in the school, he was jeered and taunted. At the end of the school year, Bill realized he could be miserable for three more years or he could get involved in student life. He chose the latter and joined the drama society and worked backstage. Then he signed on with the school newspaper and the yearbook and, in time, he was running every organization he joined. Eventually, he was given a nickname—they called him the Boss. Bill summed up his Lawrenceville experience in his book:

> Transforming myself from a lonely outsider to the Boss was a lesson in turning a bad situation to my advantage that would prove useful throughout my career.

Our courtship went on for a year, and it wasn't exactly warm and fuzzy. I saw from the start that Bill was troubled. When he was good, he was very good—thoughtful and intelligent with a sly humor. When he was bad, he was depressed and not easy to be with. I realized that he needed someone to look out for him. I enjoyed his company, I was interested in what he did, and I truly wanted to help him. The subject of marriage didn't come up. We traveled to Europe in July 1963 and met an English financier named Charles Clore while in Ischia, Italy. At a dinner party, Clore stood up and announced to all that I was going to be the next Mrs. William Zeckendorf. I don't know where he got the idea, but there was nothing I could do but laugh. Later that evening,

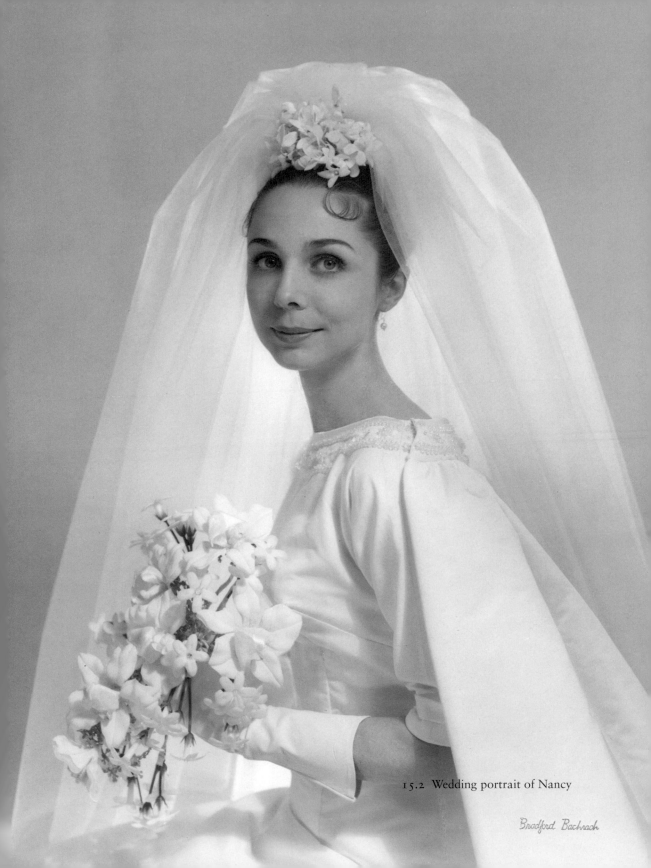

15.2 Wedding portrait of Nancy

Bradford Bachrach

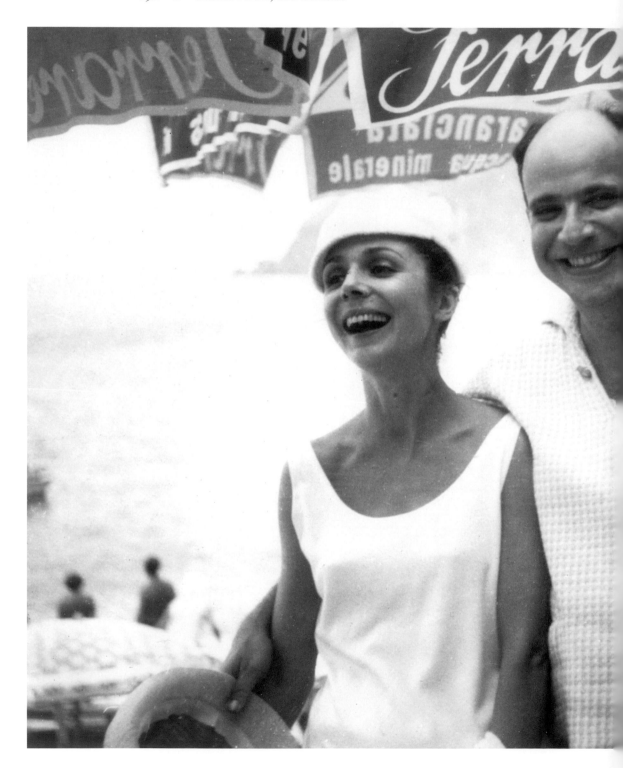

15.3 Nancy and Bill at Ischia, Italy

Bill asked me to marry him, and I said yes. When we returned to New York, he did a one-eighty and said flatly, "I can't do this." I was floored. For the rest of the summer, I saw other guys. I dated John Loeb, a fine man, but I was trying to make Bill jealous. Meanwhile, Bill was seeing others, too, particularly Iris Love, whose company he enjoyed. Iris was an archeologist and famous for discovering a temple to Aphrodite in Knidos, a Greek city in modern-day Turkey. That was the scenario. Who knows what might have happened had not two things occurred? Bill was interested in Iris, but he must have realized that she wasn't the marrying kind, as she was always surrounded by women. (Iris later became the long-term companion of Liz Smith, the popular newspaper columnist.) Nevertheless, when we broke up, he went to see her on some Greek island. He told her what had happened, and she said,

"Go home and marry Nancy."

At the same time Iris Love was dispensing advice, Irma Kolodin called me and begged me to speak with her son. I agreed. When Bill returned from Greece, he called and invited me out to dinner. I said yes. During dinner, we chatted, and after dessert, he said,

"OK, let's get married." I said yes again. To toast our engagement, he ordered a great bottle of Burgundy. The next day, I went to see Alicia Markova at the Metropolitan Opera House. I told her I was leaving to get married. She was sweet and understanding. And it was done.

I think that the stalls in our courtship had a lot to do with Bill's first marriage; he behaved in a once bitten, twice shy manner. Although his first marriage augured success, it failed. No one had been happier than his father when Bill married Guri Lie, the daughter of the first Secretary-General of the United Nations, Norway's Trygve Lie. Why wouldn't Bill Sr. be elated? He put together the parcel on which the United Nations rose. Bill and Guri were good people but ill-suited. Among other traits, each was disposed to melancholy and needed bolstering. They stayed together for three years, but it was not meant to be. Their divorce was civil and without animosity between them

or between Guri and me. One thing made it easier for the two of us to get along. Early on Bill and I had discussed the prospect of having children. Since he already had two sons—Arthur and William (Will)—with Guri, we decided not to have children of our own. I confess I was relieved that he was satisfied with the existing state of affairs. If he'd wanted kids, I'd have had them. But he didn't, nor did I, and neither of us ever regretted our decision. Bill and Guri were united in their efforts to make things comfortable for their boys. There was none of the dreadful push and pull that many divorced couples put their children through. After his divorce from Guri, Bill lived in a Manhattan hotel during the week and in his country home in Mt. Kisco on weekends. It was a pre-Revolutionary house, definitely not to my architectural taste. But Bill loved the place and all the male comfort it offered. During their growing-up years, Arthur and Will lived with their mother but were with us on weekends. We'd pick them up on Fridays, take them to Mt. Kisco, and deliver them back on Sundays. I'd play with them in the daytime and read them bedtime stories at night. I didn't have to cook because, lucky for them, we had help. I got along with the boys. Guri would call to check on them, asking me to see that they'd eaten properly or had gone to bed on time. I appreciated that she thought of me as an ally. Someone once said I should have been more of an Auntie Mame to my stepsons. Maybe I should have been, but it wasn't my role to play. I tried to be a good stepmother; I hope I succeeded.

※

Chapter Sixteen

ABOUT SIX MONTHS BEFORE I began seeing Bill, I had left 253 West 55th Street and moved into a larger place on West 72nd Street. It was hard saying goodbye to my little nest, but it was time to move on. It held many sweet memories but too little space. During the time Bill and I were dating and after we got engaged, he lived at the Gotham Hotel. While there, he was approached by Jeffrey Leeds, a young man who wanted to open a disco in the basement of the hotel. Bill thought it was a good idea and backed him. They opened L'Interdit, which we went to practically every night. Not because I wanted to, believe me. I hated the noise and the awful, loud music. It wasn't my scene, but it was part of Bill's business world and I felt duty bound to be there. Many nights I'd end up hiding in the ladies' room, crying.

My West 72nd Street apartment was fine for Nancy King, but not enough for the soon-to-be Mr. and Mrs. William Zeckendorf Jr. Soon we were apartment hunting. We found a place at 30 East 72nd Street right off Madison Avenue in a building Bill's father owned. We took it because it was what we could afford. It was spacious, and I fixed it

up nicely, but it was on the second floor and there wasn't much light. I would have welcomed a little sunshine in my life during the few years we were there. While the apartment was being renovated, Bill and I lived in the Drake Hotel. Jeffrey Leeds, the young man who'd had the idea for L'Interdit, wanted to open a discotheque in the Drake, and again asked Bill for backing. Bill agreed, and they created Shepheards. Bill had two nightclubs in New York before he ever put up a building.

In the early days of matrimony, my life fell into a routine. Monday through Friday we were in the city. I went to ballet classes in various studios around town because I was no longer professionally dancing and didn't need the strict supervision of a specific teacher. In the evenings, we went to dinner and the ballet, the opera, or the theater. Except for the dance classes, time weighed heavily during the day. After the breakneck pace of my earlier years, it was difficult to adjust to a life bent towards leisure. Bill was busy all the time, but I wasn't cut out to be the little woman waiting for my husband to come home. Bill's safety valve was his country home. He could unwind there, ride horseback, blast Beethoven on his Bose speakers, swim in the pool, or sit on the porch and relax with a good book. I knew the constant pressure he was under and the kind of solace Mt. Kisco offered him. So, I went along with it. When we had some cash, I redid the kitchen and set up a little studio with a barre in it. No matter what I did, I never warmed to the place. Like most country houses, Bill's retreat had a name. It was called Spilling Pond.

In addition to my ballet classes, there was another constant that helped me get through the early years—the need to keep my houses in order. Both our apartment and Spilling Pond were shipshape. Give me free time and I'll start organizing whatever is at hand. I fuss inordinately over my closet, and I find it deeply therapeutic. I have enjoyed clothes my whole life and have been fortunate enough to wear couture clothing most of my married life. What few realize is that I never

paid couture prices for my wardrobe. Back in the days when I had to have ball gowns for opening nights, galas, and benefits, I learned how to shop at the fashion houses. The person who taught me was Bill's stepmother, Marion. As the wife of William Zeckendorf Sr., it was de rigueur to buy her wardrobe from designers in Paris. One time I stayed with her in Paris for a few days and she took me to Balenciaga. I was wearing a pink knit minidress that I bought at S. Klein On-the-Square for ten bucks. The staff at Balenciaga was admiring my $10 dress and telling Marion I had great style. I may have had great style, but I didn't have great money, not enough to buy couture dresses. Or so I thought. Marion taught me otherwise.

"Come back tomorrow, Nancy, and when you do, tell them you want to see the models' dresses downstairs."

The next day I returned and followed Marion's instructions. I was taken downstairs and shown dresses that were made for the models, dresses that sold for thousands of dollars in stores. In Balenciaga's basement they cost one hundred dollars each. I bought three of them that first trip and, for a while, I returned to Paris every year to replenish my wardrobe. The money I saved more than paid for my trips. Thanks to my step-mother-in-law, I was able to assemble a distinctive wardrobe. I'm wearing couture clothes in the society page photos that chronicle my public life. I've let much of the clothing go, but I've kept some of the classics, Balenciaga, Givenchy, and Lanvin from Paris, and Pauline Trigère, an American designer born in Paris. I met Pauline through Lewis Ufland, her publicist. Pauline became a good friend of mine and Bill's. She'd left her native France before the Nazi occupation and was on her way to South America, passing through New York. Adele Simpson, a noted American designer, convinced her she'd be better off staying in the United States. Pauline took Simpson's advice, settled in New York and, after working at a couple of ateliers, struck out on her own. She launched her first collection, eleven dresses, in 1942. She went on to become an award-winning couturiere. The workmanship on her clothing was equal to the clothes I brought back

from Paris. In those days, the top designers were architects of clothing. I look at the fashions in magazines today and wonder who wears these outfits? Look at the parade of costumes that throng the Metropolitan Museum's gala opening each year. It's a ridiculous reality show, in which all you have to do is dress outrageously. I can only imagine what Pauline would have to say. Pauline's styles were elegant. I loved her clothes and I adored her. She was delightful company, a sharp-witted conversationalist with a never-ending repertoire of bawdy jokes. I once read that you should never tell a joke in a book because most people will know it and the rest won't get it. I'm willing to take the chance because Pauline told a joke that never fails to amuse me.

> Two cannibals on a desert island are starving when they come upon a shipwrecked sailor and quickly dispatch him. They boil him up and are busily eating when the first cannibal looks up and asks, "How are you doing?" "I'm having a ball," replies the second cannibal. "Slow down," says the first cannibal, "you're eating too fast."

Speaking of dining, and getting back to the early days of my marriage, I always enjoyed a good meal, but I never had any interest in cooking one. I was interested in food when I was dancing because I had to be vigilant while visions of ice cream danced in my head. I was very interested in food when Bill and I ate our way through France. I'm not as interested now. Today, I eat to live. I make a tuna fish sandwich or salad for lunch and sometimes I forget to have dinner. The best food I ever had was during our Mt. Kisco weekends. Ed Giobbi, an artist and cookbook author, was our neighbor and friend. Ed was a fabulous chef. He taught me how to make a couple of dishes—poached chicken and a cold pasta—and they were almost all I ever cooked. It isn't surprising that Bill and I dined out a lot. He would get lost in the wine list, and I'd spend most of the time trying to drum up conversation. When we were at home, sometimes he barely said a word. I knew the pressure

he was under at work and did what I could to make life easier for him, but he could be so withdrawn. Worse, there were times when he would lash out for no reason. I couldn't get over the fact that this successful man was also insecure and full of doubts about himself. At first, his fortunes were tied to his father's, but Bill would put his own mark on the New York City landscape. His achievements seemingly gave him little solace. He was a kind, good person, but his behavior sometimes made me miserable.

Around Christmas, Bill didn't come home until late one evening. I didn't know where he was. Later, I found out that he was dining with Iris Love. I knew they weren't having an affair—but the idea that he was spending time with her and not even telling me was upsetting. I was agitated and went to Beekman Place to speak to Marion Zeckendorf. She listened and advised me not to say anything, which wasn't surprising since that's what she did with Bill Sr. I didn't take her advice. I confronted Bill, who admitted he had been out with Iris. I was so angry that I walked out and spent the night at the Barbizon Hotel. The next morning, I got on a plane and flew home to my parents for a few days. I needed to cool down. They must have realized something was going on but, no surprise, they didn't say a word. Today, spouses are more independent in their marriages. In those days, you did everything together as husband and wife. Bill had broken the rules.

My marriage was rough going for two decades, but I was lucky enough to have escape valves. One that I relied on came from Brigitta. She always talked about her visits to Ischia, an island off the coast of Italy, where she took mud baths. She felt they restored her.

"For two hours afterwards, you feel the heat going out of your body," she explained.

I needed restoring, so I flew off to Ischia and the Regina Isabella hotel. What a heavenly place. A hotel with the aura of a sanitorium offering all sorts of healthy activities and treatments. The mud baths

were as calming as Brigitta had promised. I became a convert. For years, I went to Ischia and took the baths. Getting away and being coddled restored my soul, preserved my sanity, and helped me deal with my life at home. Bill didn't like me to leave but he'd let me go to Ischia. Along with the Ischia mud baths, my other salvation was going to ballet classes. Still, I was miserable for twenty years. I stayed because there were two Bills. I loved one of them, and the other was ill. I also did it because I was a dancer and accustomed to making things work. The contretemps over Iris, however, was a wake-up call. It was obvious I needed to be involved in something other than being Mrs. William Zeckendorf Jr. As luck would have it, at the same time I was looking for something to do, the American Ballet Theatre was looking for someone to do something for it.

The American Ballet Theatre was founded in New York in 1939 by Richard Pleasant with the help of Lucia Chase. The two had met when Lucia was dancing with the Mordkin Ballet. Two years later, Pleasant backed away from managerial duties, and Lucia became the director. The company's initial and abiding purpose was "to preserve the great works of the past and provide contemporary choreographers with opportunities to create." In 1945, Oliver Smith, a theatrical designer and interior decorator, became co-director. He and Lucia ran the company together from 1945 to 1980. Oliver was a brilliant designer and brought with him distinctive ideas for sets, costume design, and the very theater itself, which became hallmarks of the company. We became good friends. He also brought his friend Jacqueline Kennedy Onassis onto ABT's board which was a boost to the company. She wasn't simply a figurehead; she genuinely loved ballet. Jackie helped raise money and personally contributed. To honor her benefactions, ABT named its teaching facility the Jacqueline Kennedy Onassis School. Money makes the world go around, especially when it comes to the arts. It didn't hurt that Lucia herself was an heiress from a socially prominent New England family.

16.1 Antony Tudor and Nancy at party following an ABT gala

Born and raised in Waterbury, Connecticut, Lucia Chase was educated at Bryn Mawr College but left after two years to pursue a theatrical career in New York, where she studied acting, singing, and dancing.

"Acting was my first love," she said, "music second, and dancing a hobby."

While studying in New York, she married Thomas Ewing Jr., heir to a carpet company fortune, with whom she had two sons. Six years into the marriage, Ewing contracted pneumonia and died. Lucia found that neither acting nor singing eased her grief, so she turned to what had been a hobby and found consolation there. She began studying dance in earnest with Mikhail Mordkin and made her professional debut with his company at the age of thirty-eight, a time when most dancers are contemplating retirement. She went on to dance lead roles with Ballet Theatre and continued when it became the American Ballet Theatre. She was in her mid-sixties when she stopped dancing principal roles. But she didn't retire, she moved into character and pantomime roles such as the Queen Mother in *Swan Lake,* which she performed right into her eighties, according to her granddaughter.

In a world strewn with failed dance companies, ABT survived in part because Lucia Chase was devoted to keeping the company afloat. The well-known secret of its success was Lucia's willingness to put her money where her heart was. Though she fervently tried to keep her benevolence under wraps, everyone was aware of it. The *New York Times* noted that she "was obviously wealthy in an artistic field that was conspicuously poor." Even Broadway mined the situation. In *Look, Ma, I'm Dancin'!,* a 1947 musical comedy about a ballet company, a character modeled on Lucia comments, "Surely there must be easier ways to lose money than this!"

Under the directorship of Lucia and Oliver, ABT performed the classics and presented new works by Tudor and American choreographers such as Jerome Robbins, Michael Kidd, Herbert Ross, and Eliot Feld.

Meanwhile, a coterie of dedicated women helped support the company primarily by arranging special events to raise money. One day, Enid Berkoff, a member of the coterie and someone I knew personally, asked me to help with an upcoming benefit at the Waldorf Astoria. I was predisposed to favor ABT because Tudor was there, so I agreed. They wanted me to put together the dance program for the evening which didn't seem all that difficult until I was informed that the entire company was touring in South America. How do you put together a program when the beneficiaries are not going to be there to perform? Aghast but undaunted, I quickly improvised and arranged for dancers from the Met Opera Ballet and the Katherine Dunham studio, as well as soloists from various other groups, to appear. Somehow, we pulled the thing together and it was a success; money was raised, and the program was praised. I had a ball doing it. A while later, I received a phone call from ABT's executive director. They were planning a gala benefit to celebrate the first phase of a new production of *Swan Lake* and were wondering if I'd be willing to help. I said OK and asked who was the chair?

"Well," he answered. "We were hoping that you'd do it." That was flattering; I'd only done one program for them.

"I'd be delighted," I said.

"When is the gala scheduled?"

"In six weeks."

I was shocked. Six weeks to prepare a major benefit. It was insane for any number of reasons, all of them sound. First, benefits are announced at least six months in advance. I was about to mention this when I thought, why not. I chaired my first gala benefit for ABT and loved every minute of it, and ABT was pleased with the results, too. I was off and running. In the next fifteen years, I would chair nearly twenty galas for ABT and raise hundreds of thousands of dollars. The best part was that Lucia Chase became another great lady in my life.

Except for the time that Tudor had me audition for her, I didn't know Lucia Chase. She'd been in South America when I helped with the first

gala. We hit it off right away. I loved her New England sensibility, which was offset by a wonderful sense of humor and a genuine sensitivity to other people's needs. She was the boss, but she wanted to be one of the members of the company. When ABT was on tour, she rode on the bus with the company and shared lodgings. After I'd been named chairman of the gala, I went to Lucia's office for a brief meeting. She handed me a little tin box.

"This is for you, Nancy. All my friends are in it, and they'll give us some money. I hope."

The box contained a hundred index cards with the names and addresses of the contributors to whom I would be going for the next fifteen years. It's funny that a super money-raising machine arose from a little tin box. Not long after the first gala, I was invited to join the ABT board. I've been on that board for half a century, although I'm an honorary member now. When I joined, the board consisted of Lucia, Oliver, Priscilla Stevens, Charles Payne, who was running the company, and a woman whose name escapes me now. But it was Lucia's show. In time, I would become her right-hand woman and unofficially assist her in many aspects of the company. It was unusual for her to allow someone into her territory. I think she recognized that I was interested in helping her, not in taking over. My area of expertise was benefits and galas and, for fifteen years, I was hard at work running fundraisers for ABT. By the way, I was never paid a cent for my efforts; everything was done as a volunteer. Of course, not being paid gave me a lot of leeway. Even so, there were times when Bill and I were in dire straits financially, and I wanted to be earning money to help out. At one point, a friend volunteered to make a donation to ABT specifically earmarked as a salary for me. The president of the board thought it was a bad idea. At first, I was upset by his response, but I knew he was right.

During this time, I met a woman with whom I became very close. Her name was Joan Fontaine. Just as it had been with Brigitta, I couldn't get over the idea that a famous Hollywood movie star would want to

16.2 Portrait of Lucia Chase

be my friend. No matter what I've achieved, there is always the part of me that remains the little girl from Tidioute who idolized dancers like Zorina and actresses like Joan Fontaine, but in her wildest dreams could not picture herself in their company. I will say that as starstruck as I was, I wouldn't have been friendly with someone simply because she was famous. Both Brigitta and Joan were exceptional. Joan was bright and well-read with a sharp sense of humor. She loved opera, too. She lived down the block from me, and we saw each other regularly. One day, she called and said that she was a little under the weather and staying in bed. She asked if I could bring some milk and orange juice. I shopped and went to her place. She motioned for me to sit on the bed as she began to talk. All the while I'm thinking to myself, I'm sitting on Joan Fontaine's bed, talking with her. At the time, Joan was dating a man in whom she was interested, but she'd found out he was seeing someone else. The other woman ran the beauty department at Bergdorf Goodman, and Joan wanted to know what she was up against. She asked if I'd go to Bergdorf's and scout the competition. It sounded straight out of *The Women*, a movie in which Joan had appeared. Of course, I said yes. Later that day, I telephoned Bergdorf's, asked for the beauty department, and was connected to Madame X. I told her I was doing a gala for ABT and wanted to talk to her about Bergdorf's getting involved. I thought that was a clever ploy. Not only would I help out a friend, but I might get something for ABT out of the deal. She said she'd be happy to talk to me. The next morning, I went to Bergdorf's, met with the other woman, and chatted about the ABT event. I told her I'd be in touch.

"You've got nothing to worry about," I bluntly reported to Joan. "She's not that attractive."

I saw a lot of Joan for five years. We'd get together in the city and she'd visit us in Mt. Kisco. Then she moved to the West Coast. Joan was an ardent golfer, and golfing is a year-round activity in California. I didn't see her much after that, but whenever she'd visit New York, we'd meet.

I know our relationship would have remained close had she stayed in New York. I still get a kick out of remembering that I was best friends with a genuine Hollywood star. One thing I do regret is that I never asked her what was the cause of her celebrated feud with her sister, Olivia de Havilland. It would have been nice to know the story directly from the source.

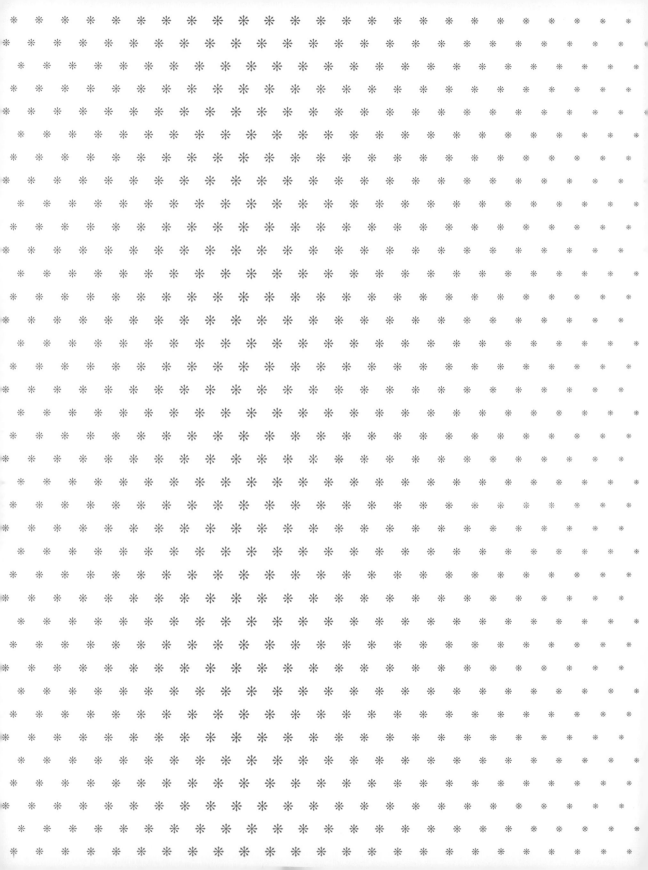

Chapter Seventeen

Putting on benefits, galas, and special events involves an enormous amount of work. When it came to running them, I had everything down to a science. It's like working a jigsaw puzzle, and I love jigsaw puzzles. Every facet of the event has to be covered: guest lists, invitations, printed programs, catering, and the program itself. Possibly the most important aspect—the seating arrangements—was my favorite. You don't get a lot of Brownie points for putting persons in the optimal places, but believe me, it can make or break an event if you don't do it right. I loved organizing the guest seating. Putting people together—from those who've paid a lot of money to those who've bought a single ticket—requires a lot of work. Done well, it is an art form. My technique never changed. Once all the tickets had been sold, I'd write down the names of the attendees on individual 3x5 index cards. I'd spread the cards all over my living room floor, on the tables, and on the sofas and chairs. I'd pick various names and put their cards together in a group. If the gala was at a theater and followed by a dinner, I'd seat the theater and then the tables. I'd spend hours going around my room picking up cards and making

adjustments, always trying to make the mixes better. You must always put some important people in the back so that the people seated there think they're in a good place. I don't know why, but I had a gift for knowing who would click that rarely failed me. I remember one ABT benefit at the New York State Theater. We got a deal and were able to buy out the house for $15,000 which seats more than 2,500 people. That meant we didn't have to charge as much to clear a profit. We sent out invitations for $25 a ticket on a first come, first served basis. In all honesty, it wasn't first come, first served. It rarely is. You honor the big donors no matter when they respond. Aside from that, all the ticket requests were seated in the order received. The house sold out, and I went to work. I wrote all the names on individual index cards, put them in order in a big box, and sat down with two of my ABT friends. We began organizing the seating at six o'clock one evening. Around three o'clock in the morning, I pulled up a card with a name I'd never seen before, Doris Vidor. Even though her response had come in later, I had a feeling that this lady should not be seated in the fourth ring, so I placed her in the first ring. It turned out that Doris Vidor was the daughter of Harry Warner (of Warner Bros.) and had been married to Billy Rose, Charles Vidor, and Mervyn LeRoy, all three of whom were major figures in the entertainment world. Rose was an entrepreneur and Vidor and LeRoy were top Hollywood directors. Her son, Warner LeRoy, reimagined and ran the Tavern on the Green restaurant in Central Park. This woman was connected and precisely the kind of person ABT would want to have involved. And that's exactly what happened. Not only did Doris and I become good friends, she joined the board and became a patron of ABT. In fundraising, you develop an instinct about when to bend the rules. Mind you, no one in the audience that evening complained about his or her seat. No matter what the organization or the venue, my seating formula worked—and I was at it for a long time. Knowing how upset people can get if they feel they're being snubbed, Gael Greene, *New York* magazine's food critic, once asked me how I was able to seat so many people successfully.

"It's no big deal," I answered. "It's instinctual. I have a feeling about who's going to get along. For one thing, I put the boring people together and they have a wonderful time. They all think they're at the best table."

When chairing a special event, you always strive to come up with something different, something that makes people want to be there. Stars sell. If you have Nureyev or Baryshnikov or Makarova, or any popular dancer, people will turn up. There are other enticements, however, and one of the most compelling draws is novelty. A good example of taking the humdrum and turning it into an event that must not be missed was the ABT benefit in 1969. That year, we were going to premiere a film of *Giselle* with the ABT company, featuring Carla Fracci and Erik Bruhn, two of the top dancers of the era. The designated venue was Alice Tully Hall at Lincoln Center. The challenge was that we were trying to sell a movie that would eventually be shown in local cinemas, which was different from seeing a once-in-a-lifetime live performance. How were we going to fill one thousand seats in Alice Tully Hall with a movie? We needed a glitzy enticement to pique interest. Sherwin Goldman was the executive director of ABT at the time, and a friend of his came up with an intriguing idea. She proposed that we have a group of celebrated New Yorkers host private dinner parties before the screening. The intimate gatherings would then converge at Tully Hall. Everyone thought it sounded great. To manage the pre-theater arrangements, we hired a man who presented a long list of notable names and guaranteed that he could persuade them to give dinner parties. It didn't take long to realize that he was full of baloney. He was fired, and that left me in charge of recruiting hosts. Time to bring out the little tin box and to glean sponsors from Lucia's list. (As far as I know, this was the first time that private dinners were incorporated into a gala benefit. After we did it, everyone started doing it. Private dinners became the rage.) We did the math and figured out that twelve dinner parties would accommodate the number of needed patrons. I then set

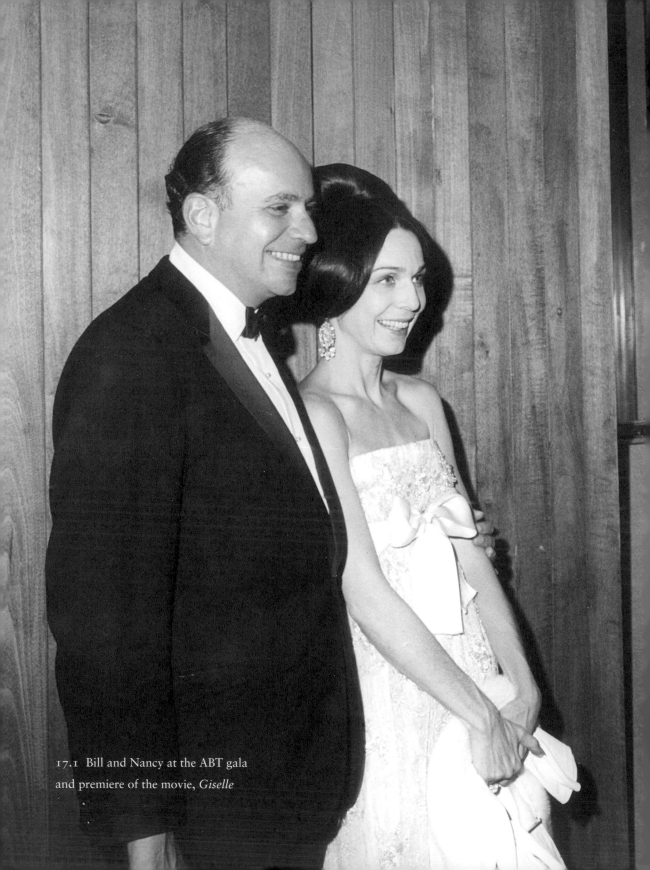

17.1 Bill and Nancy at the ABT gala
and premiere of the movie, *Giselle*

to work enrolling a dozen famous hosts. The selection included opera singers Licia Albanese and Teresa Stratas, cartoonist Charles Addams, Agnes de Mille from the dance world, actors Ruth Ford and Hermione Gingold, film critic Rex Reed, and artists Robert Indiana and Andy Warhol (with Ultra Violet as co-hostess). The invitations went out and the responses poured in. I got a phone call from Mrs. Bernard Gimbel's secretary who said that Mrs. Gimbel, the widow of the department store owner, wanted to go to Andy Warhol's.

"Are you sure?" I asked. "It's going to be pretty informal. He's serving hot dogs."

"Hold on please," said the social secretary, who I knew was covering the mouthpiece of the phone while she spoke to her employer.

"Mrs. Gimbel loves hot dogs," she replied in a matter of seconds.

The evening was a huge success and there was no question that the dinner parties made the difference. Everyone was comparing dining experiences and talking about the menus which ranged from Andy Warhol's wieners in The Factory to a lavish penthouse smorgasbord high in the sky. Everyone enjoyed the film, too. A good time was had by all and it wasn't about the food or the movie; it was about being there.

The ABT planning committee was as much fun as it was work. We'd arrange programs consisting of piecemeal selections from a variety of ballets which made for a diversified evening. Oliver, Tudor, Lucia, and I would then figure out our various assignments. I didn't aspire to run the programs myself, but I knew what would sell, and gradually the others began to defer to me. One time, Rudolph Nureyev was going to appear, and he wanted to do the second act of *Giselle*. Not a scene, the whole damn act.

"No," I said to him. "You can't do that, it's too long."

Imagine, me giving orders to Rudolf Nureyev, and imagine Rudolf Nureyev taking orders from me. I believed then, and I believe now, that gala selections should be short and sweet. My husband felt the same way. According to him, "Nobody ever complained that a gala was too short."

17.2 Nancy wearing a Balenciaga
gown at the *Giselle* movie gala

Of all the benefits that I presided over for ABT, the one that remains special was the Twenty-Fifth Anniversary Gala in 1975. At the planning session, people began proposing scenes from certain ballets and suggesting performers to do them. While they were talking, I had an idea that I thought would add a twist to the evening. I'd always been fascinated by tableaux vivants, once a very popular entertainment. Tableaux vivants are living pictures in which a group of individuals recreates scenes from history, art, literature, or quintessential everyday moments. Live nativity scenes that are staged at Christmas are one example. In a tableau vivant, costumed players assume roles, strike their poses behind a curtain and remain frozen for half a minute or so after the curtain rises. Upon recognizing the depicted scene, the audience bursts into applause. When tableaux vivants crossed the Atlantic, Americans added their own spin. Paintings such as Botticelli's *The Birth of Venus* became popular subjects as it enabled players to show ample skin. Despite the bits and pieces of nudity, tableaux vivants remained a good old-fashioned form of entertainment. Thinking about tableaux vivants at the planning session, it occurred to me that many of the original members of the company were still around, people such as Lucia, Nora Kaye, Agnes de Mille, Sono Osato, Tudor, and Hugh Laing. I suggested that we use some of the renowned ballets from the ABT repertoire with the original performers in their roles. Everyone loved the idea, and we created an evening around it. The night of the benefit, two Tudor ballets, *Pillar of Fire* and his version of *Romeo and Juliet*, were performed in tableau vivant style. The ballets were announced, and the curtain parted to reveal a scene with the original principals frozen in position. Past and present were united. The evening was a huge success. In 1979, ABT was given another movie to premiere as a benefit. This time, it wasn't an art house ballet film like *Giselle*; it was a major Hollywood production that would later be nominated for eleven Academy Awards. I'm referring to *The Turning Point*. We'd been handed a hot property, and we did very well, indeed.

I was successful at what I did for ABT because I'd been a professional dancer and was as knowledgeable about ballet as I was about opera. I knew what I was talking about when I referenced *Swan Lake, Sleeping Beauty, Rodeo,* et al. Being informed and ardent about the cause made me a credible advocate. I could never ask for money for something that I didn't thoroughly embrace myself—I know because I tried a couple of times without much success. There was one other group that I was involved with for ten years—the Dance Notation Bureau. Theirs was a cause I believed in. The Bureau preserves works by creating dance scores using a symbol system called labanotation. Dance scores function for dance the same way music scores function for music. Instead of performers relying upon memory to recreate exact choreographed steps, ballets are now being documented in full for posterity.

✳

Chapter Eighteen

ON MARCH 6, 1968, an Air France plane crashed into the northwestern slope of La Grande Soufrière in Guadeloupe. Everyone on board was killed, and among the passengers was Marion Griffin Zeckendorf. It was a tragic end for a genuinely lovely lady. Among Marion's many acts of generosity was the time she stepped forward to help her husband, and mine, too. Bill Sr. had given her a large sum of money when he was riding high. When she learned that he and Bill Jr. were having difficulty raising funds for a project, she returned the gift. Bill Sr. was shaken by Marion's death and went on to establish a charitable fund in her name. He grieved and threw himself into his work. In time, he began dating again. In 1972, he married Alice Bache. Alice, too, was a fine person. The marriage, however, lasted barely two years. There's no mystery here. Bill Sr. was a philanderer, and anyone who married him had to accept his predilection or leave. Up to that point, I liked all of Bill Sr.'s wives. They were intelligent and informed women who were kind to me. Bill Sr. married for the last time in 1975. When he died in 1976, his fourth wife, Louise, became his widow.

During the time Bill Sr. was married to Marion, they lived at 30 Beekman Place, a building he owned. When he bought the building, Bill Sr. had I.M. Pei design and erect a penthouse apartment on the roof. It was modern, stunning, and very Pei, and I was crazy about it from the moment I first saw it. The relationship between William Zeckendorf Sr. and Ieoh Ming Pei was remarkable. In the late forties, Bill Sr. wanted an architectural "idea man," someone who could put into visual form the ideas that he was generating at Webb & Knapp, his real estate company. Nelson Rockefeller recommended Dick Abbot, a former member of the Museum of Modern Art staff, as a scout. It was Abbot who brought Pei to Bill Sr. At the time, Pei was a professor at the Graduate School of Design at Harvard and had not built anything. When he and his wife, Eileen, came to visit Bill Sr., he brought some of his sketches. Bill Sr. was impressed with what he saw:

> I could see from his sketches that he was truly talented. I also found him obviously intelligent and very imaginative, as well as a bon vivant and knowledgeable gourmet. It was a case of instant recognition and liking.

Bill Sr. convinced Pei to leave academia and join him at his firm. Pei's first job was redesigning the Webb & Knapp headquarters at 383 Madison Avenue. That's when he created Bill Sr.'s igloo office. From there, Pei went on to conceive and guide many Webb & Knapp projects. Even when he formed his own firm in 1955 and was free to work with other companies, he continued to work with Bill Sr. Early on, the two of them became good friends outside the workplace. Bill Sr. would swoop in, grab Pei and Eileen, and whisk them off on an adventure. He introduced them to France and all its glories, with special attention given to French wines. (Despite his patron's preference, Pei's allegiance was to Bordeaux rather than Burgundy.) They were a strange pair, the gruff developer and the genteel architect, but they respected each other. According to one architectural critic, "together they became the most

active urban renewal developer and architect in the country." I was impressed with the relationship between my father-in-law and Pei. Pei was like one of the family. I loved what he did, but he was also a wonderful man, charming, personable, knowledgeable, with a veritable twinkle in his eye. His architectural creations were magnificent. I went to Qatar to see his stunning Museum of Islamic Art. I'd have traveled to the ends of the earth to see anything Pei did. He also invited us to the opening of his Fragrant Hill Hotel in China. We had to miss that one because Bill's father had a stroke.

Bill and I were the lucky beneficiaries of his father's special friendship. Pei was appreciative of all that Bill Sr. did for him, and he wanted to return the favor by doing things for Bill and me. We traveled with the Peis to Paris and to Burgundy, ostensibly because he wanted to look at the limestone for which the region is well known. However, we spent as much time enjoying the wine and food as we did looking at limestone. On another occasion, Pei was scheduled to speak in Hong Kong during the time that China was closed to the world. Eileen was joining him, and he decided that Bill and I should come along. He wanted to show us Hong Kong just as Bill Sr. had shown him Paris. The four us spent a few days touring the city and dining like kings. That was one of Pei's promises, "You're going to have the best Chinese food you've ever eaten." How right he was. Bill was enjoying himself so much that he decided to take a three-week vacation and do more touring. It was surprising for him to take time off like that, but I was glad he did. We visited Thailand and India and went on to Afghanistan. Bill had agreed to assess the hotel situation and consult with government officials while we were there. Afghanistan had a lot of French and English tourists, but they didn't have hotels in which to put them. From the moment we arrived, we were guests of the king, whose cousin met us at the airport. He wanted to know how long we intended to stay. Bill said we planned to be there for the weekend. The cousin wouldn't hear of it.

"Oh no, Mr. Zeckendorf, we want you to see the country."

So, we remained and were taken everywhere, from the huge statues of the Buddha in Bamiyan (they were blown up by the Taliban in 2001) to Herat where we saw the Great Mosque. We drove up and down through the mountains and returned to Kabul. We had dinner in Herat in a private home that was luxurious, yet the bathroom was outdoors. After dinner, the women separated from the men, that is, the Afghani women departed while I remained with the gentlemen. We were in a large room and a trio of musicians was playing. I couldn't resist. I got up and started dancing. Bill was beaming. As I danced, I could see the women looking through the latticed windows watching me. I wondered what they were thinking. The entertainment ended, the men applauded and got down to business. They wanted to get Bill's take on the hotel situation. They weren't paying a consulting fee; they were just asking. Bill said it didn't make sense to build an independent hotel in each city. He said they'd be better off making arrangements with an organization like Holiday Inn, which uses the same template for its hotels. Not long after we were there, the King was deposed, and Afghanistan became a republic. I don't know if any hotels evolved from our stay, but our time there created an indelible memory. It is a fascinating country, biblical in its simplicity and starkness.

Our next stop was Iran. In those days, like many people we knew, Bill and I dabbled in marijuana. I had brought some with me in a naïve and unthinking way. Afghanistan was, after all, pot heaven. I had placed the joints in a tin Sucrets box and put the box underneath the flap of my carry-on bag. When we arrived at the airport, all the passengers were taken to a large room where grim security guards started searching the luggage. They were looking for drugs. One man took my carry-on and opened every cosmetic in the bag including the eyebrow pencil and lipstick. I was petrified. The consequences of my carelessness, the danger it put us in, flashed through my mind. But he never lifted the flap and never found the marijuana. I was shaking when we got on the plane

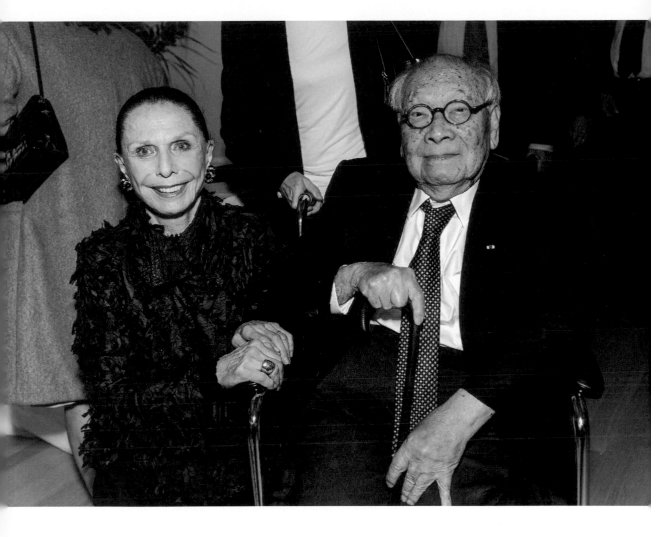

18.1 I.M. Pei and Nancy at a party for the release of Bill's memoir, 'Developing My Life'

and went directly to the lavatory where I flushed the cigarettes down the toilet. From that day on, I never smoked pot again.

Like most bachelors, Bill Sr. didn't pay much attention to his surroundings. After Marion was gone and no one was there to keep life in order, the penthouse became rundown and needed updating. Bill Sr. wasn't interested in rejuvenating his penthouse. Beekman Place had been his home with Marion, and he didn't want to bring his new bride into the place he'd shared with her predecessor. He was ready to move on. It was fortunate that Alice Bache had a lovely apartment of her own. Bill Sr. moved in with her and prepared to put his penthouse on the market. I was upset when I heard his plan. I loved that apartment, and I was afraid for it. God knows who would buy it. I hoped it would be someone with taste and character who would feel obliged to preserve a master architect's work. I hoped, but I was savvy enough to realize that might not be the case. Why shouldn't someone who appreciated the place take it over, someone like me? Bill and I were living in our East 72nd Street apartment where the sun didn't shine, and this was a perfect opportunity to go towards the light. The penthouse offered a change of scene and bringing it up to date was a project that I could throw myself into wholeheartedly. Shortly after Bill Sr. announced his intention to sell, I asked my husband how he'd feel about moving into his father's place. He thought a moment and said,

"Sounds like a good idea."

The penthouse was in Marion's name, and we purchased it from her estate along with everything in it—the furniture, the silver, the china, the art, the whole shebang. I couldn't wait to restore it to its original glory, and I hoped that the brightness of our new home might lighten my life with Bill.

I have always arranged and composed my own residences, but I am no interior decorator. For me, it's not about interior decoration; it's about space, how it works, and the use and usefulness of it. I love blueprints. I love sitting down with them and looking at all the lines and the way

they meet and part and join again. I don't think I could have been an architect, though, as I'm poor with numbers. I have an instinct about where things should go. My aesthetic is simple: follow the line. Some people devise a bedroom with a closet in front of the bed, a chair in the middle of nowhere, or a door randomly placed in the mix. Nothing lines up, and it should. Life is all about line. Line tells the truth whether it's in design or in ballet. When I stood at the barre and did an arabesque, I was following a line. In the same manner, I followed a line when designing my homes. Every one of them was organized with a place for everything and everything in its place. I felt pure delight when I began working on the penthouse. The first thing I did was to contact an architect friend, Manfred Ibel, whom I knew through the composer, Sam Barber. I asked Manfred if he'd help restore my new home—bring it back to life. Manfred was delighted to work on an I.M. Pei design. One major mechanical improvement was the installation of air conditioning. When Pei designed the penthouse, air conditioning wasn't commonly used in private dwellings. Manfred researched the latest in air conditioners and hired a highly recommended company. The unit was installed in the living room wall. Because the rooms flowed into each other, it functioned as central air conditioning. It was a difficult installation because the power source had to be placed on the roof of the penthouse and finely calibrated so that the vibrations didn't shake the whole apartment. They did a wonderful job. The floor was white tile throughout, and rather than windows, there were sliding doors. The walls were painted white with redwood paneling around the living room fireplace and redwood doors that opened to the wine cellar. Bill Sr. had to have his wine cellar, and so did his son. I saw no reason to change the color of the walls, so they were repainted white. While the painters were at it, though, I asked them to paint over the redwood paneling. It was the one element I didn't like. Redwood was used a lot then, but it didn't appeal to me. In the end, the entire apartment was a monochromatic white. I thought it looked amazing—modern, crisp, and neat. The final modification was the back balcony. Since the time the penthouse had been built, a building

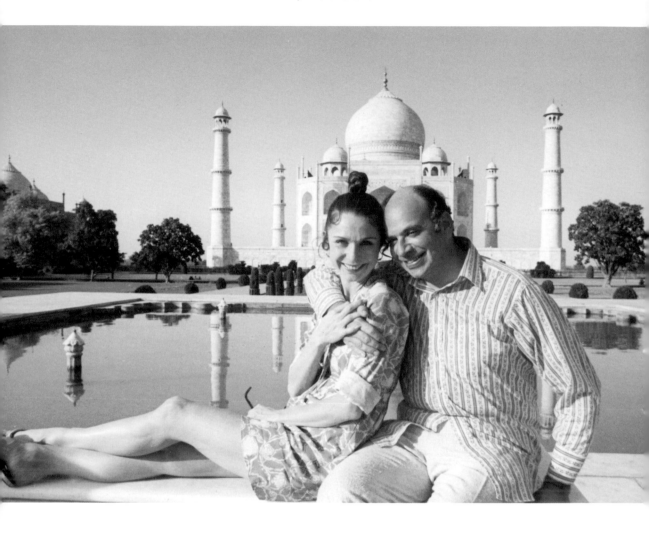

18.2 Nancy and Bill at the Taj Mahal

had gone up behind that was not attractive to look at. I had an open framework fence installed; it blocked the intrusive presence of the other building and protected us from prying eyes. It all worked well, although I might have done more if we'd had more money to spend. When the apartment was finished, Pei came over to see what I had done. I was nervous, mostly about covering up the redwood. He walked slowly through the rooms, stopping here and there to look closely at some detail. He completed his inspection within fifteen minutes and said,

"You've done a good job, Nancy, a really good job."

Such music to my ears. He liked the all-white look and agreed with my choice to cover the redwood. But what impressed him the most was the air conditioning.

I loved living in Beekman Place. While there, my interest in architecture deepened. Our previous apartment was decorated in a conventional English style, nice, comfortable, but not contemporary. Beekman Place opened my eyes. I was impressed with Pei's overall work, but now I began to register the subtle and personal touches of his throughout our new living space. Not only had he designed the penthouse, he had guided Marion and Bill in selecting the furnishings. His recommendations ranged from a striking rug in the living room to wonderful sculptures by Lipchitz and Lachaise. The first time Joan Fontaine visited us, she was clearly impressed with the apartment, except for the big sculpture by Lachaise which commanded a prominent spot.

"Boy, that's ugly," she said.

That was the only time I questioned her taste.

Beekman place was the first truly contemporary home I lived in, and I knew I'd found my aesthetic. But even up there in the warmth of the sun, being with Bill could be unrelentingly silent. The worse it got, the more I zeroed in on ABT. Because I was so busy with my work, I could push aside my despair at home. If there's one thing I know how to do, it's focus.

❋

Chapter Nineteen

O NE DAY I WAS WALKING BACK from an ABT board meeting with Justin Colin, a retired investment banker. When we reached my building, Justin said goodbye and started walking away. He turned around and walked back.

"Nancy, I've had something on my mind for a while and this is as good a time as any to bring it up."

I couldn't imagine what he was going to say. We knew each other from the board, but that was it. I stood there dumbfounded as he continued,

"I've been doing some research and I'm impressed with your husband. Would you tell him I have $250,000 to put into whatever he wants to?"

This was exactly the kind of boost Bill needed. When I told him what Justin said, he was delighted. It took nearly six months for him to come up with a suitable project. It was the late 1970s, and economic growth was stagnant. Real estate was hard hit. Apartment and condo sales were low. The travel industry was sluggish; hotels were not turning a profit. Even so, when the Delmonico hotel came up for sale,

19.1 Portrait of Bill in the late 1970s

despite the desperate state of realty, Bill had a hunch. He knew what to do with it and he wanted to purchase it.

Originally named the Viceroy, then Cromwell Arms, the Hotel Delmonico on Park Avenue opened in 1929. The Delmonico took its name from a fashionable downtown restaurant of another era, and the owners had to go to court to win the right to use the name. Like most old hotels, the Delmonico had its share of lore and legends. Broadway musical star Mary Martin lived at the Delmonico. Ed Sullivan and his family lived there and rented a separate suite for the office and head-quarters of his famous television show. In August 1964, on their first visit to the United States, the Beatles stayed at the Delmonico. During the two-day tour stop, fans stood outside, eight feet deep behind bar-ricades. The lobby and corridors were patrolled by uniformed police. The hotel switchboard received two hundred thousand incoming calls. Bob Dylan came by to meet the boys for the first time and effectively introduced them to cannabis.

Evaluating the Delmonico as a potential purchase, Bill recognized the declining rates of hotel occupancy—regular hotel visitors simply weren't visiting. His idea was to convert the entire property into rental apart-ments, which he thought would do better than hotel rooms, particularly since the guest rooms were spacious and could be converted easily into luxury rentals. He took Justin's money, used it as part of a down pay-ment, and bought the Delmonico for six million dollars. What's more, as part of the deal, he got a rental apartment for us thrown in. That was a surprise to me, and a mixed blessing. While he was negotiating the Delmonico deal, Bill told me that he could no longer afford to maintain both Beekman Place and Mt. Kisco. One of them had to be sold. Which was it to be? The choice was easy for me. I could live without Mt. Kisco and was about to say as much, when something struck me. Bill was of-fering me the choice, even though he was deeply attached to his country place. I couldn't let him lose it. It hurt, but Beekman Place went up for

sale, and we received $70,000 for it. That was big money back then, but can you imagine how many millions an I.M. Pei-designed penthouse would fetch today? Leaving that apartment was one of the hardest days of my life. It felt like an expulsion from paradise. I realize how insensitive and spoiled that makes me sound. There are people in this world who don't have a roof over their heads, and here I am kvetching about going from one luxury residence to another. I adored our home on Beekman Place. I had put my whole being into bringing it back to life. I'd restored the work of an architectural genius who had given the results his blessing. It was a defining effort and an accomplishment I was proud of. I had a good feeling just being in that apartment, and now it was over.

Early in the afternoon of my last day at 30 Beekman Place, I had scheduled a meeting with Tex McCrary. Tex and Jinx Falkenburg, his former wife, had hosted a popular radio and television talk show for many years. I knew Tex personally because he did public relations work for Bill's father. Tex was doing a special program on the Statue of Liberty and asked me to join the committee. It was bad planning on my part; I was not in the mood for a committee meeting, but I couldn't back out of it. It wouldn't have been fair. I was wearing a bright green suit when I left Beekman Street and fighting back tears as I walked to the meeting. When it ended, I walked to my new home in the Delmonico. I never saw the Beekman Place penthouse again. I can't say why I became so attached to the penthouse in the half dozen years we lived there. Maybe it's because I found a new career while living there or maybe it was simply a matter of aesthetics. Whatever the reason, that penthouse was my Shangri-La, even though nothing had changed as far as my marital situation. Bill was still subject to terrible bouts of depression. If anything, they'd gotten worse. We'd drive to the country on weekends without a word being said, not a word. When we entertained and had people over for dinner, he was a perfect, if passive, host. He saw to it that everyone's wineglass was filled, and he was an attentive listener but rarely initiated conversation. Since the majority of our guests were big talkers,

it wasn't noticeable. I thought about asking for a divorce many times, and then he'd do something or say something that reminded me how much I loved him, and I'd dig in for another round. One day in ballet class I was so upset that Eddie Villella's wife, who was in the class with me, asked what was wrong. I mumbled something about my married life being difficult. She listened and said,

"Why don't you leave him?"

When I heard that coming from someone else's lips, I knew I'd reached the point where I couldn't handle things on my own. I went to Larry LeShan. Larry said I had to confront Bill, to tell him that unless he sought help, I couldn't stay with him. I tried a few times, but it was like getting up the courage to speak to my father about ballet school. Finally, I couldn't keep it in. That evening, I told Bill it was impossible for me to live with him the way he was and that he had to get professional help.

"Please," I begged. "you have to see someone."

"Why don't you see someone?" he answered.

"I have been seeing someone," I responded.

Bill walked out of the room without saying another word. The next morning, he came to me and said,

"Tell me where to go."

I got a referral from a trusted friend, and Bill made an appointment to see the doctor. He put Bill on proper medication and met with him regularly. It wasn't a miracle cure or anything like that. Bill was improving, but still could get depressed and go into a funk. He was trying, though, and that helped relieve the stress. I would stay the course. I fought to get out of Tidioute; I fought to become a dancer; and I fought to save my marriage.

✻

Chapter Twenty

OUR RESIDENTIAL APARTMENT at the Delmonico wasn't ready when we moved in, so we had to stay in one of the converted hotel suites on a lower floor. It was ugly right down to the repulsive yellow shag carpeting. Eventually we moved to an apartment that occupied the entire thirty-first floor. The views were astounding; it was like being on top of the world. But as far as the interior and the fixings, it was awful. The first time I walked in and looked around, I lay down on the floor and cried. I remember looking up at the mullioned windows and nearly gagging. Aesthetically, I was floored. I was fortunate to have Birch Coffey, an architect who often worked with Bill, guide me. Out went the mullioned windows and the other remnants of the old design as Birch turned our space into a modern dream dwelling. I loved what he did. Birch said he enjoyed working with me, and I felt the same about him. I am cuckoo for great architecture and have a real soft spot for architects.

"You know how to make storage space, Nancy," he told me, "and how to fit everything in the right place. You're a genius at it."

That kind of praise was music to my ears.

At the time we moved into the Delmonico, Bill had set up his offices in two rooms on the fourth floor which he went to every day, leaving me on my own. The hotel had been cleared of all residents and was upside down and inside out with renovations. It was spooky and, at the same time, fun to be living in such a large empty building. One day I was walking through the lobby and I took a peek into the grand ballroom. It was piled with furnishings from the hotel's transient rooms—beds, bureaus, chairs, sofas, coffee tables, mirrors, prints, lamps—all waiting to be sold. I took a long look. It was good stuff. Why sell it? Why not use it? I went to Bill's office and told him what I'd seen and made a suggestion. Wouldn't it make sense if I took some of the good furniture on hand and used it for the residential apartments? Bill thought it made great sense, especially since it would save money. So, I took on the task of refurbishing the Delmonico. In the end, I created twenty-seven furnished apartments. First, I went to the ballroom and totaled up the number of available furnishings by category so that I knew what I had to work with. Then I designated specific rooms for storing similar pieces of furniture, namely, a chair room, a table room, a headboard room, a coffee table room, etc. Every weekday morning, two housemen would come to our apartment and knock on the door. I'd put on my uniform, a Zabar's apron and rubber gloves, and with the housemen I would go down to the ballroom, rummage through the furnishings, and take each item to its designated room. The men handled the heavy pieces, and I carried the lightweight incidentals—prints, pictures, lamps. Eventually, the empty apartments were cleaned and painted, and I began decorating them. The one-bedroom apartments needed minimal furnishings. I was committed to spending as little money as possible. Our housekeeper in the country was a talented seamstress, so I took full-length silk curtains from the hotel rooms to her, and she shortened them to fit the apartment windows. I found a man to redo all the Venetian blinds. We installed new carpets. There's so much you can salvage, and carpets usually don't make the cut. The apartments

turned out looking pristine and harmonious. I repeat, I'm no interior decorator, but I do understand space. The apartments rented quickly, and no tenant ever complained. Conversely, nobody ever thanked me for what I did, not even Bill. What's more, I never got a penny for it. It never occurred to me to ask to be paid.

Bill believed that with the right commercial tenants two unused spaces on Delmonico's ground floor—an abandoned ballroom and a large room which had been the hotel's restaurant—could be real money-makers. When he learned that Christie's, the British auction house, was interested in opening a New York branch, he was convinced that the ballroom space was perfect for them and began making inquiries. As it turned out, Christie's felt the same as Bill. They moved in. Before long, Bill had to make more space for them on the floor above and install a connecting stairway and elevator. As for the other space in the Delmonico, that too would become a hot spot.

Someone had introduced Bill to a Belgian-born French chanteuse and nightclub owner from Paris who wanted to open a branch of her pop-ular disco in New York City. When she told Bill what she was looking for, he said, "I've got a perfect place for you." He took her to the Delmonico, showed her the remaining empty space on the ground floor, and she signed a lease. As part of the deal, she got a small penthouse apartment. In May 1976, Regine's eponymous disco burst onto the scene and was the go-to club for the super chic. Well before Regine's officially opened, she had sold thousands of memberships. Unlike most discos, there was a strictly enforced dress code. No one got by the front door if he or she wasn't properly attired. Mick Jagger was turned away because he was wearing sneakers and no tie. Both Christie's and Regine's brought glamour to the Delmonico. Years later, when the stock market shot up and tourism began to flourish again, Bill had sec-ond thoughts about having converted the hotel to apartments. He felt that it may have been more profitable as a hotel. I told him to get over

it. He sold the Delmonico for thirty-two million dollars in 1981. For a six-million-dollar investment, that seemed like a good deal for his investors, and one that included our living quarters at one thousand dollars a month rent for thirty-two years. I grew to love the place. We had our aerie in the sky with its glorious views, and I was proud of the work I'd done to bring the Delmonico back to life. I think that renovating those rooms was one of the best things I ever did. I know for certain that it helped me get over the sadness of leaving Beekman Place.

In the early 2000s, the Delmonico was sold to Donald Trump. The lease on our apartment was nearly up, so rather than hang around for the noise and confusion of the upcoming renovations, we moved into the Museum Tower across from the Museum of Modern Art. It's been my New York home ever since.

❋

Chapter Twenty-One

BILL AND I WEREN'T NIGHTCLUBBERS or club joiners except when it came to Burgundy wine. Besides the Tastevin Society, the only club that we belonged to was Doubles at the Sherry-Netherland. You could go there and have lunch or dinner and be among friends. I don't think we went there more than a handful of times. One thing I didn't do, which most women in my position often did, was invite friends out to lunch. I didn't invite anyone out to lunch because you were expected to go to the best places, and they were expensive. Bill never told me not to take someone out to lunch; I couldn't see spending money that way. By then I'd learned to live in the style to which Bill was accustomed, that is to say, awash with money one moment, and wrung out the next. Bill never gave me a budget and he never made a peep about anything I wanted to do or buy. Then again, he knew how practical I was. At one point, things were so bad for so long, I went out and got a realtor's license, hoping to bring in a little something to help us stay afloat. I wasn't much of a real estate agent. The few apartments I showed were so gruesome I couldn't bear the thought of taking people's money from them.

We didn't frequent clubs and we didn't entertain at home much either. I didn't have cocktail parties or lavish dinner parties, just weekend dinners in the country with our group of friends. Our chief social events were the wine dinners. We didn't go out to be seen. Even so, people assumed that Bill and I were among the superrich—and if you caught us on the right day, at the right hour, we might have been, but it never lasted. I mean, all the buildings Bill put up and sold, all the hotels he built, all the discos and restaurants, everything gave the appearance of wealth. Even Brigitta once commented, "You must be rolling in dough."

Real estate isn't like that. You make money on projects, but you can as easily lose your shirt on them, too. It is a gamble. We didn't move in the exclusive circles of big wealth because we couldn't keep up with them, nor did we want to. We moved in the arts circles, ballet and opera particularly. That's why we were in the newspapers. And if someone sees your picture on the society page wearing a fancy ball gown and chatting with Jacqueline Kennedy Onassis, then it might well seem you are "rolling in dough." Wrong. Any time I was photographed with Jackie Onassis, it was because I volunteered for the American Ballet Theatre and we were on the board. And, more often than not, she was the honorary chair for the galas I oversaw.

I liked Jackie. I didn't socialize with her outside of the ballet, but we had a few extended encounters, and each time I was impressed by her ability to zero in on people and make them feel important. Maybe the best party I ever gave for ABT was a supper at the New York Public Library for the Performing Arts after a performance. I worked with the caterer to come up with something unusual. Instead of conventional place settings and service, we put baskets on the tables, one for each guest. Each basket contained pate, cheese, prosciutto, a baguette, crudité, a tarte Tatin, and a split of Champagne. The guests were invited to dig in. Everyone got a kick out of picnicking. No one had ever done anything like that before. I don't think it was my idea. The caterer probably thought it up,

but I bought into it and brought it off. I'm more an organizing force than a creative one.

During the supper, Jackie came over to my table.

"This is the most charming and delightful and creative thing I've ever experienced," she said.

Believe me, I memorized her exact words. And while I'm not convinced the statement was entirely true, I knew she meant it. Another notable exchange with Jackie took place at the ballet when we were seated in the same box. Bill and I were in the back and Jackie sat up front. During intermission the person next to her left. Not wanting her to be alone, I went down and sat beside her. We talked for a while and she asked, in that signature breathy voice of hers,

"How did you meet your husband?"

I told her how Irma Kolodin had masterminded the courtship of Nancy King. Jackie seemed to enjoy the story. When her companion returned, I went back to my seat. Bill asked what we talked about, and after I told him, he said,

"Why didn't you ask how she met her husband?" Now why didn't I think of that?

Jackie was interested in the dancers as well as the dance and enjoyed hearing general gossip about the company. One weekend in the country, I was surprised to receive a phone call from her. She did call me occasionally, but it was when I was in the city.

"I've a question for you," she said. "I was at the ballet last night and when Gelsey (Kirkland) and Misha (Baryshnikov) came out for the curtain call, the wildest thing happened. Gelsey took one of the roses out of her bouquet and instead of handing it to Misha, she put it on the floor. What's going on with those two?"

"Gelsey's clever," I laughed. "She and Misha are having one of their usual spats and trying to one-up each other. Instead of handing him the rose, she dropped it so Misha had to bend over to get it. It was all done to make it look as though he was bowing to her. He must have been furious."

Speaking of Baryshnikov, during my association with ABT, two extraordinary dancers joined the company, both had defected from the Soviet Union. The first was Natalia Makarova in 1970, followed by Mikhail (Misha) Baryshnikov in 1974. They trained at the Vaganova Academy in St. Petersburg and performed with the Kirov (Mariinsky) Ballet. Onstage they were peerless, but offstage all those years of living behind the Iron Curtain had affected their behavior. At first, they wandered around in a perpetual state of awe in their new surroundings. I can only imagine what a shock it must have been to be free to do and say what you wanted after all those years of repression. In the totalitarian U.S.S.R., no one could be trusted, not your fellow dancers or members of your family. You had to be exceedingly careful of what you said lest you be denounced. Life was spartan and deprivation was commonplace, even among elite artists. It took time to adjust to American freedom and abundance. In the beginning, Makarova struck me as someone haunted by the past. She seemed to be looking over her shoulder as if expecting someone to come up behind her. Not timid, but apprehensive. She was a lovely person, yet she occasionally exhibited a certain grabbiness. Here's an example. Slippery spots on dance floors are a performer's nightmare. Dancers rely on rosin to prevent falls. A rosin box is a small, shallow wooden box about half-full of amber colored rosin. There's always a box on the floor—in an out-of-the-way corner if you're in a studio or in the wings if you're onstage. You put your shod feet in and swish them around. The thin layer of rosin that adheres to the shoes provides traction. For whatever reason, there was rarely enough rosin in the studio box. I got fed up and took matters into my own hands. I bought a container of rosin chunks, brought them to the studio, and crumbled them into the box. One afternoon Makarova came over and pointed to the container in my hands.

"Where are you getting?" she asked, pointing to the chunks.

"They're mine," I explained. "I bought them."

"May I borrow?" she asked.

"Yes, of course," I said.

"Oh, thank you," she cried.

Before you could say Nina Schelemskaya-Schlesnaya, she grabbed the container and hurried away. I never saw those rosin chunks again. My guess is that all those years of not having things to call her own might have given her a different understanding of the word borrow.

Makarova was with the company both as a dancer and choreographer for eleven years. She left ABT to form her own company, which lasted only one season. When her company folded, she came back to dance with ABT and appeared as a guest artist with other companies, especially The Royal Ballet. In 1983, she made her Broadway debut in a revival of *On Your Toes,* for which she received the Drama Desk, Theatre World, Astaire, and Tony awards for best actress in a musical. In 1989, she returned to Russia and gave her farewell performance at the Kirov where her illustrious career had begun. After she retired from dancing, she continued to choreograph and direct productions with ballet companies all over the world. In May 2020, she was scheduled to return to ABT to celebrate the fortieth anniversary of *La Bayadere,* which she had revived and choreographed. Because of Covid-19, the season was cancelled. I regret having missed the opportunity to see her again. Natalia Makarova was one of the greatest ballerinas of her time.

Like Makarova, when Baryshnikov came to ABT, he was in his own world, but his world seemed more contemplative than haunted. He was always exploring and absorbing everything going on around him. Misha was bright, polite, and what a dancer. Everyone loved him—the dancers, the staff, the board of trustees, and the audiences. Lucia was crazy about him. She found an apartment for him and asked me to fix it up, which I did with some of the leftover furniture from the Delmonico. He was grateful and wrote me a charming thank you note. (Yes, I still have it.) While he was with the company, he became the premier male dancer of that era. And he didn't stop there. He turned to acting, got a Tony nomination for his appearance in *Metamorphosis* on Broadway, and was nominated for an Academy Award for his performance in

The Turning Point. Then he won two Emmys for his television dance specials. The awards and adulation never went to his head. For four years he reigned supreme at ABT, so it was a complete shock when he announced that he was leaving for the New York City Ballet. The consensus of opinion was that he wanted to work with Balanchine. Balanchine rarely coached dancers outside of his own company—he wouldn't even work with Nureyev and Makarova. Misha must have realized that the only way he could work with Balanchine was by joining the New York City Ballet, which he did. It was a smart move, but I was upset about it. Misha was a big drawing card, and his absence would hurt our company and Lucia. When I voiced my disappointment to her, Lucia defended him.

"He's an artist, Nancy. We shouldn't stand in his way. He wants to spread his wings, and you can't blame him."

I did, though. I wasn't as big a person as Lucia.

At the time Misha joined NYCB, Balanchine was in failing health and beginning to exhibit early symptoms of the degenerative brain disease that eventually killed him. Consequently, while Balanchine did coach Misha in some classic roles, he never choreographed a new work for him. It must have been a huge disappointment. About a year and a half after he left, Misha did a complete turnaround and returned to ABT. He was welcomed back as a principal dancer, and soon thereafter, named the new artistic director. In 1978, ABT announced a new president— Don Kendall, CEO and chairman of PepsiCo. Soon after joining the board, Kendall met with Lucia to offer her a final contract, not to be renewed after its two-year term ended. Lucia accepted the inevitable. It wasn't long before the board was considering Misha as the new artistic director. Lucia had kept the company going for most of its life. Whether she was ready to retire or not, the fact that Misha was replacing her made it easier to accept. If it had been someone else, she may have put up some resistance. But Lucia had utmost faith in him and believed he would be perfect, as did everyone else. I confess that I was not thrilled

about his appointment. When it comes to ballet, I have tunnel vision. I've always believed that ABT should be a bastion of pure dance in both classical and contemporary forms. Since its inception, ABT was known for doing classic, full-length story ballets, including *Swan Lake*, *Sleeping Beauty*, and *Giselle*, as well as modern works such as *Rodeo*, *Pillar of Fire*, *Jardin aux Lilas*. When Misha took over, I anticipated changes in the repertoire, and I was right. Among other innovations, he allied himself with a few avant-garde companies. Let's face it—I was doctrinaire, Misha was not. I also admit that his diverse view contributes to his genius. But, with Lucia gone and a change in the company's direction, I knew things would be different for me.

At first, things were OK. Misha took time off from performing and spent it absorbing everything around him. One afternoon, I was taking a ballet class taught at the studio of David Howard, one of the most sought-after ballet teachers at that time. Misha came to the studio to take class. Naturally, when Misha was in a classroom, the adrenalin surged. The dancers began performing as though they were onstage. Even I felt the pressure, and I wasn't a professional anymore. After the class, on my way out, I passed Misha. He nodded at me and said,

"That was pretty good."

I was flattered that he'd paid attention to what I was doing. For him to extend praise was icing on the cake. Moments like that made it possible for me to continue my work, but it was inevitable that we would clash. And we did.

In the initial phase of Misha's return to ABT, it had been many months since he danced before a New York audience. When he told us that he was ready to start dancing again, we planned a gala featuring Misha. Baryshnikov's first New York appearance after an extended absence was a major selling point. I quickly got to work planning the event and sending invitations. We sold out immediately. I was excited about the evening. Two weeks before our gala and without any warning, Misha

performed at a Paul Taylor benefit. Naturally, the media covered it as "Baryshnikov's Return." I wrote to the president and the executive director and told them this was unconscionable. We had sold a benefit based on Misha's return to the New York stage. Bad enough it made us liars, I felt it scarred ABT's reputation. All of which I put in my letter. The board's response was, in effect, "Misha will do what Misha will do." That's how it was—Misha could do no wrong. I got it. He was the main attraction and the future. What was my integrity compared to his dazzle? This didn't bode well for me. In addition to his going off and dancing for Paul Taylor, Misha was becoming more involved with planning the galas and promoting his own ideas about what they should be. He didn't like the piecemeal approach of spotlighting a number of artists. He wanted to showcase the ballets that were going to be performed later in the season. That was how the New York City Ballet organized its fundraising events. Misha brought a lot of NYCB into ABT. In short, he wanted to do things his way, and he was the boss. With Lucia gone and Tudor not doing any new major choreographic work, I could see that my opinion no longer carried weight. Once upon a time, I had a lot of behind-the-scenes influence, much more than most people realized.

That Lucia confided in me, relied on me, and valued my input was a given. One afternoon in the early 1970s, she called me into her office. She was seated at her desk, and I settled into the chair opposite her. I expected to be asked to plan a gala or a special event. Lucia got right to the point.

"I want you to do something for me, Nancy," she said.

"I want you to promise me that if anything should happen to me, you would take over and run the company with Enrique Martinez."

I was convinced that I was hearing things. I wasn't. Lucia went on to explain her request. There was discord in the company at the time. Most of it came from a member of the board who, Lucia believed, had an eye on the director's seat and was not qualified. Lucia didn't want her company to fall into such hands, hence, she settled on me. She realized that I couldn't do it on my own and added Enrique Martinez to

the mix. Enrique, ABT's ballet master and assistant director, had been a dancer with the company. He was well-liked and well-versed in the company's business. In Lucia's mind, Enrique and I made the perfect pair to take over the reins. Not in my mind. I would have done anything for Lucia short of what she was asking. There was no way that I wanted to assume any part of the directorship. I know what's beyond my capacity and talent—running a ballet company tops the list. I wasn't qualified. You have to make decisions and fire people. I would have found both difficult to do, especially letting people ago. Also, it was a fulltime job, and I was married. Lucia was a widow and her whole life was running ABT. I talked my way out of it and convinced Lucia to hang in there. Imagine, Lucia Chase thinking I could run her company. And now Misha was the boss. I admired him as an artist, and I understood that he wanted things his way as the new director. It was time for me to move on. I'd had a good run and was content with my years at ABT contributing to the financial success of nineteen galas and raising its profile in the world of ballet. I loved the challenges it provided and the opportunity to hone skills that would continue to serve me well. It had given me a refuge and a mission that enabled me to offset the ups and downs of my personal life. Best of all, being around Oliver, Lucia, and Tudor had made everything worthwhile.

I can never say enough about Antony Tudor's influence on my life. During those ABT years, we grew close; my teacher and mentor became my dear friend. I would have done anything for him. At one point, my devotion was put to the test. Tudor asked me to be the executor of the Tudor Trust, a collection of all his choreographic works. That meant I would be looking at ballet companies and deciding whether or not to grant their applications to perform Tudor's works. This definitely wasn't my thing, and for a little while I was panicked. Tudor also spoke to Tony Bliss who suggested that his wife (my maid of honor, Sally Brayley) would be a good choice, particularly since Tony was a lawyer and could keep an eye on the legal end. Tudor was a practical man, and

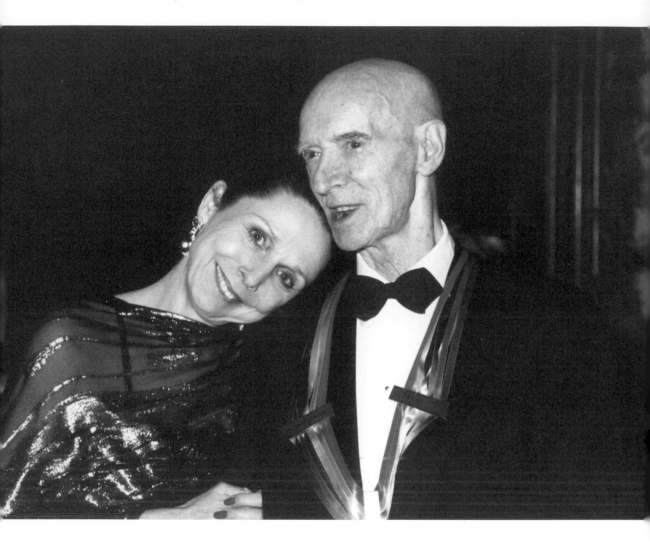

21.1 Nancy and Tudor at the Kennedy Center Awards

this was a perfect solution. Sally Brayley Bliss became the head of the Tudor Trust—and she does a fine job running it.

In 1986, Tudor was tapped for the Kennedy Center Honors and was preparing to go to Washington for the ceremony. Sadly, his life partner, Hugh Laing, would not be accompanying him. Outside the ballet world, their relationship was largely closeted, and Hugh did not want anything to take away from Tudor's evening. Neither one of them felt comfortable appearing together in public. Although I wasn't close to Hugh, I later learned that he had urged Tudor to take me in his place. Tudor agreed, but he said that if I didn't do it, he wouldn't ask anyone else. As if I wouldn't do it—I was thrilled that he asked me. What a compliment. No matter how decorative I was, I knew Tudor never would have taken me if he didn't respect me. Isabel Brown, a close friend of his, and once an ABT dancer herself, joined us. It was a remarkable weekend marred only by Tudor's poor health. I was more a caretaker than anything else, but I was happy to serve. Just being in his presence as he received one of the country's highest awards was an honor and a privilege.

Little more than a year later, I received a phone call at 12:30 in the morning. It was Hugh. He was calling from Tudor's residence in the First Zen Institute of America on East 30th Street. His voice was shaking when he said,

"Tudor just died. I need you."

I threw on some clothes and took a cab to the Institute. Hugh had also called Isabel, and we all spent the night together talking about Tudor. After the funeral service, the three of us took Tudor's ashes to Woodlawn, the same cemetery where Rudi is buried. I don't think that I'd spoken to Hugh more than a dozen times in all the years I'd known Tudor, but from then on, I felt a bond. I called every day to see how he was doing, as did Isabel. We didn't have much time to cultivate our friendship, though; he died within the year. After the funeral service, Isabel and I took his ashes to Woodlawn and put them with Tudor's. They had to cover up their relationship when they were alive, but they're together now.

Chapter Twenty-Two

A S ALWAYS, THE MANNER in which Bill and I lived depended
on cash flow. During one cash-strapped period, shortly after
we sold the Delmonico, we had to get rid of Spilling Pond. It
didn't bother me a bit; I couldn't wait to get out of there. But
Bill needed a weekend retreat, so I found a place to rent in Chappaqua.
It wasn't far from Mt. Kisco in mileage, but light years away in style—a
contemporary glass house reminiscent of Philip Johnson's Glass House
in Connecticut. I named it Happy Hill and was keen to move in. One
Monday morning, Bill left Spilling Pond for Manhattan while I stayed
on. Early that afternoon, the movers took over. Without telling him,
I'd arranged to have everything he loved, including the precious Bose
speakers, transferred and set up in our new residence. I created a mu-
sic room for him where he could hover over his speakers to his heart's
content. Four days later, when he drove to Happy Hill, everything had
been transported and put in place, including me. Bill walked through
the door and was instantly at home, except that this place, unlike the
pre-Revolutionary Mt. Kisco throwback, was streamlined and up to
date. He was so pleased with our new quarters, especially his music

room, that Spilling Pond wasn't mentioned again. As for me, I had a chance to create a contemporary environment. Who could ask for anything more? A year or so later, when the cash started flowing again, we bought the house. I wanted to add a master suite, but how to add a room to a glass house without affecting the contemporary lines of the exterior and the integrity of the interior? There was a beautiful spiral staircase in the living room going down to the lower level, and it occurred to me that we could continue the spiral without changing anything on the main level. The only way was up. With the concept in place, I called our architect friend Frank Williams, and soon a perfectly integrated bedroom suite was added on to the top of our glass house. We rarely entertained in the city, but we did invite people to Happy Hill on the weekends. After dinner, I'd put on a brief recital for them consisting of dances I'd choreographed. I thought it was great and loved doing it. Bill loved it too, but once observed, "You rehearse so much, it's as though you were performing on the Met stage." I told him that was the point. I wanted to do my best whether it was for an audience of a dozen friends or a theater full of strangers. My brother Jim found out about my shows and asked if I would come back home and do one of them. I think he got a kick out of playing impresario for his famous sister. It gave me a chance to perform, so I did it. I returned to Tidioute where Jim had rented a grange hall, and people actually turned out. I danced to *Carmen*, some Brahms waltzes, and Scott Joplin. It took a half-hour. Short and sweet, that's my way. And so, our life continued, still no bed of roses, but worth the challenges. Out of the blue, an opportunity arose that changed everything.

St. John's College is a liberal arts college with dual campuses in Annapolis, Maryland, and Santa Fe, New Mexico. In the early 1980s, the college wanted to sell an eighteen-acre plot adjacent to the Santa Fe campus. Bill was asked if he would be interested. Nothing much was going on in New York at the time, and Bill was eager to be doing something. The proposed project could be exactly what he needed,

and the fact that it was in Santa Fe heightened my interest. Given how enthralled I was by Santa Fe during the two summers I danced with the SFO and given that meeting Irma Kolodin there had set the course for my post-dancing life, it's odd that twenty years had passed without another visit. Bill had never been to Santa Fe. Our married life was centered in New York and filled with everything the city had to offer. When we traveled, it was to Europe and the Caribbean. Santa Fe was out of the way and off the map for us. Now, however, we had good reason to go. We flew out and stayed at the Bishop's Lodge, the very place where I had met Bill's mother.

St. John's property was near the Museum Hill area of Santa Fe, two miles from the Plaza, the center of town. The views were lovely. Bill felt it was the perfect spot to build a condominium complex. He was excited by the prospect of building something on his own. His work so far had been to clear the way for his father's projects while trying to keep the company from going under. Long after Bill Sr. died in 1976, Bill continued to oversee his father's ongoing projects. Creatively, my husband was starving. Santa Fe offered him a banquet. Shortly after the Santa Fe development was undertaken, Bill also started a number of major projects of his own. For the next ten years, he was on an astounding roll. After Bill died, I remember showing his son, Will, a list of his father's projects. Will couldn't believe the output of the last decade before Bill retired. "He did all that, in that space of time?" he marveled.

Getting started with the Santa Fe project was no piece of cake. The locals were wary of a New York developer who built skyscrapers. The newspapers had little good to say about us. Almost every tree that had to be cut down was mourned on the front page of the *Santa Fe Reporter*. "New York Developer Comes to Santa Fe and Knocks Down Pinons" read one headline. Bill persevered and did everything in his power to back up his good intentions, particularly by adhering strictly

to the building code. But no matter what he did, for a long time, we were viewed as city slickers capable of bad acts. The task of placating Santa Feans became a lot easier when David Ater—a respected local banker and real estate investor—joined us as co-developer and project manager. Meanwhile, Bill asked me to give the place a name. Since the views played an important role in the setting, I proposed Los Miradores which loosely translates as "places to look from." I was pleased and proud when Bill asked me to be the design consultant for Los Miradores. He never would have done that unless he had full confidence in my ability. That meant a great deal to me.

Work on Los Miradores began, and for the next few years I traveled back and forth from New York to Santa Fe every six to eight weeks. I stayed for three or four days and returned home. Bill's son, Will, served as a long-distance project manager, looking after things from the East Coast. When Will was accepted at Harvard Business School, he had to step away. Around the same time that Will left for school, I got a call from one of the realtors involved with Los Miradores.

"Nancy, I went to the condos to see how things were going, and one of them has a fireplace in a room that I don't think it belongs in."

"I'll be right out," I told him.

I flew out of New York the next day and went straight to the property. Sure enough, a fireplace had been put in the wrong place. I won't go into detail, but it turned out that the guy who'd been acting as on-site project manager was also a partner in another Santa Fe development. The nicest way I can put it is that Los Miradores was given the short shrift. We needed a project manager stat, and that's when Bill asked me to step in.

"You can handle it until we get a permanent replacement," Bill said.

Now, in addition to overseeing the landscaping, the marketing, and the design, I was responsible for everything including construction. I was buoyed by Bill's conviction that I could do the job. I love construction work. I get a kick out of looking at plumbing fixtures. Blueprints

enthrall me. And, of course, there was my long-standing infatuation with space. Overall, Los Miradores had been beautifully designed, but adequate attention had not been paid to how the inner space was to be used. I walked myself through the blueprints and worked out as many details as I could. I imagined going through the front door and asking the questions that should be asked. Where do I put my handbag? Where's the closet? Where's the kitchen? Where are the bathrooms? Where are the bedrooms? It sounds simplistic, but you'd be surprised how often these important details concerning space are overlooked. I took a lot of time with the blueprints making certain that the space would be comfortable, useful, and pleasing to the eye.

I spent nearly four years as project manager until David Ater was able to take over. During that time, a condo at Los Miradores became available and Bill and I took it. It was easier to have an established household than to keep checking in and out of hotels. I was spending more time at the condominiums. Our base remained Manhattan; Santa Fe was strictly business. I liked being there, but we were there because we were building. In the early 1990s, we invested in another Santa Fe project, Sierra del Norte. We bought and sold lots—again with the help of David Ater—which turned out to be far more profitable than selling condos.

Gradually, I began to feel the pull of my second city. Unlike me, Bill wasn't immediately drawn to Santa Fe. It's hard to believe, but it was only after he came to Santa Fe that my husband discovered his Southwestern roots. He was genuinely surprised to learn that after immigrating from Hamburg, Germany, in 1856, his great-grandfather, William Zeckendorf, spent six months in New York City attending school, then traveled for six months by wagon train to Santa Fe where he went to work for his older brothers, Aaron and Louis. He was fourteen years old. The Zeckendorfs, along with the six other German-Jewish families with whom they'd immigrated, became prominent citizens of

New Mexico, both in Santa Fe and Albuquerque. Great-grandfather William eventually left for Arizona and settled permanently in Tucson where he prospered as the proprietor of a general store. Though the Zeckendorfs started out as merchants, they also dabbled in real estate. Bill once said that Bill Sr. didn't talk that much about his family's past because he was "too busy living in the present." That was Bill Sr.'s way. My husband, on the other hand, appreciated his Santa Fe roots. Still, his home was Manhattan, and more than once he announced,

"I know you like Santa Fe, Nancy, but, just so you understand, when I retire it's going to be in New York."

So much for firmly stated intentions. When my husband retired, we settled permanently in Santa Fe. The man who was going to spend his golden years in New York City chose instead to stay in Santa Fe. While his defection had a lot to do with physical and financial difficulties, he came to prefer the leisurely Southwestern pace. We kept the New York apartment, and Bill occasionally went back to see friends, enjoy concerts, operas and ballets, and attend wine dinners. Ultimately, home became Santa Fe. He was a changed man. The depression, the anxiety, the doubts, all of them lifted. Even though he lived in constant pain, he was content. At first, the going was somewhat rough. In keeping with the erratic reversals of a developer's life, when Bill retired, after ten boom years of construction, he was ten million dollars in debt. That's the price you pay for personally guaranteeing your projects. We had taken a loan from the bank to acquire the Sierra del Norte lots. However, in the late 1990s, the financial situation was souring. It appeared that the bank was going to call in our loan. If they did, we stood to lose the property. However, there was a fail-safe. In a similar situation, Marion Zeckendorf, unbidden, had returned money that had been given to her by Bill Sr. for him to stay solvent. In our case, we needed to give the bank $450,000 to hold onto Sierra del Norte. Like Marion, I was in a position to help my husband. Bill had given me a large sum of money from the sale of a hotel in LA, and I didn't hesitate to return what was needed to keep us afloat. We were able to retain the

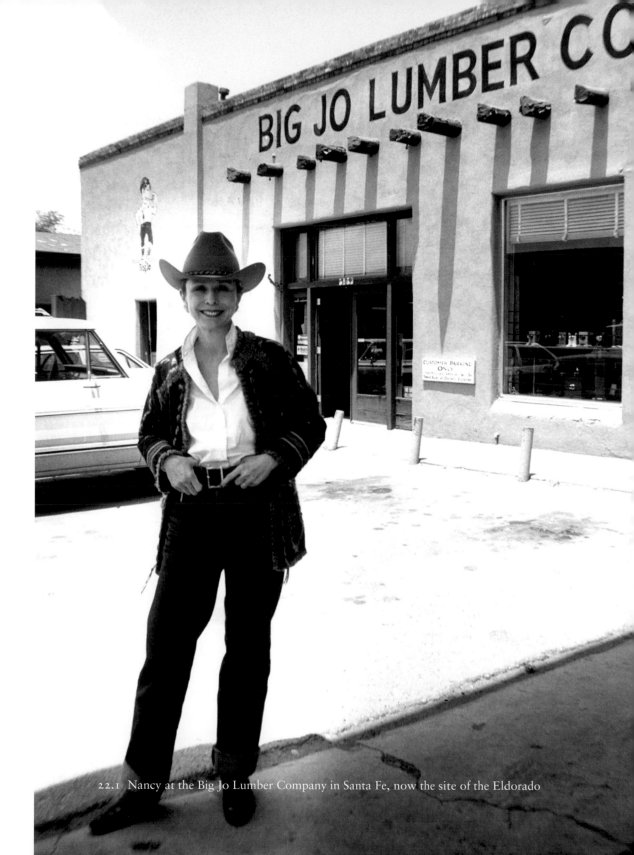

22.1 Nancy at the Big Jo Lumber Company in Santa Fe, now the site of the Eldorado

22.2 Nancy and Bill's home in
Chappaqua, the bedroom addition
by Frank Williams

property and eventually pay off all our debts, primarily with the money from the Sierra del Norte sales.

In 1983, during the construction of Los Miradores, Robert Love, a realtor friend, told Bill and me that there was a two-acre piece of property for sale on West San Francisco Street, which he urged us to buy. He said we needed to build an upscale hotel where potential buyers could stay when they came to look at the Los Miradores condominiums. Neither of us had put two and two together, but the minute Robert brought up the idea, we realized he was right. We were selling luxury condos, and the few small hotels in town where interested parties could stay were not exactly luxury—hardly an inducement to settle in Santa Fe. I must add that times have changed. Ugly ducklings have become swans and there are lovely lodgings in and around town. We told Robert we were interested, and he spoke to the two owners. They were hesitant about selling to us. It may have been the city slicker stigma. I told Robert and Bill I'd go over and talk to them myself. I thought I might be able to change their view of us. So, I trotted over to the Big Jo Lumber Company. After introducing myself to the owners, I revealed my own lumber-related origins, and pretty soon we were talking the talk—two-by-fours, tenpenny nails. I was no city slicker; I was like them. We got along fine, and they agreed to sell. It was a high price, too, but the city slickers didn't bargain. We gave them what they wanted.

Smooth sailing did not follow. There was local opposition. Santa Fe is a small town and many residents wanted to keep things the way they were, which we already knew from our experience with Los Miradores. Words such as "large" and "luxury" struck discordant notes in the community. However, we convinced enough opponents that a large luxury hotel would be an asset, not a detriment, and we were given the go-ahead. There was an aesthetic bonus which Bill Zeckendorf had grasped inherently. A cathedral stood at the end of San Francisco Street. Placing an imposing structure at the other end would anchor

the commercial street and create a harmonious line. The property was bought, the lumberyard was razed, construction began, and in December of 1985, the Eldorado Hotel opened its doors. It's the largest hotel in town (five stories), and some local residents think it's too big, but the Eldorado has become an integral part of Santa Fe's social, business, and artistic life.

Even as he eased into his new life, my husband couldn't stay idle. Retirement wasn't a word Bill Zeckendorf completely understood. He had his music and his books, but he wanted to get involved with his new community. He was asked to join boards, including the Santa Fe Chamber Music Festival, Saint Vincent Hospital, The College of Santa Fe, and The Lensic Performing Arts Center. He was a significant asset to these groups because he knew how to get things done. Santa Feans were eager to take advantage of his knowledge and skills. A colleague from the hospital board told me that having Bill as a trustee was a real coup because he had insights and sound ideas that he proposed with characteristic modesty. Bill was thrilled to discover that Santa Fe had a Tastevin chapter. Bill and I were home. During his twenty years in Santa Fe, my husband came into his own—and the community and I were direct beneficiaries. Those two decades were the best years of our lives together.

✳

Chapter Twenty-Three

I CONTINUED TO WORK at the condos and settled into my new life in Santa Fe. One afternoon when Miranda Levy and I were having lunch, the conversation rolled around to the Santa Fe Opera. She knew that I'd danced with the company for two summers.

"You should be on the opera board. I'm going to propose you," she said.

When I got home, I told Bill what had happened.

"I don't think I want to be on the board."

"Oh yes you do," he answered.

And so, I joined the board, and over the next fifteen years would become vice president, president, chairman, and chair of the capital campaign.

Perrine McCune drove me to my first meeting. Perrine and her husband, Marshall, were major benefactors. Among other things, they covered the opera's yearly deficit in the early years. Perrine picked me up in a vintage Buick; I remember that she was wearing white gloves. As we drove, I worked up the courage to ask her what the board dues were. She turned and said gently,

23.1 Opera founder John Crosby with Nancy

"My dear, we don't talk about that."

Sure, I thought to myself, when you can pay down an opera company's deficit you don't have to think about paying dues. I dropped the subject.

I was looking forward to seeing John Crosby at that first meeting, and he was exactly as I remembered him—about as off-putting a person as I'd ever met. Someone who could alienate others without even realizing it. It didn't matter who you were—board member, big donor, famous musician, architect, or the director of television opera for PBS—he could wither anyone. It was our first encounter in twenty years, and he never even looked at me. True to form, he was focused on getting what he wanted for his opera company. There was never a detail too small for him to contest. If he didn't like the way things were proceeding at meetings, he would threaten to walk out. Jim Polshek, the architect whose firm was hired to build John's third opera house, called him "a nitpicker beyond any I ever dealt with." I can attest to that. I attended many meetings in Jim's office, and at ninety percent of them John announced that he was going to leave. He'd get up and start toward the door, but he never made it out. He'd always get what he wanted. Jim accepted the dramatic outbursts because he knew that John respected what the architectural firm was doing. There was a tacit dialogue between them that Jim came to rely on. Despite John's punctiliousness, he and Jim grew to have, as the architect put it, "a very warm, albeit silent relationship." John wasn't a big talker. As for my own relationship with John Crosby, it blossomed. We became good friends—although I always took a deep breath when I had to telephone him. Some things never change.

I'd been a board member for a while when Tony Riolo, the executive director, asked me to do a gala. I liked the idea and came up with what I thought was a unique plan. Instead of a single event, why not have a gala weekend starting with a grand ball on Thursday, followed by pre-opera dinners on Friday (opening night) and Saturday, and wrapping up with a Sunday barbeque luncheon at one of the prestigious art

galleries in town. The board liked the concept, and the next thing I knew, I was planning a gala weekend and knee-deep in index cards. I never changed my ABT modus operandi. Even after computers took over, I relied on my tried-and-true method for seating arrangements. I admit I'm a dinosaur, but I'm comfortable doing it the old-fashioned way because it personalizes the process. Months before the first gala weekend, the index cards would be placed in the four corners of my living room. One corner was for the Grand Ball at the Eldorado Hotel (to this day, the only place in town with a large enough ballroom). The next corner contained cards for Friday's opening night dinner. The third corner contained the theater seating for opening night; the last corner was for seating of the second opera on Saturday night. Sunday's barbeque at Nedra Matteucci Galleries didn't require formal seating, or I would have been out of corners. The initial opening weekend of the gala was a triumph. Ever since, the opening weekend celebration has remained an integral part of the Santa Fe Opera season—and a proven money maker.

Time moved on, and so did the plans for the new opera house that John wanted. I became involved from the beginning. John invited me to participate in many activities, including the architectural meetings with Jim Polshek. John sought my opinion about many aspects of the new house. He invited me to select seats and pick colors for them, as well as wood finishes for the walls. I was pleased that he trusted my judgment. Of course, it was always better if my judgment jived with his. For the most part, it did. There were some sticking points that I fought for. Jim wanted to have pedestal sinks in the bathrooms. I told him no.

"You can't do that in a ladies room. Women need a long counter to put their bags and programs on while they wash their hands. And you need a long mirror above the counter so they can see to put on lipstick." I have to laugh. Men usually design women's spaces, and they know nothing about women's needs. That was the great thing about John, though. He encouraged me to speak and he listened. In most instances, he heeded my advice. I was finishing my three-year term as chairman of the opera when the

capital campaign for the new house was announced. We ran into trouble getting an important businessman to chair the campaign; nobody stepped up. So, even as my time on the board was ending, I was asked to be the chair. According to the by-laws, a trustee could serve as president of the board for three years and chairman for another three years. After consecutive terms, the trustee was required to leave the board for at least a year before returning. I was a lame duck, and if I chaired the campaign committee, it would be as an outsider and not as a board member. This bothered me. I told Bill, and he agreed that under no circumstances should I chair the campaign without being a board member.

"You tell them that you want three more years on the board or you can't be the campaign chairman." They agreed. I remained on the board for an additional three years. I knew from the start that I was on borrowed time, but it was an exhilarating and productive time.

Robert Glick was hired as director of resource development at SFO and worked together with me on the campaign. We got along well. We both loved opera and enjoyed what we did. During the capital campaign, we reserved a table for lunch at Escalera, a restaurant in the old Sears building and home to the one and only escalator (*escalera*) in town. Escalera was *the* place for lunch, and our little table was a seminal gold mine. We always walked away with a big pledge—at that table alone, we raised six million dollars for the cause. The tables at Escalera were covered with white butcher paper. One afternoon, the owner laughingly offered to have pledge forms printed on the table coverings so we could ink the deals right then and there. Escalera was home base, but we knew we also needed to travel in search of donations.

Around the time construction was starting on the new opera house, Robert and I began discussing ways to expand the giving base. While the Santa Fe community had money, most of the supporters were individuals rather than businesses and corporations. It was obvious that we needed corporate donors. Robert did some research and came up with Phelps Dodge, a mining corporation with a large presence in New

Mexico and Arizona. Contributing to New Mexico's prestigious opera company would be a worthy civic gesture, given that Santa Fe was home to both the state legislature and the SFO. When Robert mentioned Phelps Dodge, the name rang a bell, but I couldn't put my finger on it. While Robert set up a meeting at the Phelps Dodge headquarters, I did some research on my own. The day of the meeting, I took an early flight to Phoenix. Robert had gone ahead the night before and he met me at the airport. We walked to the car and got in. Before he put the key in the lock, Robert turned to me.

"How do you do it?" he asked.

"Do what?" I didn't know what he was talking about.

"You get off the plane and you're in your traveling clothes and you look a little, let's say, tired. As we walk to the car, you take off this top you're wearing, turn it inside out, shake it, and put it back on. Then you twist your hair this way and that, and in the five minutes it takes us to get to the car, suddenly you're a glamour girl. I repeat. How do you do it?"

"You ain't seen nothing yet," I said, reaching into my handbag for my makeup kit. "I haven't even put on my face."

We arrived at the headquarters and were ushered into a conference room where we were introduced to half a dozen executives, including the CEO and the director of philanthropy. When we were all seated around the table, I spoke up.

"Before we begin, may I read something to you?"

The guys looked at me curiously but no one said a word. The CEO told me to go ahead.

I reached into my bag and pulled out a book about the Zeckendorfs.

"I'm going to read a selection from this history of my husband's family which I think you'll find interesting."

Robert was staring at me with his mouth slightly open. The CEO asked me to go on. I put on my glasses and opened to the marked page. The brief passage I'd selected told the story of Bill's great-grandfather and great-uncle who'd settled in Tucson where they ran a general store.

23.2 Exterior of the new Santa Fe Opera.

23.3 Nancy chaired the $21 million capital campaign in 1996
to build the new Santa Fe Opera house, designed by Jim Polshek

As a sideline, the Zeckendorf brothers grubstaked miners. On one occasion, they discovered a rich copper lode which was sold to two gentlemen back in Boston—one named Phelps, the other Dodge—and the Phelps Dodge Mining Corporation was on its way. I finished reading, closed the book, smiled, and said,

"That's the story, gentlemen. Now, if you don't mind, speaking for my husband and me, we'd like some of our money back, and we'd like it to go to the Santa Fe Opera."

It took less time for them to come up with a six-figure gift than it took me to read the story. We spent the rest of the meeting talking and laughing. Phelps Dodge's contribution gave a big boost to the drive. Among other things, it paid for the hard surfaces of the parking lots, the water collection systems on the roofs, and the gray water recycling on the grounds—all of which are in place thanks to that long ago Zeckendorf grubstake.

We raised twenty-one million dollars for the Santa Fe Opera. The capital campaign was exciting and invigorating, a high mark of my association with the SFO, marred only by John Crosby's declining health. He'd had health problems all his life, beginning with the asthma that brought him to New Mexico as a teen. His ailments increased as he aged. He had arrhythmia but he wouldn't give up smoking and continued to work to the point of exhaustion. Board members were concerned and began talking among themselves. The consensus of opinion was that he should retire. John had been general director and chief conductor for nearly forty-five years, the longest unbroken tenure in American opera history. Asking the founder and leading figure of an organization to step down is a tricky business. I'd already watched it play out with Lucia Chase. At one point, knowing how close John and I were, the board asked me to convince him to step down. I knew it was time for a change, but I wasn't going to be the one to tell him. I politely refused. My reluctance reveals why I was never the perfect choice for president of the SFO board. A board president should be impartial, and when it came to what was good for

the opera, I sided with John. Although I didn't participate, board members started dropping hints here and there, and John picked up on them. In time, he accepted the fact that he could no longer run the show and retired as general director in 2000. In 2002, at the age of seventy-six, he died of complications following heart surgery.

About the time the board was trying to get John to retire, I was nearing the end of my additional three-year term on the board. I didn't want to leave because I felt that I could be of help to the company. The board had changed, though, and they were looking for more change, too. I'd already been through this with ABT. At ABT, I had my hand on the galas and fundraisers. At SFO, I was absorbed in every aspect of the organization. I knew and loved the people who were part of it. I went to my last meeting feeling that it was the end, and I was right. One trustee proposed to make me a lifetime member of the board, but was told, "We don't have lifetime members." My immediate thought was, well, this would be a good time to begin. A few people tried to make it nice for me, but the message was "goodbye and come back and see us in a year." It hurt.

Although the end of my association with the Santa Fe Opera was not what I'd anticipated, I look back with great pleasure at my time there. I grew up and came into my own with the SFO. I took great joy working with John Crosby. John became my champion, as I was his. He joined my dad, Tudor, Pei, and, of course, Bill, as major male influences on my life. (Rudi was different. I was his girlfriend and so much younger. He didn't want to talk business or life with me.) The Santa Fe Opera was the house that John Crosby built, and I am proud to have been a part of it.

❈

Chapter Twenty-Four

I n the late 1940s, Jimmy Durante, a popular comedian, had a
weekly radio program. Among the regular cast members was
Candy Candido, a man with remarkable voice range. Candy
had a catch phrase that he repeated every week. He'd start in
a high-pitched voice, "I'm feeling mighty..." and plummet to a deep
bass, "low." That's exactly where I was, mighty low. I was out in the
cold and no longer attached to the Santa Fe Opera which had become
part of my DNA. It had been difficult leaving ABT, but the break was
my choice and I remained part of the ABT family. It was different with
the Santa Fe Opera. I'd been put in an untenable position—trustee
terms were restricted according to the by-laws and mine were over. I
tried to convince myself that I'd been fundraising long enough, and it
was time for something else. But what? I was in my mid-sixties hav-
ing spent the last thirty years raising money for organizations with
which I was passionately involved. Now I was adrift. I was miserable
for a while and gradually began pulling myself together. My efforts
to get back to normal were sustained by my new relationship with
my husband.

All the years of putting up with the silences, the depressions, the anxieties had paid off. The real Bill—the kind, loving, caring person who had been in the wings for so many years—was now at the heart of my life. It was wonderful to be with him, to talk, to laugh, and to work. Our relationship grew stronger, but Bill's health began to weaken. Much of my time was spent assisting him. He was a big, strapping guy, but four hip surgeries, four back surgeries, and countless hospital visits had depleted him. He was always in pain, yet he never complained. He was heavily medicated at times, which occasionally proved awkward and potentially dangerous. Here's an instance. Bill loved to drive. As his mobility decreased, driving the car allowed him to get around in the world, even though the act of getting behind the wheel was an ordeal. One day, on his way to a board meeting, he fell asleep at the wheel. The car went to the other side of the road and banged into a gate. He was going slow, so the car and a dislocated gate were the only casualties. Later, when he went to court to face charges, the judge asked him to describe the event. Bill Zeckendorf, ever honest, began his account.

"Your honor, I had taken so many drugs that…"

"Shhh," silenced the judge, tapping his gavel to keep Bill from incriminating himself.

In the end, the man whose gate had been damaged didn't press charges, and the judge let Bill off with a mild admonition. Bill had no previous offenses. It was a blip on an otherwise clean record. I'd been urging Bill to give up driving for a long time, but he'd resisted. The crash was a wake-up call. He realized that it was not safe for him to be at the wheel anymore. He stopped. He didn't like it, but he did it because, as always, he wanted to do the right thing.

Meanwhile, it was becoming more difficult for me to care for him. Early in 2002, he was going into the hospital for one of his surgeries, and I knew I couldn't handle him myself when he came home. As diminished as he was physically, Bill was still a big man and needed constant assistance; getting to his feet was a major effort. I needed

help. That's how Connie Ross came into our lives. Connie was recommended by a friend. One morning, she came to the house for an interview. I liked her right off the bat. I asked if she could take care of my husband for three or four weeks. She accepted but made it clear that she was available for only four weeks. As it turned out, Connie looked after Bill for nine years. He was crazy about her, and he trusted her. If anything was wrong, he'd say, "Ask Connie." Connie claims that I was the real caregiver because I saw to it that everything in Bill's world was right as possible. Connie and I were a team. We'd talk about what was going on with Bill, she'd offer analysis and guidance, and I'd speak to his doctor. Nine times out of ten, Connie was spot on. Bill would listen to whatever she told him. Many times, he was too weak to speak up for himself, and she'd do the talking. According to her, whenever he talked, it was always about me.

"Nancy this and Nancy that," she said. "He has you on a pedestal, all right."

"Oh," I explained, "it's because he doesn't like to talk about himself, so he talks about me."

I don't know what I would have done without Connie, or what I'd do without her now. Bill died in 2014, but Connie Ross drops by regularly. We have a pact: we're going to look after each other forever, period.

With Bill in good hands, I was able to relax, doing things simply because it pleased me to do them and not for a cause. I pretended I was on permanent sabbatical and relieved not to have to ask anyone for money. I attacked my closets with renewed vigor. I thought I was content to take it easy, but I thought wrong. I was still a bit lost when, once again, Bill came to my rescue.

※

24.1 Bill served as the Grand Sénéchal of
New York's chapter of Tastevin in the 1990s

Chapter Twenty-Five

A T THE TURN OF THE TWENTIETH CENTURY, Nathan Salmon, an itinerant pushcart peddler born in Syria was stranded in Santa Fe, New Mexico, during a snowstorm. The storm moved on, but Salmon and his wife did not. They remained in Santa Fe where Nathan made his fortune in investment properties. By the time he died in 1941, he was one of the wealthiest men in New Mexico. A civic-minded man, Salmon wanted to give something to the town in which he had prospered. Shortly after the 1929 stock market crash, he decided to build a motion picture theater. Salmon and his son-in-law, E. John Greer, hired Boller Brothers, the top movie theater designers of the day. On June 24, 1931, during the Great Depression, the Lensic formally opened. (Lensic is an acronym of the initials of Salmon's grandchildren, Lila, Elias, Nathan, Sara, Irene, and Charles.) It was a big theater for a small town with eight hundred and thirty seats. Santa Feans were awestruck by its size and the elaborate decorative style of its Spanish/Moorish architecture. Among other delights, stars sparkled in its ceiling and cloud formations billowed around them. Like many movie houses of that era, the Lensic not only showed films, but also featured vaudeville acts and concerts performed by internationally

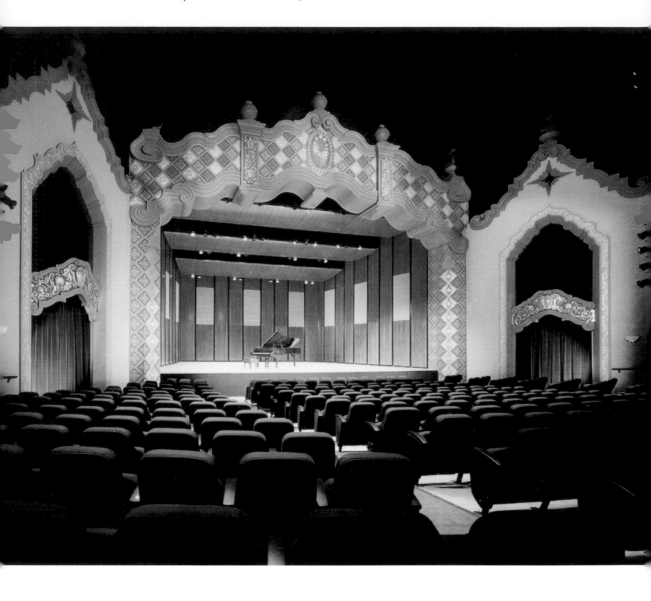

25.1 Interior of the Lensic Performing Arts Center in Santa Fe

known musicians and entertainers. In its heyday, some of Hollywood's biggest stars, including Claudette Colbert, Rudy Vallee, Rita Hayworth, and Roy Rogers, appeared in person to promote their latest films. In 1938, Judy Garland was there to sing "Zing! Went the Strings of My Heart" from her movie, *Listen, Darling*. In 1940, thousands filled the streets to see Olivia de Havilland, Errol Flynn, and Ronald Reagan in person at the premiere of Warner Bros.'s *Santa Fe Trail*. On the classical side, musicians such as Gregor Piatigorsky, Alexander Kipnis, Rudolf Firkusny, Bidu Sayao, and Rise Stevens performed, as did Martha Graham's dance company. The Lensic flourished for decades and then faded. Other diversions, particularly television, kept potential moviegoers away. While movies continued to be screened, live events ceased. In 1999, the Lensic was permanently shuttered. My husband put the plan together for the Lensic's second act. Bill was actively involved from the beginning, meeting with people, putting the deal together, and trying to secure the proper zoning. I stayed out of the picture. This wasn't a ballet or an opera, it was a building. Bill and I rarely spoke of it until one evening after he returned from a board meeting. I opened a bottle of Burgundy, and as we sat down for a quiet drink together, he said,

"Nancy you've got to raise the money for the Lensic."

"I don't want to," I said.

"Well, I'm afraid you're going to have to. You're the only one. Nobody else can do it."

I kept insisting that I wasn't looking for something to do, but Bill was smart enough to know that I needed something to do. In the end, I was smart enough to know he was right. Two days later, I went to a committee meeting. The next thing I knew, I was back in the saddle again.

First, he solved the problems with the zoning while I put together a campaign to bring the theater back to life. As far as raising money in Santa Fe goes, it can be tricky. Santa Fe has a population of approximately 84,000, including a large group of retirees. There are many not-for-profits in Santa Fe, and they all go to the same people, the same

store owners, the same banks. The city has no corporate businesses. If you get $2,500 or $5,000 from a bank, you're doing well. Nor did we have a lot of big money individuals to go to. Yet, the Lensic was a unique cause galvanized by the theater's special place in Santa Fe. People remembered sneaking in as kids, going on dates as adolescents, sitting in the crowded balcony, sharing popcorn, sipping Cokes, and smooching while watching the latest Hollywood offering. The Lensic was part of their growing-up years, and when it comes to raising money, that kind of fond familiarity has a potent effect.

When we began the campaign to create the Lensic Performing Arts Center, Joe Schepps, one of my colleagues on the board, arranged a lunch meeting for Bill and me with a generous couple from Texas, Anne and John Marion. Right before we met with the Marions, I checked with Joe to ensure they had been told that I was going to ask for money. I'd been fundraising most of my adult life, and I had rules. I wouldn't solicit anyone unless they knew the purpose of our meeting. Joe said he told the Marions that he wanted the four of us to get to know each other better. That made me nervous. I didn't feel right about asking them to lunch and then asking for money. But it was too late to do anything but proceed. The Marions were lovely people, and we hit it off, but all through lunch, I felt awkward. We discussed the Lensic, and it was apparent that they were expecting something, but nothing was happening. I was trying to find the right moment to make the pitch. Finally, Anne Marion put down her fork, looked me in the eyes, and said,

"I'll give you a million dollars if you can match it three times."

I learned a lot from that lunch. I began to rethink my staunch insistence that people should be forewarned that they're going to be asked to contribute. By keeping my mouth shut, we got more money than the five figures I would have asked for.

We raised nine million dollars in our initial Lensic appeal, and that was used to renovate the space. I began gathering a workforce. I hired the

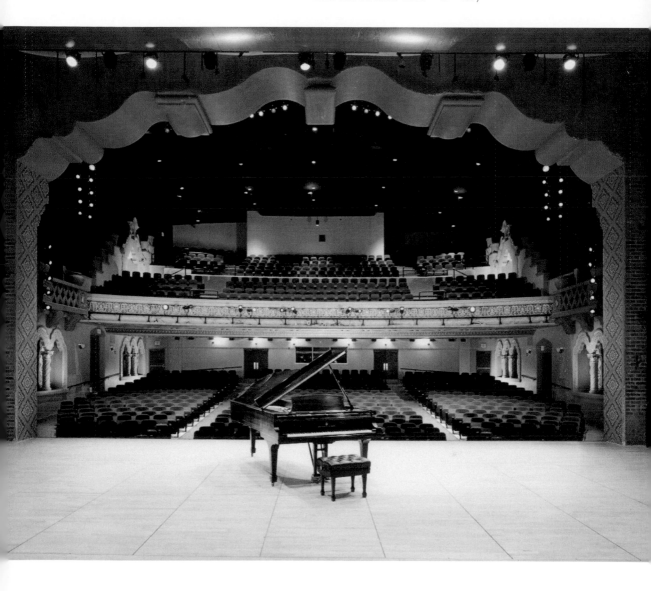

25.2 The Lensic theater, view from the stage

25.3 The Lensic stage,
view from the balcony

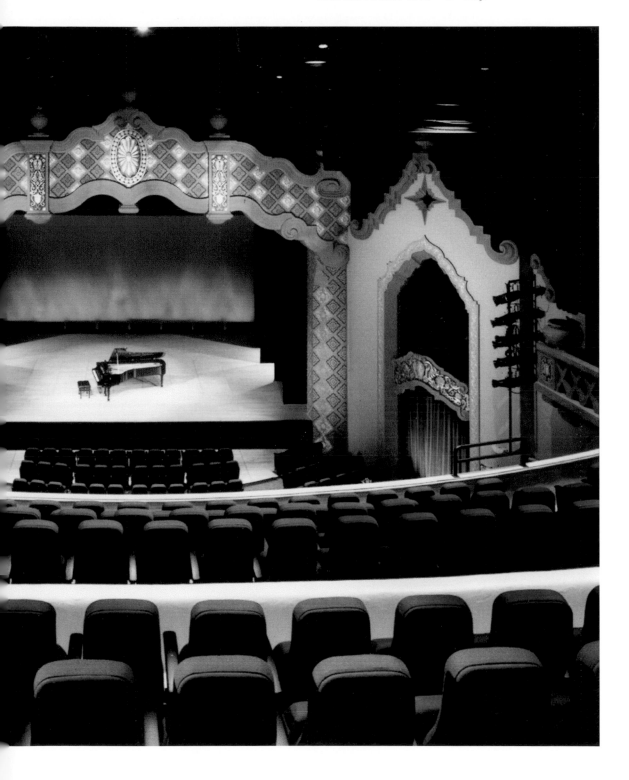

acoustician who worked with John Crosby on all three opera houses. He must have been ninety at the time, but he was an expert. I asked people from the Santa Fe Opera to help rebuild the marquee, refurbish the crystal chandeliers, rewire the original sconces, and implement other restorations. Sometime later, I began another fundraiser, this time to raise money for an endowment. It's all well and good to put up or restore a building, but once it's standing, you have to have money to keep it up to date. Technology changes fast; state of the art at the beginning of the year is antiquated by year's end. It's daunting because you think you've got everything covered—then the boiler breaks down. There is always a problem that needs to be solved by raising money. Working with the Lensic is different from working with ABT or the SFO, each of which represented my two big loves, dance and opera. That said, the Lensic does provide a home for music and dance—and opera, too. We screen *The Met: Live in HD* opera broadcasts. I've been with the Lensic for more than twenty years, helping with the galas, chairing annual fund drives, and working with a wonderful group of people throughout. When I get tired and think about retiring, I remember that I've never dealt well with sabbaticals. Since Bill is no longer here to get me moving, it's up to me to heed what he preached and stay active and engaged.

❄

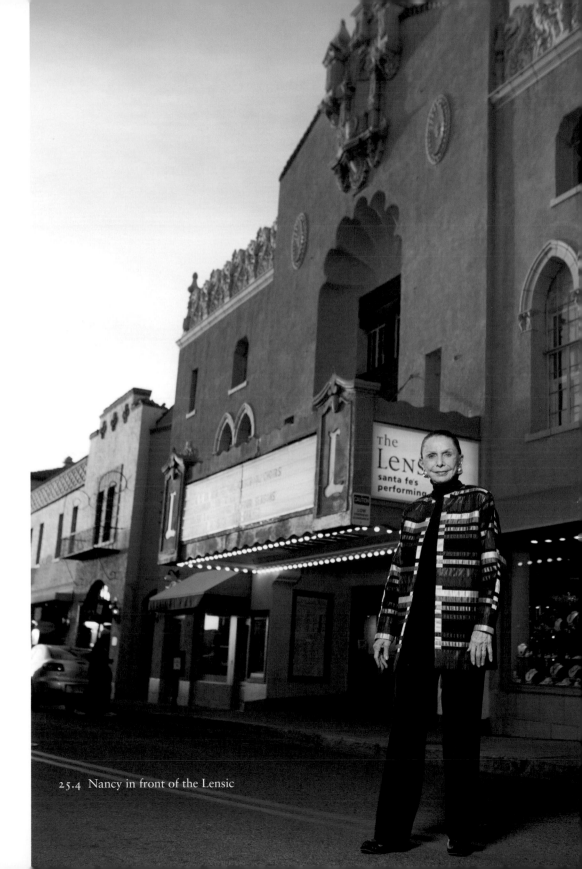

25.4 Nancy in front of the Lensic

Chapter Twenty-Six

WHEN BILL WAS TAKEN to the hospital late one afternoon in February 2014, he was heavily sedated and totally debilitated. I was told to stay home and come the following morning. The attendants put him in the ambulance and closed the doors. I watched as the ambulance started slowly down the driveway. Just before reaching the road, it came to a stop. The driver got out, ran back, and said, "Mr. Zeckendorf wants his iPhone." That was so Bill. I got the iPhone and gave it to the driver. The ambulance disappeared from view, and I went inside. Bill had been so ill for so long, I knew in my heart that he would not be coming home. Early the next morning, I joined him at the hospital. He was failing. As I sat by his bed, he reached over and took my hand in his. He was struggling to say something, but he didn't have enough oxygen in his lungs to talk. I put my head down, straining to hear him. He could get out only three words.

"I love you," he whispered.

As far as I could recall, that was the first time he'd ever said that to me. We weren't in the habit of expressing our feelings. I was touched by it. Those were his last words. Bill died the next day.

There were memorials in Santa Fe and New York City. The former was held at the Lensic and the latter at the Pierre Hotel. Bill's sons had arranged the New York memorial and chose the Pierre because that's where many of the Tastevin dinners were held. I spoke at both events to remind his family, friends, colleagues, and everyone who was there, what a good man Bill Zeckendorf was. I didn't need to remind anyone. I was stating what everyone already knew. Whatever trials I experienced in my married life, that's where they stayed. In the world, Bill was always a kind, thoughtful, and just person. And when we moved to Santa Fe, he became that person for me as well. Taking care of Bill made me a stronger and better person. I made a commitment and stood by it. Bad times and good times, I spent half a century with Bill Zeckendorf, and I miss him.

After Bill was gone, there was no question that I would continue to work with the Lensic. I know Bill would have wanted me to, and I could never let him down. Buildings need to be kept up, and it's essential to have money available. We're currently working on another endowment fund drive, and when it began in the spring of 2016, I was back to the same old routine. One of the Lensic's initial contributors was a charitable foundation headquartered in Santa Fe. In the beginning, they gave us $350,000 for the sound system and followed with annual gifts of $10,000. Both of the founders had died within the last four years, and I thought that would be the end of it until I read in the newspaper that the foundation had given to a local organization. I figured that if the foundation was viable, I should request $10,000 or $15,000 for the Lensic's annual fund drive. I arranged to meet with the foundation's director.

On the appointed day, I went to the director's office. My goal was to secure a donation to the annual fund drive. As a separate item, I brought a folder of information about the endowment campaign—the Lensic named it the Zeckendorf Endowment. It never occurred to me to ask for an endowment gift from this foundation, but I wanted to provide the director with the current facts and financials of the Lensic.

"I hope you can see your way clear to contribute to the Lensic annual fund again," I said.

I was disheartened by her response.

"I don't know if it's something we can do again," she replied.

She opened the endowment folder, scanned the material, and handed it back to me.

"I'm afraid we can't give anything to the annual campaign. The request really doesn't fit our requirements."

My heart sank.

"However," she continued, "knowing the good work that you do, we'd be happy to contribute a million dollars to the Zeckendorf Endowment."

When I heard that, I did something unprofessional, something I'd never done before. I burst into tears.

❋

Chapter Twenty-Seven

I f friends had told me that I would find a lifelong career as a fundraiser after I stopped dancing, I would have assumed they were nuts. Yet, here I am, nearly sixty years after I retired from the Met, fundraising for causes I believe in. While it's safe to say that most people don't enjoy asking others for money, it's never bothered me—I like the challenge. Growing up, I didn't even know there was such a profession as fundraising. Lucia Chase started my second career when she handed me her little tin box of names and told me to contact them. Guided by Lucia, I learned on the job. People like Marty Segal were helpful. Marty was the elder statesman of Lincoln Center for the Performing Arts where he co-founded and served as chairman of the Film Society of Lincoln Center, now called Film at Lincoln Center. A successful businessman and a beloved figure in the New York cultural scene, Marty raised money for the arts. Asking for money and being beloved don't always go together, but they did with Marty. I learned so much from him—one recommendation in particular I've always followed: when asking for money, present your best case and hope for the best. It often happens that potential donors can't give because they're contributing to other causes. Your response is,

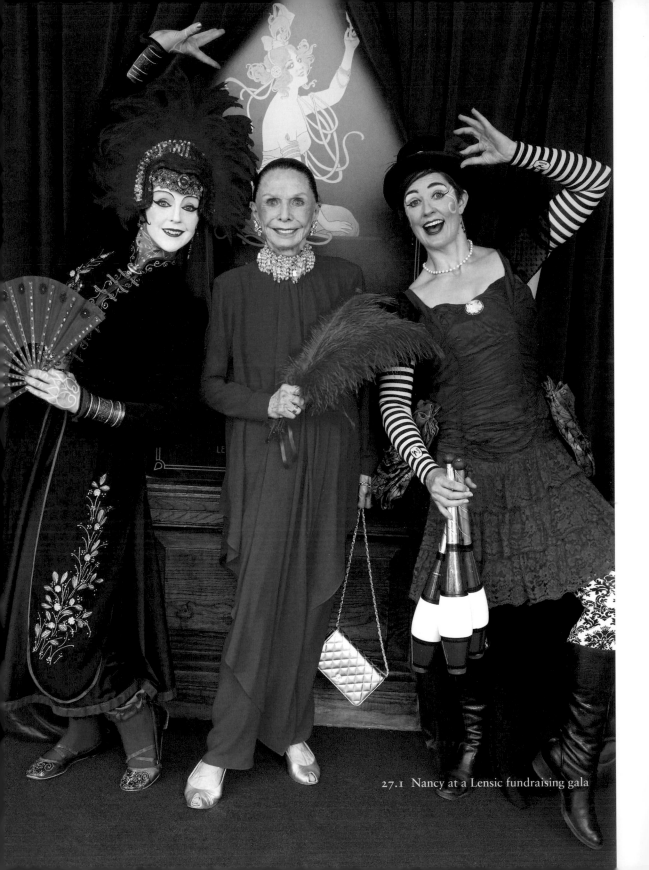

27.1 Nancy at a Lensic fundraising gala

"how wonderful that they have your support." You don't want to make anyone who is charitable feel bad. It's better to praise their benevolence and leave it at that.

During my time at ABT, I was more an event planner than a fund-raiser. I came into my own with the Santa Fe Opera. Robert Glick used to call me a closet development director. Call me whatever you wish, I never wanted the responsibility of a title, only to do the work. Inspired by my passion for music and dance, I raised money for the American Ballet Theatre and the Santa Fe Opera. I was also doing it for Lucia Chase and John Crosby, respectively. I was connected to them and their organizations. It was different with the Lensic because there was no personal connection motivating me. However, it is a venue for events and activities that I care about, and it enriches the lives of people who live here, so I'm completely comfortable asking others to support it financially. In its own right, fundraising is an art form, too. Like dance, it requires the same key ingredients for success—a genuine commitment to your project, preparation, intuition, and a flair for showmanship.

Looking back on my years of performing, I was both shy and a show-off. Yet, no matter how reserved you are in your private life, if you're in the performance world, you need to be an exhibitionist. I never had inhibitions when it came to performing, whether it was doing a number with Louellen on board the *Ile de France*, dancing around a dinner table in Afghanistan, or spinning around the Eldorado ballroom. At the Santa Fe Opera balls, people would clear the dance floor and I'd go out and improvise. I don't do things like that anymore because, thanks to my aching back, I can't. I'll still get on the dance floor as part of the crowd, but not as a soloist. I can do that because I keep myself in shape by exercising and taking long walks every day. It's easy to take those walks because I'm in a location conducive to them, which brings me to the subject of Santa Fe—the best place in the world to live. I mean it.

Let's start with what everybody talks about, the weather. It's perfect. There is snow in winter, but it's usually gone the minute the sun comes out. If it's not too cold, you can sit outside. Santa Fe is a high desert, so the summers are hot, but there is no humidity. Life doesn't depend on air conditioning. As far as cultural life, we're among the top art markets in the country with museums and galleries galore. Annual events such as Indian Market, Spanish Market, and the International Folk-Art Market showcase the cultural heritage of artists and their families. In addition to the Santa Fe Opera, we have the Santa Fe Chamber Music Festival, the Desert Chorale, the New Mexico Jazz Festival, Santa Fe Bluegrass and Old Time Music Festival, and more. I'm beginning to sound like a tourist information bureau, but I am an unabashed fan of my adopted home-town. Bill used to say Santa Fe is a small town without a small-town men-tality. He was right. I know all about those mentalities. In Tidioute, gossip was currency. In Santa Fe, nobody gives a hoot. You can be straight, gay, rich, poor, married, divorced, single, it doesn't matter. It's a casual place, not a clubby one.

The Santa Fe population includes Native American, Hispanic, and Anglo American families who've been here for generations. There's a large group of new settlers who have put down roots in this northern New Mexico town. Bill and I fall into that group. (Bill's ancestors settled here as mer-chants in 1853, so he might have a claim to the old guard.) There's also the cowboy hats and boots folks. They may rent a house for a while, but they're usually gone within a year. I'm not saying that anyone who wears cowboy boots and hats doesn't belong (mea culpa, once upon a time), but you can tell by the way they're dressed and what they say, that they might be looking for something that doesn't exist here. Young people are always coming here because there's mystery and magic in Santa Fe. They're ed-ucated, but they often wind up working in an art gallery or a restaurant. When career prospects wane, they move on, replaced by a new bunch of eager hopefuls. It's true that Santa Fe residents come from divergent walks of life, but everyone gets along. I'm comfortable here. There's nowhere

else I would rather be, including New York. No question, I've come full circle. I'm back in a small town, not as small as Tidioute, but still a small town. The difference is, Santa Fe encourages big dreams, and believe it or not, I still have a few.

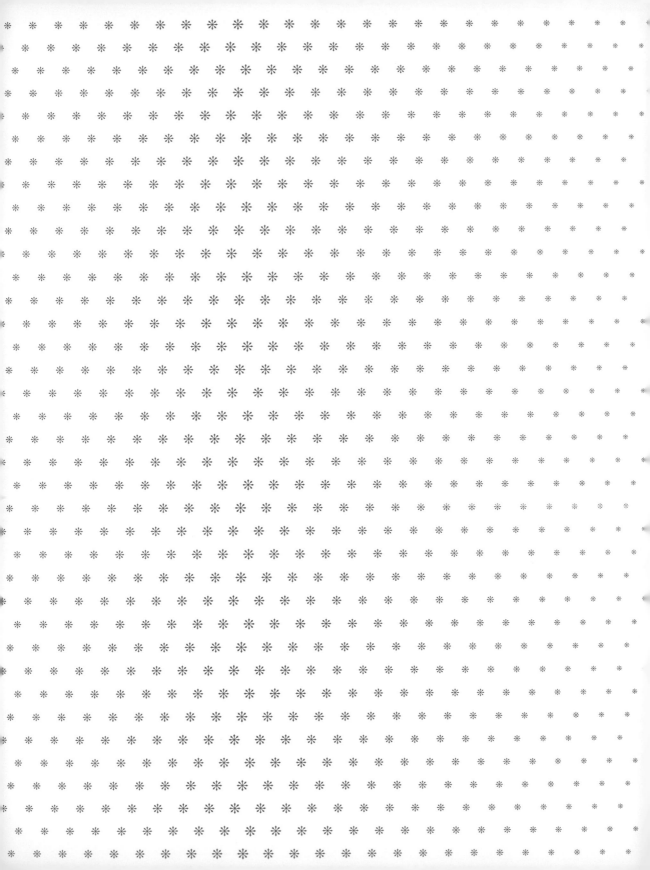

Epilogue

BEFORE BILL DIED, we talked about Los Miradores—that I might buy a place there to fix up and, as Bill said, rent it, sell it, or live there someday. He added, "If you go first, I'm staying here in this beautiful house in Sierra del Norte." At the time, we were living in a magnificent home designed by my good friend Greg Teakle. It was the second home he designed for us. There was an indoor exercise pool and a great wine cellar to hold Bill's beloved burgundies.

So, what did I do? Shortly after Bill died, I bought a place in Los Miradores but not before asking my designer friend, Joan Lombardi, to come see it. I asked her if we could make it thoroughly contemporary—and we did, without changing the outside. I think it is my best house ever—at least for me now.

Shortly after I settled in, my friend and former owner of the Four Seasons restaurant, Tom Margittai, came to dinner. He looked around and said, "You could show me this house anywhere and I would say, "this is Nancy's house."

Nancy at home in Santa Fe

I guess I will be fundraising for the Lensic until I die. You know the phrase, "Once a dancer, always a dancer." It applies to fundraisers, too. I am in touch daily with the Lensic staff, especially Aggie Damron-Garner, who calls me every morning just to be sure I'm still here. It is a privilege to continue to be part of the Lensic and see the talented staff in action. I keep in touch with my colleagues who are still alive from the Met. My friend Gigi Bennahum, who writes wonderful books on dance, lives in Albuquerque. She danced with me both seasons we performed with the Santa Fe Opera. Bruce Marks, my dance partner, continued his career as a dancer and director of several ballet companies. He lives with his partner in Florida. We share a lot of books, and each winter we spend a week together in Mexico talking old times, teachers, and friends.

Lolita San Miguel, a dance colleague from the Met, is the supreme expert on Pilates. She travels the world teaching, and we speak often.

I hadn't seen Misha since my days at ABT, so imagine my surprise and delight one evening at an ABT performance in New York. I was walking up the aisle to my seat in the theater and someone hugged me—it was Misha.

I wish I had kept in touch with Jo and Ellen from my summer at Interlochen. They got me out of Tidioute and on my way to dream of being a dancer.

Debbie and I talk every day because she runs my life—beautifully, patiently, and lovingly. What a joy and wonderful gift she has been all these years.

I am lucky here to have a best friend, Kathie Reed, who was not a dancer but a great traveling companion. We have gone to many wonderful places.

My pals of 15 years who are still on the staff of the Santa Fe Opera remember my birthday every year with cards, balloons, and lasagna. What's left to wish for? I adore them and will never forget how it made my heart sing to work with them.

I saved the best for last. His name is William James. His lovely parents are my stepson Will and his wife Anna. Will and I have always stayed in touch, and for that I am grateful. Will's brother, Arthur, has two children, Artie and Jenny, who are precious to my life.

✳

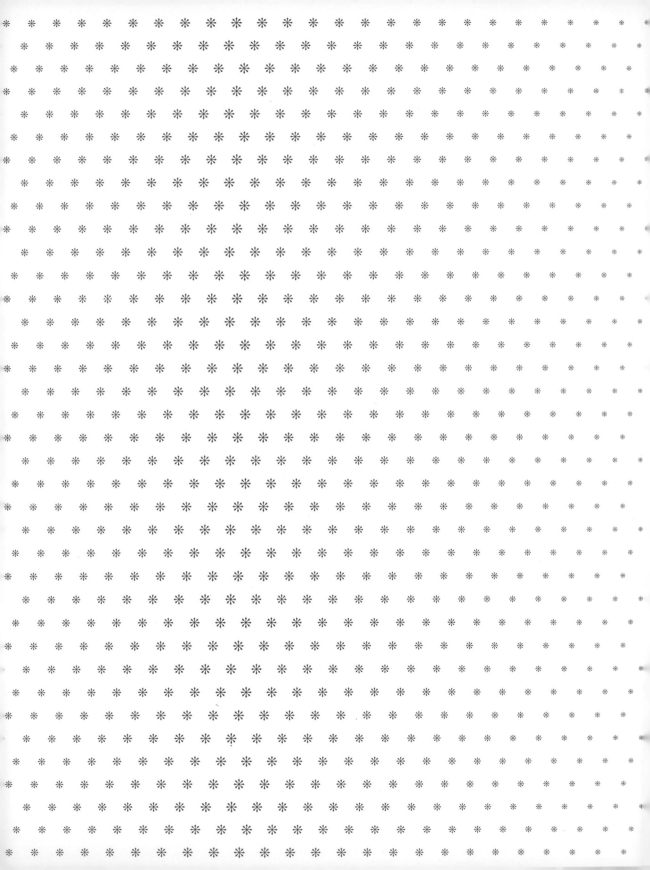

Acknowledgments

I'm grateful to Gigi Bennahum for providing good advice and inspiring me to go forward, to Kelly Hardage for not leaving me alone until I did this book, to Shelby Stockton Lamm, my editor, project manager, and friend, to Joan Oliver for helping me understand the many complicated aspects of the publishing world and for her very helpful advice, to Jane Scovell for patiently listening to me for weeks as I told her about my life, to Leshek Zavistovski and his late wife Toni for introducing me to Jane, to Craig Ladwig for advice, inspiration, and his clear vision, to Debbie Klein for interpreting everyone's emails and transferring them to my fax machine, to photo researcher Neil Ryder Hoos, and to Shannon Medrano for the book cover design.

Jane Scovell wishes to thank Nancy Zeckendorf for living a life that was a delight to record. Thanks also to Amy Appleton, Lucy Appleton, Bill Appleton, Jane Donahue, Andrew Barraclough, Charlotte and Ben Sarraille, Isabelle and Kate Appleton, Mikki Ansin, and Sydney Sheldon Welton, perspicacious editor and dearest friend.

All proceeds from the sale of this book will be donated to the Lensic Performing Arts Center in Santa Fe, New Mexico.

NZ

Credits

Every effort has been made to contact copyright holders. Please contact the publisher for any additions or corrections.

COVER
Photo of Nancy on Los Miradores construction site. Courtesy of Zeckendorf family.

BACK COVER
Photo of Nancy in costume jumping for joy. Photo: Rad Bascome.

CHAPTER 1
1.1–1.4: Courtesy Nancy Zeckendorf.

CHAPTER 2
2.1, 2.2: Courtesy Nancy Zeckendorf.

CHAPTER 3
3.1: Courtesy Nancy Zeckendorf.

CHAPTER 5
5.1, 5.2: Courtesy Nancy Zeckendorf.

CHAPTER 6
6.1: Courtesy Nancy Zeckendorf.
6.2: Courtesy Nancy Zeckendorf.
6.3: Cover of Collier's, May 10, 1952. Photo of Nancy Zeckendorf by Anton Beuehl.

CHAPTER 7
7.1: Courtesy Nancy Zeckendorf.

CHAPTER 8
8.1: Courtesy Nancy Zeckendorf.

CHAPTER 9
9.1, 9.2: Publicity photographs. Photographer unknown. Courtesy Nancy Zeckendorf.

CHAPTER 10
10.1: Photo: Arnold Weissberger.
10.2: Courtesy Nancy Zeckendorf.

CHAPTER 11
11.1, 11.2: Photo: Louis Melancon. Courtesy Metropolitan Opera Archives.
11.3: Photo: Daniel Entin.
11.4: Photo: Louis Melancon. Courtesy Metropolitan Opera Archives.
11.5: Photo: Rad Bascome.

CHAPTER 12
12.1–12.3: Courtesy Nancy Zeckendorf.

CHAPTER 13
13.1,13.2: Stravinsky's Perséphone at the Santa Fe Opera, 1961. Photos by Tony Perry, courtesy of The Santa Fe Opera.
13.3: Photo: Laura Gilpin. © 1979 Amon Carter Museum of American Art.

CHAPTER 14
14.1: Photo: Louis Melancon. Courtesy Metropolitan Opera Archives.
14.2: Courtesy Nancy Zeckendorf.
14.3: Photograph by Lotte Meitner-Graf, London. Copyright © The Lotte Meitner-Graf Archive. info@lottemeitnergraf.com.
14.4, 14.5: Courtesy Nancy Zeckendorf.

CHAPTER 15
15.1: Photo: Arnold Weissberger.
15.2: Photo: Bradford Bachrach.
15.3: Courtesy Nancy Zeckendorf.

CHAPTER 16
16.1, 16.2: Courtesy Nancy Zeckendorf.

CHAPTER 17
17.1, 17.2: Courtesy Nancy Zeckendorf.

CHAPTER 18
18.1, 18.2: Courtesy Nancy Zeckendorf. Photographers not known.

CHAPTER 19
19.1: Courtesy Zeckendorf family. Photographer not known.

CHAPTER 21
21.1: Courtesy Nancy Zeckendorf. Photographer not known.

CHAPTER 22
22.1, 22.2: Courtesy Nancy Zeckendorf. Photographers not known.

CHAPTER 23
23.1: Photo: Michael Heller/New York Times credit t.k.
23.2: Photo: Herbert Lotz - NMHM/POG.
23.3: Photo: © Robert Reck.

CHAPTER 24
24.1: Courtesy Zeckendorf family.

CHAPTER 25
25.1–25.3: Photos: © Robert Reck.
25.4: Photo: Kate Russell.

CHAPTER 27
27.1: Photo: Courtesy InSight Foto, Santa Fe, NM.

EPILOGUE
Photo: Kate Russell.

Index

Page numbers in *italics* denote photographs.